平面設計這樣做就對了

100種格線設計的基本法則

U0014017

遠流出版公司

平面設計這樣做就對了

100種格線設計的基本法則

Layout Essentials

100 DESIGN PRINCIPLES FOR

USING GRIDS

貝絲·唐德羅（Beth Tondreau） 著

林卓君 譯

遠流出版公司

國家圖書館出版品預行編目(CIP)資料

平面設計這樣做就對了--100種格線設計的基本法則 ／ 貝
絲.唐德羅(Beth Tondreau)作；林卓君譯. -- 初版. -- 臺北市：
遠流, 2013.01　　面；　公分
譯目：Layout essentials : 100 design principles for using
grids
ISBN 978-957-32-7038-6(平裝)

1.平面設計 2.版面設計

964.6　　　　　　　　　　　　　　　101015691

平面設計這樣做就對了

100種格線設計的基本法則

Layout Essentials:100 design principles for using grids

作者	貝絲·唐德羅（Beth Tondreau）
譯者	林卓君
總編輯	汪若蘭
編輯協力	李佳霖
封面設計	李東記
行銷企畫	高芸珮
內頁排版	張凱揚

發行人	王榮文
出版發行	遠流出版事業股份有限公司
地址	臺北市南昌路2段81號6樓
客服電話	02-2392-6899
傳真	02-2392-6658
郵撥	0189456-1
著作權顧問	蕭雄淋律師
法律顧問	董安丹律師

混合產品
源自負責任的
森林資源的紙張
FSC™ C016973

2013年1月1日　初版一刷
2017年4月　初版三刷
行政院新聞局局版台業字號第1295號
定價 平裝新台幣390元（如有缺頁或破損，請寄回更換）
有著作權‧侵害必究 Printed in Taiwan
ISBN 978-957-32-7038-6
遠流博識網 http://www.ylib.com　E-mail: ylib@ylib.com

「設計就像水晶玻璃杯。所有與設計相關的事物都要仔細地規劃呈現，而非掩蓋原先想要表達的美麗事物。」

──碧翠絲・瓦德
(BEATRICE WARDE)

目錄

「在版面設計中，格線是最容易被誤解、誤用的元素。只有源自於需要格線設計的需求，才能發揮效用。」

—德瑞克・伯沙（DEREK BIRDSALL），《書籍設計札記》（NOTES ON BOOK DESIGN）

開始運用

「解決完所有文字編排的問題後，設計者必須能跳脫結構的框架，同時又善用框架，創造出動態的視覺頁面，讓讀者一頁接一頁看下去，這樣格線才算真正發揮功效。」

——提摩西·沙瑪拉（TIMOTHY SAMARA），《創造與打破格線（MAKING AND BREAKING THE GRID）

導言

「……羅森柏先生
十分重視格線，
視其為版面構成
不可或缺的工具。」

— 〈論格線之於藝術家羅勃·
羅森柏（ROBERT
RAUSCHENBERG）
的重要性〉，麥可·金麥曼
（MICHAEL
KIMMELMAN）撰，
紐約時報訃聞
（2008.05.14）

格線能為讀者組織內容和空間，安排整體閱讀版面。

格線也是訊息內容的邊界，制定規範，使版面保持井然有序。

儘管格線已被使用了幾個世紀，每當提到格線，許多平面設計者總還認為與瑞士人有關。一九四〇年代崇尚整齊的風潮，當時以系統化的方式編排內容，格線便應運而生。幾十年後，一般都認為格線規律、呆板、無趣，是古板設計的象徵。但到了今天，格線又再度獲得專業人士青睞，不管是設計新手，或已具備幾十年經驗的資深老鳥，都將格線視為極為重要的工具。

本書介紹一百個格線設計的原則，可讓本書使用者在設計版面、系統或網站時，找到靈感。在說明每個原則時，會提供一個過去幾年設計和出版的案例，有老字號傳統出版社，也有新的媒體。

我希望本書的案例能提供概念、引起興趣、激發靈感，同時引導使用者牢記，最重要的溝通原則就是：「版面設計與字型安排一定要和內容相關。」

基本認識

1. 組成元素

格線有幾大元素，包括邊緣、標記、欄位、參考線、區塊和單元。

欄位

欄位是放入文字或圖像的垂直空間。版面或螢幕上的欄寬和欄數，會視內容而有所改變。

基本單元

基本單元為分隔獨立的空間，彼此間距固定，可形成連貫又有條理的格線狀設計。幾個單元可組成數排大小不同的欄和列。

邊緣

邊緣是頁面留白處，指的是頁面版心與裁切邊（包含跨頁空白）之間的空間。邊緣也可容納較次要的訊息，如註解和圖說。

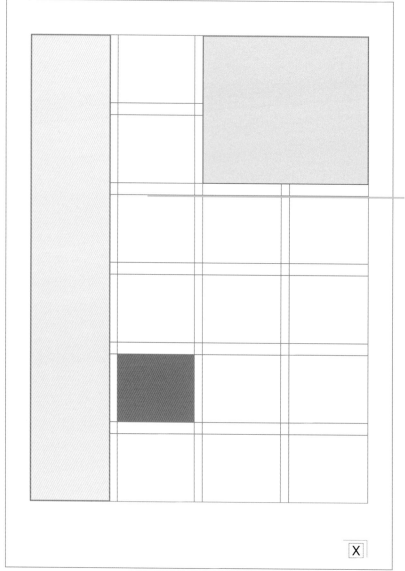

區塊

區塊是幾組單元或欄位構成的特定區域，可以提供放入文字、廣告、圖像等的空間。

參考線

參考線是將空間分為橫條的準線。即使參考線在版面上不會真的顯示出來，但可以藉此善用空間和版面元素，引導讀者按順序閱讀。

標記 X

標記能引導讀者往下閱讀。它標示出目前的所在頁數，而且會出現在頁面的同一位置，例如頁碼、逐頁短標（頁首與頁尾）、小圖示等。

2. 基本架構

單欄式格線
單欄式格線一般用於刊登連續的走文,例如報告、論述或書籍。在頁面或跨頁上,最主要的部分就是文字欄。

雙欄式格線
雙欄式格線適用於文字多、或想在各欄位呈現不同訊息的情況。欄寬可選擇兩欄同寬或一寬一窄。若是一寬一窄,理想的寬度比例是寬的欄位為窄的欄位兩倍。

多欄式格線
多欄式格線比單欄或雙欄更有彈性,可以結合不同寬度的欄位,適用於雜誌和網頁設計。

單元式格線
單元式格線最適合處理複雜的內容,如報章、行事曆、圖表和表格。單元式格線能結合橫列和縱欄,將頁面結構劃分成較小的區塊。

階層式格線
階層式格線把頁面切割成幾個區塊,大多都是以橫列組成。

3. 評估內容

在決定使用何種格線設計時,內容、邊緣、圖片多寡、希望的頁數、螢幕頁面或版面都會有所關聯。但最重要的是內容,內容決定格線的結構。要選用何種格線,取決於各個設計需求,不過以下是一些通則:

- 編排連續走文時會使用**單欄式格線**,如報告或書籍。單欄比多欄看起來文字量沒那麼嚇人,而且看起來比較賞心悅目與舒適,很適合藝術類書籍或目錄。
- 對於比較複雜的內容,**雙欄式和多欄式**較有彈性。可一分為二的欄位,能有最多變化。多欄式格線還適用於網頁,便於編排大量訊息,包括最新消息、影音和廣告。

- 至於在行事曆或日/月曆上的大量訊息,**單元式格線**能有助於將各組訊息編排為清楚的區塊。單元式格線也可應用在內容分屬許多區域的報紙上。
- **階層式格線**能水平分割頁面或螢幕,對簡單的網頁來說極為實用,因為可以把各區塊訊息分層排列,讓讀者往下拉頁面時,更容易閱讀。

所有類型的格線都能讓頁面井然有序,也都和周詳規畫與計算有關。無論設計者是以畫素、pt級數或毫米計算,格線規律有序的關鍵在於要確定所有數字都考量在內。

名稱
Good magazine

客戶
Good Magazine, LLC

設計公司
Open

設計者
Scott Stowell

這個草圖出自於設計大師之手,展現格線設計是如何形成。

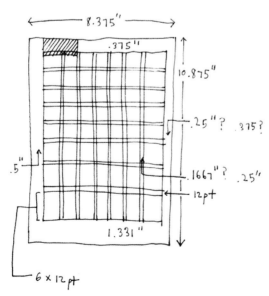

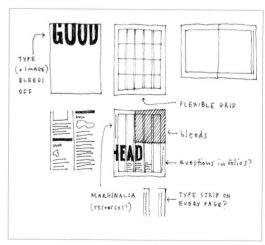

從這些草圖可以看出,設計者幫雜誌版面草擬了幾種可能使用的格線設計。

4. 先看重點;學會計算

先考慮主要文字內容,評估設計案的複雜程度。大部份的案子都有限制,例如開本大小、頁數和顏色。在把重點放在內容的同時,也要注意影響案子的其他因素。

一旦確定頁面或螢幕的尺寸以及文字部分,就要思考如何把各元素放進頁面。若只需要編排文字,可以把文字放入指定的頁數中。若還需要放進圖片、標題、box或圖表,就要先確定文字需要多少空間,剩下的才是圖片、圖表等其他內容可放的空間。你可能經常必須同時計算所有元素會占的空間有多少。

決定好版面要採用哪種設計方向和合適的架構後,就可以繼續進行標題和各階層訊息的細節。(見下一個原則)

文字編排小訣竅

字體是否恰當,與字的大小、粗細、字的間距和行距有關。連續走文若保持一致的形式安排,能有助於讀者輕鬆閱讀。這樣,同則內文的字體大小也可維持不變。

若要編排大量文字內容,字型除了美觀,還要符合功能需求。若是使用於連續走文,字型就必須夠大,行距也要夠寬,才利於長時間閱讀。若是橫排的每行走文不長,就要避免字與字之間距離太開,可以設定較小字型,不然就是調成齊左,右邊不齊沒關係。

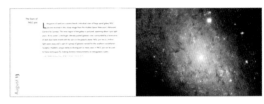

這本天文類書籍採單欄排版,呼應了宇宙浩瀚的空間概念。

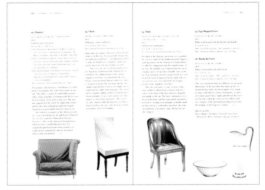

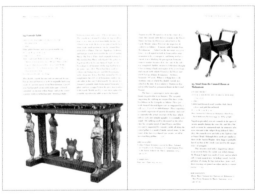

此目錄含有大量文字,使用雙欄格線來編排文字與去背的圖片。

名稱

Astronomy and
Symbols of Power

客戶

Harry N. Abrams, Inc.

設計指導

Mark LaRivière

設計公司

BTDNYC

設計者

Beth Tondreau, Suzanne Dell' Orto, Scott Ambrosino (for *Astronomy* only)

要使用單欄還是雙欄格線,取決於內容和文字長度。

5. 對讀者貼心一點

整個內容有標題嗎?副標題呢?列表?項目符號?如果沒有,需不需要加入剛提到的任何一項?還是全部都要?可以把最重要的內容放大或加粗,或者是換個字型,好從次要的內容中跳脫出來。變換字體、字級大小與粗細,都能有助於突顯不同種類的內容差異,但一切還是簡單為要。若設計編排都缺乏明顯目的,那太多的變化可能會令人摸不著頭緒。

儘管字型大小十分重要,空間安排也同樣重要。開頭的位置和周圍空間也有一定重要性。為了讓許多不同的內容便於區分,切割成幾個小區塊會讓閱讀起來更容易。插入引述在視覺上其實是形同插播;使用補充欄與box,能把內容裁切為數塊,方便讀者瀏覽。適當的編排方式可幫助閱讀者立即掌握內容。

名稱(左)

Symbols of Power

客戶

Harry N. Abrams, Inc.

設計指導

Mark LaRivière

設計公司

BTDNYC

古典風格的文字編排,使用的是Bodoni字體,能表現拿破崙時期的工藝特點。

名稱(右)

Blueprint

客戶

Martha Stewart Omnimedia

設計指導

Deb Bishop

設計者

Deb Bishop

現代風格的文字編排則是工整、確切,又充分傳達訊息。

對於入門者或只使用一種字型的人來說,訣竅是結合羅馬體(大小寫)及斜體(大小寫)字體,來定出階層關係。至於較為複雜的內容,可使用不同種類和大小的字型,來區別不同區塊的內容。

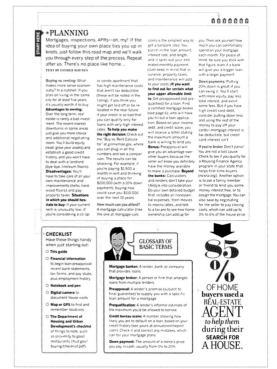

使用不同的字型和大小,以及將文字放入box內,能有效容納大量的文字。

6. 確立規則

版面設計上很少所有圖片會大小全部相同。正如同文字傳達訊息,圖片大小也透露事件或主題的重要性。有些公司會先按圖片大小排序,然後才發設計;有些公司則全仰賴設計者決定順序,或以變化圖片大小來增添頁面張力。有些複雜的圖片,毫無疑問需要放大,以提高可看性。除了透過大小變化來達到需求和動態感,版面設計也需要有所變化,才能吸引讀者的興趣。

圖片的大小可占半個、一個或兩個欄位。有時突破格線可增添戲劇效果,吸引讀者注意頁面。可利用圖片所占空間的多寡來突顯其重要性。

不同大小的圖片能在視覺上建立閱讀的先後順序。

7. 全盤考量

藉由把文字放在一個欄位或區塊，把圖片放在另一欄或區塊，可以區隔頁面中的各個元素，但要看編排的是平面書籍還是傳播媒體而定。不過大部分格線都能整合圖片和文字，給予兩者一定的重要性，讓內容清楚呈現在讀者眼前。

此跨頁強調的是文字。文字本身占一頁，圖片則占另一頁。

左圖和下圖：格線能讓圖片橫跨欄位，圖說放在下方。或者可將圖片縱向堆疊，圖說則放在圖片的左邊或右邊。

名稱
Mohawk Via
The Big Handbook
客戶
Mohawk Fine Pappers Inc.
設計公司
AdamsMorioka, Inc.
設計
Sean Adams, Chris Taillon

在紙樣的宣傳品上使用格線，可以好好編排各種圖片。

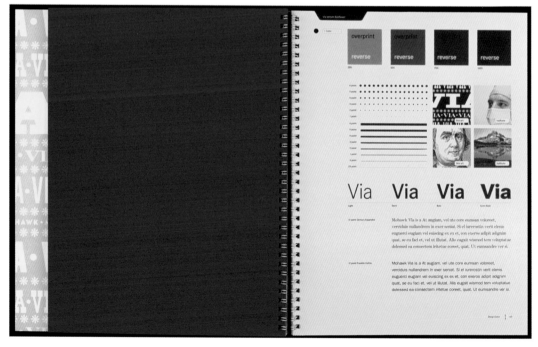

8. 用顏色界定空間

顏色可以讓單元或段落更為突出。顏色不僅可以界定頁面空間，也有助於組織頁面上各個元素。它讓頁面更生動，達到設計者期望讀者產生的印象。在決定要用什麼顏色時，先想想讀者。飽和的顏色能引人注目，不飽和的顏色則以較低調的方式襯托主文。但太多顏色會讓整體頁面看起來雜亂無章，難以閱讀。

顏色使用的要點

我們生活在紅綠藍三原色的世界，客戶和設計者幾乎都是在螢幕上觀看各種設計稿。螢幕上顯現的顏色明亮飽和又好看，以三原色呈現。不過，紙張和螢幕的顏色是大不相同。切記若是用傳統的四色印刷時，需要慎選紙張，還要不厭其煩地校正顏色，才能大致符合螢幕上的鮮明色彩。

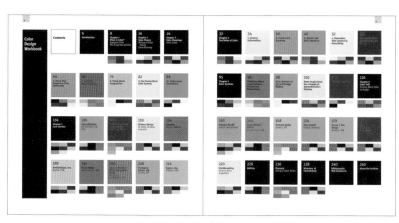

個別獨立的內容可放入以顏色形成的區塊中。

名稱
Color Design Workbook

客戶
Rockport Publisher

設計公司
AdamsMorioka, Inc.

設計者
Sean Adams, Monica Schlaug

此書的頁面顯示，顏色具有極大功能，能為整體設計增添生氣活力。

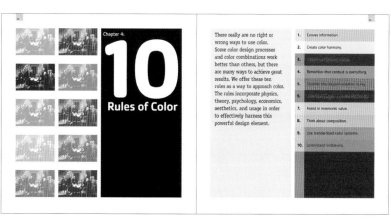

不管是在單元、box或區塊中，都能用顏色來區分文字所在的區塊。顏色可以讓單元看起來賞心悅目，並區分純放文字的box和色塊，也可用顏色達到某種功能，例如藉以區隔不同box的文字。

9. 用空間傳達訊息

空間與欄位是互有關連的。雖然格線必須清楚分明,才能讓讀者掌握一連串訊息,但未必需要填滿整個頁面。空間可以分隔訊息,讓讀者有足夠空間閱讀與理解。就設計來說,大面積留白能產生戲劇效果,而且得以聚焦。空間能表現雍容大氣和重要性,頁面上別無他物也能明顯傳達一種美感。

留白是刻意的設計,可以讓讀者停駐欣賞。

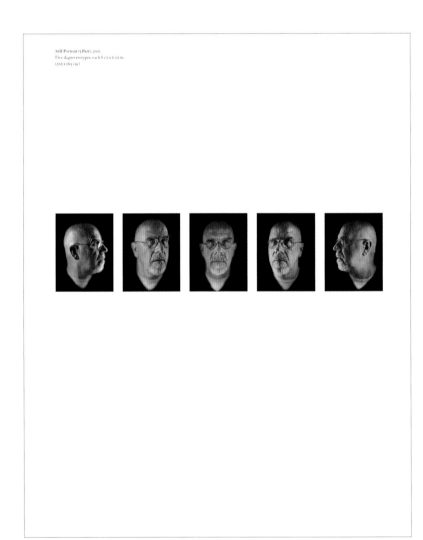

Self Portrait (5 Part), 2001.
Five daguerreotypes, each 8 1/2 x 6 1/2 in.
(21.6 x 16.5 cm)

名稱
Chuck Close | Work

客戶
Prestel Publishing

設計公司
Mark Melnick

藝術和設計一樣,都與空間有關。

10. 速度決定調性

有些格線是要用來編排制式、清楚、重複又連續幾欄的圖片或訊息,涵蓋內容是盡可能越多越好。不過,大部分格線也能讓各區塊、頁面或螢幕上的內容接續得相當流暢。頁面內容是否能吸引目光或維持讀者興致,取決於如何安排內容編排的步調。而影響步調快慢的因素,包括圖片和字型的大小與位置,以及每張圖片周圍所留的邊緣空間。

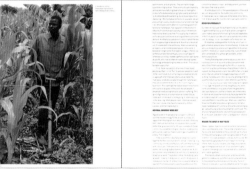

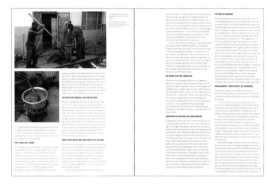
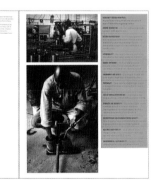

名稱

Design for the Other 90%,
exhibition catalog

客戶

Smithsonian, Cooper-Hewitt,
National Design Museum

設計公司

Tsang Seymour Design

設計指導

Patrick Seymour

設計者

Laura Howell

此流暢的排版完整清楚地呈現
一則報導。

接連幾頁或整版的連續報導需要律動感和變化。大小不一的圖片可讓內容更為生動,有助於引領讀者閱讀,激發興趣。

圖片大小則可依文字內容的特質和重要性來取決。

「設計與文字編排就像量身訂做的西裝：一般人可能不會特別注意到手縫鈕扣（字距）、合身的縫摺（對齊完美），或是高級布料（字型大小零缺點）……他們只是憑直覺認為這套西裝看起來好像價值百萬。」

—瑪莉安・本傑思
（MARIAN BANTJES）

開始運用

11. 選定字型

在為單欄式格線選擇適合的字型時，要先好好思考設計案的內容主題是什麼。有些字型看起來古典中性，適用於大部分內容；有些字型則能表現觀點，幾乎能直接傳達主題。字型能表現一種態度，或者就僅是一種字型而已。頁面上有文字的區域、字型的大小以及行距，都會影響整體頁面呈現。無論是怎樣將內容放進現有或理想的排版頁面上，比例都極為重要。

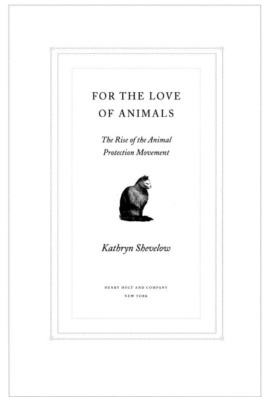

若是文字很少的版面，文字編排的細節就可謂舉足輕重。各個字母間距和字型大小的關係都是整體設計成功與否的關鍵。

名稱
For the Love of Animals

客戶
Henry Holt and Company

設計公司
Fritz Metsch

簡單雅致的頁面，搭配中規中矩的字型，呈現出一種內斂，同時也有可讀性。

My stepdaughter in Washington D.C. adopted Elsa, a loving brindle pit bull mix, from a local SPCA shelter: Elsa had been removed from a backyard littered with feces and broken glass, where she had been tied up, starved and exposed to the weather; she was restored to health, put up for adoption, and now enjoys watching television on the living room couch. My sister in Ohio has a sweet Labrador retriever, Molly, who was discovered twelve years ago when she was an abandoned puppy, wandering the streets of her town. The animal control officer, a friend, picked her up, took her to a vet, and then called my sister: now Molly enthusiastically dives into the family pool after tennis balls. Another sister and her husband, who live on an Ohio farm, foster horses that the Humane Society has rescued from their abusive owners. Their current resident, a thoroughbred named Hank, came to them a living skeleton; only the photograph taken at the time of his arrival makes it possible to connect that frail beast with the chestnut beauty frisking in their pasture today.

Most of us take these kinds of stories for granted. Many of us know someone who has adopted a rescued animal, and quite a few of us have done so ourselves. Sadly, the other side of this coin is that animals so commonly need to be rescued. Whether it is a dog fighting ring or a disease ridden puppy mill, horses left to starve in a grassless paddock, or cats dying in the home of an obsessive animal hoarder, humans are capable of extraordinary cruelty to the non-human animals over whom they have power. Often the stories are simply heartbreaking—sometimes owners are too sick, elderly or poor to care for their pets, as was probably the case in Graham's original home. Other times the stories are horrifying examples of callous negligence or sadistic cruelty. There is nothing new in this.

What *is* new, however—quite new, historically speaking—is that we have laws designed to protect animals from mistreatment. We hold their abusers accountable. The sorts of rescues that saved Graham, Elsa and Hank are often the result of investigations conducted by authorities—police, animal control officers and humane law enforcement agents—who upon receiving reports of suspected animal abuse are empowered to enter private premises, confiscate animals if their condition warrants it,

and often make arrests. Abusers may find themselves in court, and if convicted they face penalties ranging from a fine and probation to prison.

It is all too true that our current animal cruelty laws are woefully inadequate, covering too few categories of animals and permitting too many exemptions, inconsistent enforcement, and slap-on-the-wrist punishments. Pets may now have protection from abuse, but they are still generally viewed as property. Large categories of animals—most importantly those in our politically powerful industrial agriculture system—are exempt from most anti-cruelty laws. Political progress on animal welfare issues is slow and uneven. Nonetheless, there *is* progress: animal protection laws *do* exist and, however slowly, they are increasing in number and strength.

Furthermore, animal protection and animal advocacy have acknowledged places within our society. The television show "Animal Rescue," is popular, and newspapers and television news programs routinely carry exposes about animal abuse. The U.S. government gives official sanction to animal advocacy groups that work against individual and corporate cruelty, and that, through local offices, engage in animal rescue: such as the ASPCA, the Humane Society of the United States (HSUS), People for the Ethical Treatment of Animals (PETA), Farm Sanctuary, the Fund for Animals—and many, many more. Whatever their ideological and practical differences, these organizations are registered charities; we deduct our donations to them from our taxes. In many cases, particularly as regards our factory food system, such groups have been far more responsible for advances in alleviating animal suffering than our legislatures have been.

Behind our existing animal welfare laws, for which animal protection organizations have lobbied and continue to lobby, stands another historically new development: a social consensus that the abuse of animals is wrong. Granted, what constitutes "abuse" is still very much debated in our society, even among animal welfare advocates, and many people feel much more affection and compassion for some animals, such as cats, dogs and horses, than they do for others, such as cows, pigs and chickens. (The issue gets even more conflicted when we leave the realm of mammals and birds altogether and begin to consider reptiles and insects.) Many of us

A GRAY TABBY CAT with gorgeous green eyes and fuzzy white paws like bedroom slippers sits purring on my lap as I write: a loving creature with a big personality, he likes to watch the cursor scurry around the computer screen. His name is Graham, and my husband and I met him seven years ago at our local Humane Society shelter here in California, where he had arrived as a kitten, malnourished and sick, his beautiful coat filthy and matted. The police, responding to neighbors' complaints, had investigated a foul smelling house where they found more than seventy emaciated, flea-ridden cats. Graham's rescuers administered food and antibiotics, cleaned him up, gave him his improbable name (for a cat)—a name that we could not change, for it suits him perfectly—and put him in the kitten adoption room, where he claimed the attention of everyone who entered. We were lucky to arrive shortly thereafter, and he went home with us later that day: he was irresistible then, and he remains irresistible now.

Graham shares our home with two other cats. Our calico Chloe, whom we adopted from the same Humane Society shelter seventeen years ago, is the undisputed matriarch of us all. She still loves to drape herself over my shoulders and ride regally around the house. Sitong Mattie, whose lynx-point coloring and stocky, bow-legged body suggest that she is half Siamese and half bulldog, had been found on the street as a sickly stray kitten and taken to our veterinarian. Now sleek and healthy, she requests our attention by tapping us gently with her paw, gazing up at us with her endearingly crossed blue eyes.

their own kinds of knowledge, which is by definition limited to their spheres—and that this is true of humans, too. Rather than superior knowledge, it is actually "the ignorance of men concerning other creatures," Cavendish wrote, that permits them to despise non-human animals, considering themselves "petty Gods in Nature."[14] The duchess expressed her contempt for this self-importance in her speech, in her prose and, most eloquently, in her poems:

> *[Man] is so* Proud, *thinks onely he shall live,*
> *That God a God-like* Nature *did him give.*
> *And that all* Creatures *for his sake alone,*
> *Was made for him, to* Tyrannize *upon.*[15]*

SIX YEARS AFTER he witnessed Margaret Cavendish's visit to the Royal Society, John Evelyn went to see an exhibition called Paradise—a mechanical re-enactment of the creation of the world. Evelyn admired "the representations of all sorts of animals, handsomely painted on boards or cloth, & so cut out & made to stand & move, fly, crawl, roar & make their several cries, as was not unpretty." Clockwork scenes such as this were extremely popular throughout the long eighteenth century (and after), whether exhibited at shops and private showrooms or amazing the crowds at Bartholomew Fair. In the early 1700s, the clockmaker Christopher Pinch-

*When discussing human and non-human animals in a historical context, the question of language is a vexed issue. During the era covered in this book, as is often still the case today, the word "animal" and other words such as "beast" and "brute" referred to non-human animals (unless metaphorically applied to humans). I will follow this traditional practice, except when otherwise noted. I will usually se "animal" to refer to hon-human vertebrates, but i earlier historical periods it could be applied to insects and other invertebrates as well. The usual eighteenth-century practice of designating the entire human species as "man," however, is one that I generally try to avoid in my own language, though this is difficult when attempting to convey a sense of an earlier historical period. Furthermore, it does reveal the patriarchal attitudes underlying that usage, as Margaret Cavendish was well aware.

Margaret Cavendish, noblewoman and intellectual.
Frontispiece, Philosophical and Physical Opinions, 1655

beck became particularly celebrated for his remarkable mechanical extravaganzas. The "Wonderful and Magnificent MACHINE" he displayed in 1729, for instance, featured among several other marvels a scene of Orpheus charming the wild beasts and an "Aviary of Birds," whose song (or so Pinchbeck's advertisement boasted) was "imitated to so great Perfection as not to be distinguished from Nature itself." The machine also contained a dog and a duck playing, fish jumping in the sea, and a river in which swans swam, fished and fledged, "their Motions as natural as tho' really alive."[16]

Human and animal machines had been a sight on the European cityscape since the advent of the great town clocks adorned with figures that creaked into motion at certain hours. The fourteenth-century clock tower in the cathedral of Strasbourg, for instance, housed a mechanical cock that announced noon by crowing and flapping its wings. In the form of animated waxworks, peepshows, panoramas, and the playhouses'

12. 預留足夠的邊緣

若頁數很多，裝訂邊最好要留得夠大，之後在裝訂時才不會蓋住文字內容。如果設計編排的是書籍，在螢幕上看或從雷射印表機印出來的樣稿，或許看起來比例大小皆宜，但送印裝訂後的效果可能就大不相同。而裝訂邊會因裝訂而縮減多少空間，取決於書籍或簡介手冊的頁數和裝訂方式。不管是用一般膠裝、穿線裝訂或是騎馬釘，最好都先確認不會壓到內容。

裝訂方式和邊緣

有些裝訂方式會比較容易讓裝訂邊壓到內容。用穿線或PUR膠裝裝訂的書，能比一般膠裝裝訂的書翻得更開。以一般膠裝裝訂的書，文字可能比較容易被壓到，而讀者也可能不太願意破壞裝訂、把書拆開。若是以活頁簿項圈式裝訂，則要在裝訂邊為書背保留足夠的空間打洞。

名稱

Sauces

客戶

John Wiley and Sons

設計公司

BTDNYC

八百多頁的烹飪食譜書，需要足夠的裝訂邊空間。

此為烹飪書《醬料》（Sauces）的頁面，作者為James Peterson，2008年由John Wiley & Sons公司出版。此頁經該出版公司授權使用。

GOLD-PLATED CHICKEN WITH GINGER, SAFFRON, AND ALMONDS

This modern adaptation is not based on any particular recipe but is taken from several recipes in Taillevent's Viandier (fourteenth- and fifteenth-century manuscripts). Ginger, saffron, and mint are the principal flavorings; ginger and saffron were the spices most often called for in medieval recipes, and mint was one of the most commonly used herbs. The sauce is bound with almond butter, a typical medieval liaison (bread can also be used). Green-colored marzipan almonds and pomegranate seeds are used as the garniture. The almonds are a reference to the medieval cook's tendency to fashion one food from another to surprise and titillate the diner. They are sweet (and surprisingly good with the sauce), recalling the inclination to juxtapose the savory with the sweet in the medieval meal. The gold plating is extravagant and can be eliminated (or silver leaf can be substituted), but it is taken from an authentic recipe. Gold and silver foil are still used in Indian cooking to decorate desserts. Medieval diners were fond of bright colors, hence the gold, the pomegranate seeds, the saffron, and the colored almonds.

The chicken is prepared like a fricassée, but the recipe could be adapted to a sauté model as well.

YIELD: 4 SERVINGS

chicken, quartered (1 chicken)	3 pounds	1.4 kilograms
salt and pepper	To taste	To taste
butter or lard	4 tablespoons	60 grams
onion, chopped	1 medium	1 medium
white chicken stock	2 cups	500 milliliters
almond paste	2 ounces	50 grams
green food coloring or chlorophyll	Several drops	Several drops
pomegranate	1	1
saffron threads	1 pinch	1 pinch
hot water	1 tablespoon	15 milliliters
finely grated fresh ginger root	2 teaspoons	10 grams
mint leaves	1 small bunch	1 small bunch
almond butter (*see* Chapter 17, "Purees and		
Puree-Thickened Sauces," page 431)	2 tablespoons	30 grams
egg yolk	1	1
gold or silver leaf	4 sheets	4 sheets

1. Season the chicken pieces with salt and pepper. In a 4-quart straight-sided sauté pan, gently cook the seasoned chicken pieces, skin side down, in the butter or lard. After about 10 minutes, turn and cook the flesh side. Avoid browning the chicken or burning the butter. Remove the chicken.

8 • SAUCES

2. Add the chopped onions to the butter in the pan, and sweat, without browning, until they are translucent.
3. Add the chicken stock to the pan. Arrange the chicken pieces in the liquid and cover.
4. Cook the chicken in a 350°F (175°C) oven or over low heat on the stove for 15 to 20 minutes.
5. While the chicken is cooking, work the almond paste with the food coloring or chlorophyll until it is bright green. Shape the colored paste into 12 almonds and set aside.
6. Remove and reserve the seeds from the pomegranate. Discard the flesh.
7. Soak the saffron threads in the hot water for at least 20 minutes.
8. Transfer the chicken to a plate and keep it warm. Add the grated ginger to the liquid in the pan and let it infuse for 5 minutes.
9. Strain the sauce into a 2-quart saucepan and reduce it to ⅚ cup (200 milliliters). Skim carefully.
10. Gradually add the saffron, tasting so that its flavor becomes apparent but does not overpower the flavor of the ginger. Add the mint.
11. Whisk in the almond butter until the sauce has the desired consistency. Add salt and pepper to taste.
12. Beat the egg yolk with a large pinch of salt to make an egg wash.
13. Brush the top of the chicken pieces with the egg wash.
14. Apply the gold or silver leaf by holding the sheet about ½ inch from the surface of the chicken and systematically blowing on the back of the gold leaf with a 5-inch-long (13 cm) plastic straw.
15. Serve the chicken surrounded with the sauce, the pomegranate seeds, and the green almonds.

RENAISSANCE COOKING: THE SIXTEENTH CENTURY

Surprisingly little has been written about cooking in the sixteenth century. In France one important book was published, a translation of Bartolomeo Platina's *De Honeste Voluptate*. Whereas most other books were based on earlier works and were medieval in character, Platina gives us a deeper understanding of both the cooking and the priorities of Renaissance Italy and France. During the Renaissance and for several centuries thereafter, culinary methods were closely linked to health and medicine. Much of Platina's writing was influenced by medieval medicine, which itself was based on Greek medicine with its elaborate system of humors and emphasis on the use of diet to balance the basic "personalities": sanguine, phlegmatic, choleric, and melancholic. The ingredient that appears in greater quantities in sixteenth-century recipes is sugar. Although by no means inexpensive, refining methods made it more accessible than it had been during

A SHORT HISTORY OF SAUCE MAKING • 9

裝訂邊留白夠大，能確保讀者輕鬆閱讀重要的製作步驟，文字也不至於擠到太邊邊。

⌒● BOLLITO MISTO

You can make a bollito misto starting out with water, but making it with broth, especially veal broth, will take it to new heights. Making a bollito misto—an assortment of poached meats—in veal broth is an ultimate luxury because you end up with a double broth that's almost as clear as consommé. While you can make a bollito misto as sybaritic as you like by poaching fancy tender cuts of meat in the broth during the last 30 minutes or so of cooking, the soul of a bollito misto is based on slow cooking tough cuts of meat that provide flavor and sapidity to the broth. Osso buco is de rigeur and oxtail and tongue are good additions. A piece of pork shoulder—have the butcher cut off the 4 shoulder ribs attached to the pork loin—also adds flavor and plenty of juice meat. Ideally the meat is served with two sauces, a tangy tartar-like green sauce based on homemade mayonnaise and mostarda di Cremona, a sauce of candied fruits that sometimes is made with mustard oil or mustard seeds. (Mostarda refers to the wine must that was used in the sauce in centuries past.)

YIELD: 12 SERVINGS

veal tongues	2	2
two-inch thick rounds of osso buco	6	6
large pieces of oxtail	12	12
three-pound pork shoulder section (last four ribs of the pork loin), tied in two directions with kitchen string	1	1
leeks, greens removed, whites halved lengthwise and rinsed, leeks tied together	6	6
large carrots or 2 bunches medium carrots, peeled, large carrots cut in half lengthwise, cut into 2-inch sections	3	3
bouquet garni		
veal broth or water	about 8 quarts	
mostarda di cremona (see below)		
green sauce (see below)		

1. Put the veal tongues in a pot with enough cold water to cover and bring to the boil over high heat. Drain and rinse with cold water. Remove any loose or unsightly veins hanging from the tongue. Don't worry about peeling off the membrane covering the tongue; it will be easier to remove when the tongue is done cooking.
2. Put all the ingredients (except the sauces) in a pot with enough cold veal broth or water to cover. Bring to a gentle simmer and simmer until the meat pulls away from the oxtails with no resistance, after about 3 hours. Take out the tongues and peel away the membrane covering the top and sides.

3. To serve, slice the tongue and the pork shoulder and serve them on heated soup plates with the vegetables—give everyone a half a leek and a couple of carrot sections—and pieces of the oxtail and osso buco. Ladle some broth into each soup plate. Pass the sauces at the table.

⌒● Mostarda di Cremona

This ancient fruit sauce is the classic accompaniment to bollito misto. It is sold by on-line gourmet stores but you can also make it yourself if it's the summer and you have access to the fruit. If you can't find all the fruit, just substitute more of the others.

YIELD: 6 CUPS

under ripe pears, peeled, cored, cut lengthwise into wedges	2	2
quince or large apple, peeled, cored, cut into wedges	1	1
sugar	3 cups	3 cups
white wine vinegar or sherry wine vinegar	2 cups	2 cups
cherries, pitted	1 cup	250 milliliters
apricots, halved and pitted	½ pound	225 grams
large peach, pitted, cut into wedges	1	1
large figs, halved	5	5

1. Simmer the pears and apples with the sugar and vinegar until soft and then add the remaining fruit and simmer gently for 10 minutes. Gently remove the fruit with a skimmer or spider and reserve in a bowl while you boil down the poaching liquid until it is syrupy. Put the fruit back in the syrup and simmer for 5 minutes. Put the fruit in sterile jars and pour over the syrup. The mostarda should keep in the refrigerator for weeks.

⌒● Green Sauce

A quick trick for making this sauce is to use bottled mayonnaise as a base. When you add additional olive oil and vinegar, no one will ever know you started with the bottled variety.

YIELD: 1½ CUPS

mayonnaise, either homemade or bottled	½ cup	65 milliliters
minced chives	3 tablespoons	10 grams
chopped capers	3 tablespoons	10 grams
chopped parsley	3 tablespoons	10 grams
chopped tarragon	2 tablespoons	6 grams

STOCKS, GLACES, AND ESSENCES 4

A stock is a flavorful extract made by cooking meat, fish, or vegetables in water or broth. The purpose of stocks in sauce making is to supply or augment the nutritive and savory components that are released by meat and fish during cooking. Glaces are stocks that have been slowly cooked down (reduced) to a thick syrup. There are convenient to have on hand in professional kitchens because they keep well and can be added to sauces at the last minute to give a richer flavor, a deeper color.

chopped chervil (optional)	2 tablespoons	6 grams
chopped sorrel (optional)	3 tablespoons	10 grams
mustard	1 tablespoon	
wine vinegar or more as needed for acidity and thinning the sauce	1 tablespoon	15 milliliters
extra virgin olive oil	1 cup	250 milliliters
salt		
pepper		

Whisk the herbs, mustard and vinegar into the mayonnaise and then whisk in the oil in a steady stream. Season to taste with salt and pepper. For a greener more subtly flavored sauce, puree the sauce with an immersion blender.

Model for Preparing Braises and Stews

MEAT	MARINADE INGREDIENTS (Optional)
Beef	**Liquids**
Braising: bottom round, rump (well-larded)	Red or white wine
Stewing: shank, short ribs, chuck, round (well-larded)	Vinegar (good-quality wine or cider)
Lamb	**Oils**
Braising: whole shoulder	Olive
Stewing: shoulder, leg (well-larded), shanks	Grape seed
	Inert-tasting peanut or safflower
Veal	
Braising: shoulder clod, round (well-larded), breast	**Aromatic Vegetables**
Stewing: shoulder, shank	Onions
	Garlic
Pork	Carrots
Braising: shoulder	Celery
Stewing: shoulder, shank	Turnips
	Herbs
Poultry	Parsley
Stewing: older hens or roosters, duck legs, goose (larding of breasts is suggested)	Bay leaf
	Thyme
	Tarragon
Game	Hyssop
Braising and stewing: older animals or tougher cuts from large animals such as deer or boar	Basil

continues

Model for Preparing Braises and Stews (continued)

Spices	purees prepared on the side from garlic,
Juniper berries	beans, mushrooms, potatoes, turnips,
Cloves (usually stuck into onions)	celeriac root, and the like)
Peppercorns	Liver (usually for poultry, game, or rabbits)
	Blood (usually for game and rabbit civets,
Moistening Ingredients	but also coq au vin)
Water	Butter
Wine (white, red, and fortified wines, alone or in combination)	Foie gras (pureed with butter)
Stock (neutral, such as veal or chicken, or the same type as the meat being braised)	**Final Flavorings**
Spirits (brandy, whiskey, marc—flamed)	Fines herbs (without tarragon, or tarragon alone, usually for chicken, pork, or veal)
Beer	Assertive herbs (usually for red meats or game,
Cider	such as thyme, marjoram, oregano, basil)
	Spirits (Cognac, Armagnac, marc/grappa,
Aromatic Vegetables	eaux de vie, whiskey)
Same as those used in the marinade.	
	Garnitures
Herbs	The following are heated in the braising liquid:
Same as those used in the marinade.	Carrots (cylinders with core removed, turned,
	julienne, batonnets, for instance)
Spices	Turnips (turned, julienne)
Same as those used in the marinade.	Pearl onions
	Garlic cloves (peeled)
Liaisons (optional)	Mushrooms
Flour (used to coat meat before browning or sprinkled over during browning; beurre manié used at the end to finish the braising liquid)	Truffles
	These garnitures are sautéed or heated separately at the end of cooking:
Arrowroot/cornstarch (combined with water, used to finish the braising liquid; produces a glossy appearance)	Wild mushrooms (with herbs, garlic, shallots)
	Artichoke hearts
Vegetable puree (pureed aromatic vegetables taken from the braise or stew, or vegetable	Poultry or rabbit livers
	Olives
	Croutons
	Bacon lardoons

BUTTER SAUCES 15

Butter sauces can be classified into four categories. In beurre blanc–type sauces, cold butter is whisked into a flavorful liquid base. Broken butter sauces are made by cooking whole butter in a sauté pan so that it breaks. These sauces are then usually finished with lemon juice or wine vinegar. Compound butters are prepared by working cold whole butter with flavorful ingredients, such as herbs or reduced vegetable purées. Whipped butters are prepared in almost the same way as compound butters, except that a hot flavorful liquid is also incorporated into the butter.

較大的留白邊緣是要顧及圖表與補充資料等頁面元素，這些元素所占的寬度有可能比文字內容還大。較大的留白邊緣也可以做為置放圖片的區域。

13. 處理比例

就算是頁面底端，也要留心比例，記得要為頁碼保留足夠空間。

黃金比率

設計者通常用目測和直覺決定最佳比例。他們漸漸會發現其他從事與空間規劃有關的人，也用類似方法，選定相似的比例與搭配。黃金比率用於藝術與建築已有上千年歷史。黃金比率也有人稱為黃金切割，指的是各元素的比率，比如長寬比。黃金比率的數值大約是0.618。換句話說，短邊（比方說是寬）與長邊（高）的比率，要等於長邊與長短兩邊相加的比率。所以，設計者會估算22個pica寬與35.6pica高的比例。設計者大都沒有意識到自己使用了黃金比率，甚至不會談到，但許多設計書都會討論到，所以若是參加派對聚會，這個話題還挺好用的。（編按：1pica等於12 pt，相當於1/6英寸。）

名稱
The Plague of Doves

客戶
HarperCollins

設計公司
Fritz Metsch

此為《水晶高腳杯》這本設計書裡的範例。這種簡單的文字版面，能顯露出一種文學氣質。在《水晶高腳杯：16篇關於文字排版的探究》（The Crystal Goblet: Sixteen Essays on Typography）中，身兼版面設計者及學者的碧翠絲·瓦德（Beatrice Warde）寫道：「印刷應該看來不著痕跡。」同時她也表示，沉靜的設計就像水晶玻璃杯：「所有與設計相關的事物都要仔細地規劃呈現，而非掩蓋原先想要表達的美麗事物。」

頁面下方的留白（頁面底端的邊緣）比上方留白處稍微大些。此外，頁面壓了灰階花紋網底，優雅烘托標題字型。這種鮮明的質感安排很大膽，但小字的選用則讓頁面整體看起來低調不張揚。

her own way, stamping, beating, and flapping her skirts So vehement was their dance that the birds all around them popped into flight, frightening other birds, so that in moments the entire field and the woods around it was a storm of birds that roared and blasted down upon the people who nonetheless stood firm with splayed missals on their heads The women forsook modesty, knotted their skirts up around their thighs, held out their rosaries or scapulars, and moved forward They began to chant the Hail Mary into the wind of beating wings Mooshum, who had rarely been allowed the sight of a woman's lower limbs, took advantage of his brother's struggle in keeping the censor lighted, and dropped behind In delight, watching the women's naked, round, brown legs thrash forward, he lowered his candelabra, which held no candles but which his brother had given him to carry in order to protect his face Instantly he was struck on the forehead by a bird hurtled from the sky with such force that it seemed to have been flung directly by God's hand, to smite and blind him before he carried his sin of appreciation any farther.

At this point in the story, Mooshum became so agitated that he often acted out the smiting and to our pleasure threw himself upon the floor He mimed his collapse, then opened his eyes and lifted his head and stared into space, clearly seeing even now the vision of the Holy Spirit which appeared to him not in the form of a white bird among the brown doves, but in the earthly body of a girl.

Our family has maintained something of an historical reputation for deathless romantic encounters Even my father, a sedate looking seventh grade teacher, was swept through the second World War by one promising glance from my mother And her sister, Aunt Geraldine, struck by a smile from a young man on a passenger train, raised her hand from the ditch she stood in picking berries, and was unable to see his hand wave in return But something made her keep picking berries until nightfall and camp there overnight, and wait quietly for another whole day on her camp stool until he came walking back to her from the stop sixty miles ahead My uncle Whitey dated the Haskell Indian Princess, who cut her braids off and gave them to him on the night she died of tuberculosis He remained a bachelor in her memory until his fifties, when he reformed and then married a small town stripper Agathe, or "Happy", left the convent for a priest My brother Joseph seduced an Evangelical Christian from the fold My father's second

8

cousin John kidnapped his own wife and used the ransom to keep his mistress in Fargo Despondent over a woman, my father's uncle, Octave Harp, managed to drown himself in two feet of water And so on As with my father, these tales of extravagant encounter contrasted with the modesty of the subsequent marriages and occupations of my relatives We are a tribe of office workers, bank tellers, book readers, and bureaucrats The wildest of us (Whitey) is a short order cook, and the most heroic of us (my father) teaches Yet this current of drama holds together the generations, I think, and my brother and I listened to Mooshum not only from suspense but for instructions on how to behave when our moment of recognition, or perhaps our romantic trial, should arrive.

The Million Names

IN TRUTH, I thought mine probably had occurred early, for even as I sat there listening to Mooshum my fingers obsessively wrote the name of my beloved up and down my arm or in my hand or on my knee If I wrote his name a million times on my body, I believed he would kiss me I knew he loved me, and he was safe in the knowledge that I loved him, but we attended a Roman Catholic grade school in the early 1960's and boys and girls known to be in love hardly talked to one another and never touched We played softball and kickball together, and acted and spoke through other children eager to deliver messages I had copied a series of these second hand love statements into my tiny leopard print diary with the golden lock The key was hidden in the hollow knob of my bedstead Also I had written the name of my beloved, in blood from a scratched mosquito bite, along the inner wall of my closet His name held for me the sacred resonance of those Old Testament words written in fire by an invisible hand Mene, mene, teckel, upharsin I could not say his name aloud I could only write it on my skin with my fingers without cease until my mother feared I'd gotten lice and coated my hair with mayonnaise, covered my head with a shower cap, and told me to sit in the bathtub adding water as hot as I could stand.

The bathroom, the tub, the apparatus of plumbing was all new Because my father and mother worked for the school and in the tribal offices, we were hooked up to the agency water system I locked the bathroom door,

9

把書眉和頁碼加粗或字距拉大，都能讓整體版面有質感。邊緣和行距都留有足夠空間，閱讀起來十分舒服。

The Plague of Doves

IN THE YEAR 1896, my great uncle, one of the first Catholic priests of aboriginal blood, put the call out to his parishioners that they should gather at Saint Joseph's wearing scapulars and holding missals From that place they would proceed to walk the fields in a long sweeping row, and with each step loudly pray away the doves His human flock had taken up the plow and farmed among German and Norwegian settlers Those people, unlike the French who mingled with my ancestors, took little interest in the women native to the land and did not intermarry In fact, the Norwegians disregarded everybody but themselves and were quite clannish But the doves ate their crops the same When the birds descended, both Indians and whites set up great bonfires and tried driving them into nets The doves ate the wheat seedlings and the rye and started on the corn They ate the sprouts of new flowers and the buds of apples and the tough leaves of oak trees and even last year's chaff The doves were plump, and delicious smoked, but one could wring the necks of hundreds or thousands and effect no visible diminishment of their number The pole and mud houses of the mixed bloods and the bark huts of the blanket Indians were crushed by the weight of the birds They were roasted, burnt, baked up in pies, stewed, salted down in barrels or clubbed dead with sticks and left to rot But the dead only fed the living and each morning when the people woke it was to the scraping and beating of wings, the murmurous sussuration, the awful cooing babble, and the sight, to those who still possessed intact windows, of the curious and gentle faces of those creatures

5

頁碼置中是傳統設計的特點。

14. 欄位間平分秋色

兩個等寬欄位的格線,利於編排頁面上大量的內容。對稱欄位能讓頁面看起來條理分明,也能安排不同大小的圖片或空間。對於發行到國外的出版品來說,這種形式最為理想,等寬的雙欄能以兩種不同語言並列,顯示相同內容。

傳統、齊首齊尾的欄位,讓保守的編輯和讀者感覺舒適又井然有序。

名稱

Return to the Abstract

客戶

Palace Editions, for the Russian State Museums

設計公司

Anton Ginzburg, Studio RADIA

這裡的雙欄是俄文和英文對照。

оказывается совершенно неспособным проявлять свои функции прозрачности и ясности. Разбросанные в пространстве произведения отвергающие «знаки-образы художника», чем-то напоминающие «флаговые структуры», устойчивую эмблематику социальных систем, перефразированные элементы поп-арта, откровенно обнажают идеологию арт-дилерей Евгения Чубарова, его открытость к языкам массовой культуры. Но в художественных измерениях картинного пространства они трансформируются, скорее, как узловая, как внезапные описки, спотыкаясь о нечто «что-то не так», превращаясь или возвращаясь в космическое сатору. Эти «случайные» ошибки дарят нам шок соприкосновения с неведомым при контакте с, казалось бы, заведомо освоенным. Они опровергают диктат идеи однородной абстракции над витальностью творчества как выпад против здравого смысла, как выпадение в целительное безумие. В такой стратегии их образы утверждают новый принцип абстракции, освобожденный от власти личного монолога художника, но реализующий себя в контексте нового смыслового поля, «завязывая» непосредственное чувство в интеллектуальную рефлексию. Она естественно возникает в своих сгущениях и пустотах, наплывах и разрывах как горизонтальная модель

нового художественного сознания, прорывая гипноз знаковой поверхности через жест своеобразной «деконструкции».

Сама технология живописи Евгения Чубарова, ее способность комментировать и описывать саму себя порождает эффект картины как некоего живописного объекта, где сама живопись раскрывается как чистая ностальгия по живописи, как воспоминание о картине, где в гуще информационного шума спрятан в коконе бывшая «абстрактный шедевр, «нетленка», по выражению Ильи Кабакова. Ее «почерк», ее многослойный ландшафт, блестяще выстроенный со всеми своими ассоциативными рядами, где подлинные слои художественной реальности просвечивают сквозь профанные, подбрасывая загадки – все это свидетельствует о новых глубинных ориентациях в искусстве абстракции. Они говорят о витании ее абсолютно новой телесности, отрефлексированной и генетически преображенной. Ее новые формы манипулируют следами и обломками ее исторического прошлого и последствиями собственного личного внутреннего опыта художника. В них проступают сознательные цитаты мирового культуросведения, включающие целые

Жизнеупругие и разомкнутые кривые Джексона Поллока присутствуют в современной культуре как трансляторы, передающие архаичный мир и мир авангарда 10-20 годов ушедшего века. Они никогда не исчезают из нашей мифологии. Знаковая символика в пластике Евгения Чубарова корреспондирует с этими архетипами «шаманистического» текста, пульсируя в его композициях, раскрывая их еще не высвеченные смыслы.

Джексон Поллок, «Страничка из блокнота», 1938

Поиски первичных образов начала человеческой истории, его архетипов открывают парадоксальный диалог, необусловленный внешними воздействиями. В нем открывается английский мистик, поэт и художник XIX века Вильям Блейк и московский художник нашего тысячелетия, родившийся в башкирской деревне, – «культура» движения – Евгений Чубаров. Тот же пейзаж, тот же пластика, те же предельные психоделические состояния – словно они работали в одном ключе или видели одни и те же вещи перед глазами. Эти сходства были даже провозглашены независимым американским кино директором Джармушем в его фильме «Dead Man», где встречаются белый человек, носящий имя английского поэта Блейка и индеец, живущий архаической мифологией.

Вильям Блейк, «Тело Авеля, обнаруженное Адамом и Евой», 1826

a search for original images related to the birth of human history, its archetypes inspired a paradoxical dialogue, unconditioned by any external influences. The English mystic, poet and artist William Blake and Evgeny Chubarov, a Moscow artist of our times, born in a Bashkirian village amidst shamanist culture, both find a place in this dialogue. The same landscape, the same artistic style, the same extreme psychedelic states, it's as if they followed the same canon or had the same things before their eyes. These similarities have also been proclaimed by the independent American film director Jarmush in his film Dead Man, in which two men are confronted: a white man named Blake, as the famous English poet, and an Indian, who is immersed in his archaic mythology.

William Blake, "The Body of Abel found by Adam and Eve," 1826

abstraction, one that is free from the pressure of the artist's monologue and one that realizes itself in the context of a new field of meaning, packaging spontaneous feelings into intellectual reflection. It emerges naturally as densities and empty spots, inflows and gaps, as a horizontal model of a new artistic consciousness, breaking through the hypnosis of the sign surface by way of a deconstructing gesture.

The technology of Chubarov's art, its capacity for self-commentary and self-description, creates paintings that have the effect of being objects of pure nostalgia for painting. A recollection of a painting where in the thick of the information noise, as in a cocoon, a former masterpiece of abstract art is concealed, "Imperishables" to quote Ilya Kabakov. Its style and complex landscapes, brilliantly structured with all their associations, where different layers of artistic reality show through the profane, suggesting all sorts of riddles – all this testifies to the new, deep-going orientations in abstract art. They demonstrate the withering of the abstract avant-garde models and the emergence of a new corporeality, carefully thought out and genetically transformed. These new forms manipulate with the traces and debris of history and the consequences of the artist's personal experience. Intentional quotation from the world cultural heritage is evident in

this art, including whole movements and trends, skillfully woven into a new cultural context. Moreover, you find in its carpet-like continuity Chubarov's self-quotation and his mythologies existing in the collisions of dissimilar returns above the imagery and style of abstract expressionism, turning his heroic structures into archeological finds and ready-made objects. Both Jackson Pollack and Mark Toby as well as the German "New Wild" are impressed in Chubarov's intellectual energy much like film stars' names are on Hollywood plates. Post-historic handwriting reveals obvious legends in their contours of the remains of gilding, where respect borders on notions much broader than cultural memory, where irony alludes to the games in the labyrinths of time and space. In Einstein's shifted geometry with its "parallel" curvilinearity and self-relativity, these endless labyrinths bring to mind the abandoned caves and tunnels in Egyptian pyramids. Half-filled with crumbled stone, sand-drifts and excrescencies: they can be viewed both horizontally and vertically. Here you find forgotten and lost texts that were once declared revelations and prophecies. These multi-dimensional sign-bearing structures are being cleared and sorted out to be transformed into illuminations or oppositions like paradoxical tactile surfaces or jottings on the margins where the artist himself "archeologizes" his mysterious verbalism weaving the fabric of a universal manuscript that

Переосмысляя Зигмара Польке с использованием новых технологий возвращаемся к частной «вещественности» и материальности Текста. Именно проблема «пространство и текст» сегодня становится общей для европейской и русской культуры, переходя из «ткани» смысла в «ткань» пространства. Евгений Чубаров в этих текстовых слоях обретает свое собственное измерение.

Зигмар Польке, «Eggboull», 1984

Pseudo-painting of Sigmar Polke, based on new technologies, returns us to pure "objectivity" and materiality of the text as such. It is precisely the problem of "space as text" that has become common for European and Russian cultures, marked by the fact of transition from the texture of meaning to the texture of space. In these textual layers Evgeny Chubarov acquires his own dimension.

Sigmar Polke, Eggbull, 1984

Для Е.Чубарова, так как и для А.Пенка, обращение к подсознанию дает выход в иные формы устойчивости, чем окружающая их тоталитарная реальность. «Динозавры» А.Пенка, символизирующие абсолютное сопротивление тоталитарной социальности, фактически есть змееподобные существа – знаки, наполняющие своей динамикой композиции Е.Чубарова.

A.Penk, «G.B.I.» 1988

For Chubarov, the same as for A. Penk, address to the subconscious provided an outlet to other form of stability, distinct from those offered by the surrounding totalitarian reality. Penk's "Dinosaurs", symbolizing absolute resistance to totalitarian sociality, are in fact the same snake-like creatures-signs, which infuse with dynamism Chubarov's compositions as well.

A.R.Penk, "G.B.I." 1988

欄寬夠寬，內容也不多，每個欄位都能各自表現有一致性、又好讀的結構。選用一種簡潔有力的頁面架構，能同時編排所有其他的內容進來，包括box、表格或圖片。

15. 功能取向的設計

儘管一般雙欄式的格線設計都是兩欄同寬，但兩欄寬度不同也是另一種選擇。若要編排的內容很豐富，那麼為了讓版面看起來大方、易讀好懂，也可以選擇一寬一窄的格線設計。較寬的那一欄適合放連續走文，讓作者可以完整表述，窄的那欄則可涵蓋其他內容，如圖片說明、圖片或圖表。

窄的欄位適用放圖片說明，不管是出現在章節開頭或文章間，都能讓讀者易於閱讀。記得內文章節開頭留的空間常比一般內文大。

名稱

Extreme Textiles

客戶

Smithsonian, Cooper-Hewitt, National Design Museum: Extreme Textiles Exhibition Catalog

設計公司

Tsang Seymour Design

設計指導

Patrick Seymour

設計者

Susan Brzozowski

展覽目錄可視內容需要，融合各不相同的版型來編排。

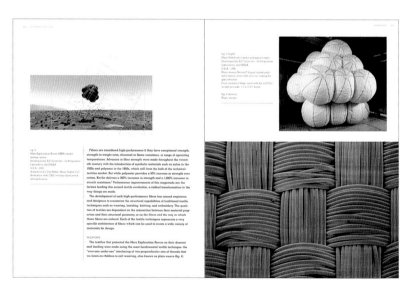

效果好又勻稱的格線設計是欄位一寬一窄，且寬欄是窄欄的兩倍。窄欄內的字型要與寬欄的相同，但要用較細的字體。使用粗細不同的字體能增添頁面豐富的質感。

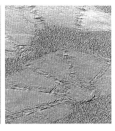

Fig. 5
Impressions left by the airbags of the Mars
Exploration Rover (MER) Opportunity in
Martian soil. January 24, 2004

This classic plain weave has the greatest strength and stability of the tradi-
tional fabric structures. While no textiles survive from the earliest dates,
impressions in clay of basic woven cloth demonstrate its use from at least
7000 BC.[2] Older than metal-working or pottery-making, perhaps even older
than agriculture, cloth-weaving has a very primary relationship to the pur-
suits of humankind.[3]

It is fitting, then, that among the first marks made by man in the soil of Mars
was that of a plain woven fabric: an impression made by the impact of the
airbags (fig. 5).[4] Each bag has a double bladder and several abrasion-resistant
layers made of tightly woven Vectran. Like most synthetic fibers, Vectran liq-
uid crystal polymer is extruded from a liquid state through a spinneret, similar
to a shower head, and drawn into filament fibers. The stretching of the fiber
during the drawing process orients the polymer chains more fully along the
fiber length, creating additional chemical bonds and greater strength. Vectran
provides equal strength at one-fifth the weight of steel. Weight is of premium
importance for all materials used for space travel, and Warwick Mills, the
weaver of the fabric for the bags, achieved a densely woven fabric at a mere
2.4 ounces per square yard, but with a strength of 350 pounds per inch.[5]

The materials are also required to perform at severe temperatures. Because
impact occurs two to three seconds after the inflation of the airbags, the fab-
rics endure their greatest stresses at both extremes of temperature: the explo-
sive gasses that inflate the bags may elevate the temperature inside the

bladder layers to over 212°F, but the temperature on the Martian surface is
–117°F. Retraction of the airbags to allow the egress of the rovers required that
the fabrics remain flexible at these very low temperatures for an extended
period of time — about ninety minutes for the deflation and retraction process.
Two other fiber types, aramid fibers (Kevlar 29 and Technora T-240) and
ultra-high molecular weight polyethylene (UHMWPE) Spectra 1000, were
also considered during the development of the Pathfinder airbags. Spectra,
a super-drawn fiber, is among the strongest fibers known — fifteen times
stronger than steel. However, it performs poorly at extreme temperatures, and
so was eliminated early in the development process. Vectran was ultimately
selected for the best performance at low temperatures, but Kevlar 129 was
used for the tethers inside the bags because of its superior performance at
higher temperatures.

The rovers themselves are also textile-based; they are made from super-
strong, ultra-lightweight carbon-fiber composites, which are being widely
used for aerospace components as well as high-performance sports equip-
ment.[6] As composite reinforcements, textiles offer a high level of customiza-
tion with regard to type and weight of fiber, use of combinations of fibers,
and use of different weaves to maximize the density of fibers in a given
direction. Fiber strength is greatest along the length. The strength of com-
posite materials derives from the intentional use of this directional nature.
While glass fibers are the most commonly used for composites, for high-
performance products the fiber used is often carbon or aramid, or a combina-
tion of the two, because of their superior strength and light weight.

One advantage of composite construction is the ability to make a complex
form in one piece, called monocoque construction. A woven textile is hand-
laid in a mold; the piece is wetted out with resin and cured in an autoclave.
The textile can also be impregnated with resin and cured without a wet stage.
The same drape or hand that makes twill the preferred weave for most appar-
el is also desirable for creating the complex forms of boats, paddles, bicycle
frames, and other sports equipment. The weft in a twill, rather than crossing
under and over each consecutive warp, floats over more than one warp, and
with each subsequent weft the grouping is shifted over one warp, creating
the marked diagonal effect typical of twills (fig. 8).

Boat builders were among the first to experiment with carbon-reinforced
composites. One early innovator, Edward S. ("Ted") Van Dusen, began mak-
ing carbon-fiber composite racing shells in the 1970s (fig. 7). The critical
factor in shell design is the stiffness-to-weight ratio, with greater stiffness
meaning that more of the rower's power is translated into forward motion.
Van Dusen found that all of the standard construction materials had about
the same specific stiffness, or stiffness per unit weight, and began experi-
menting with glass, boron, and carbon fiber–reinforced composites.[7]

For his Advantage racing shells, Van Dusen uses glass fiber in a complex
twill commonly known as satin weave. In a satin, each weft may float over

若幾乎沒有什麼圖片，或是根
本沒有，即使窄欄內空無一
物，兩個不對稱的欄位結構，
也能有平衡效果。

線條可以分割空間或是在空間
內連結欄位。就像此圖顯示，
藍色的線條成為頁面上串連各
段的織線，卻不會干擾到內容
走文，此外，線條也能夠標示
出新的段落。

The numbers in these tables represent
typical values of some important fiber
properties; the actual behavior of fibers
may differ as variants are produced for
diverse end uses. These numbers were
compiled from many different sources and
are meant for illustration purposes only.

COMPARISON OF YARN STRENGTH

MS
PBO
LCP
HMPE
P-Aramid
Carbon
Ceramic
Glass
Polyester
Nylon
Steel

— Tenacity based on area of fiber (GPa)
— Tenacity based on weight of fiber (N/tex)

COMPARISON OF MODULI

MS
PBO
LCP
HMPE
P-Aramid
Carbon
Ceramic
Glass
Polyester
Nylon
Steel

— Modulus based on area of fiber (GPa)
— Modulus based on weight of fiber (N/tex)

CARBON

Thomas Edison first used carbon fiber when he employed charred cotton
thread to conduct electricity in a lightbulb (he patented it in 1879). Only in
the past fifty years, however, has carbon developed as a high-strength, high-
modulus fiber.[8] Oxidized then carbonized from polyacrylonitrile (PAN) or
pitch precursor fibers, carbon's tenacity and modulus vary depending on its
starting materials and process of manufacture.[9]

Less dense than ceramic or glass, lightweight carbon-fiber composites
save fuel when used in aerospace and automotive vehicles. They also make
for strong, efficient sports equipment. Noncorroding, carbon reinforcements
strengthen deep seawater concrete structures such as petroleum production
risers.[10] Fine diameter carbon fibers are woven into sails to minimize stretch.[11]
In outer apparel, carbon fibers protect workers against open flames (up to
1000°C/1,800°F) and even burning napalm: they will not ignite, and shrink very
little in high temperatures.[12]

ARAMIDS

Aramids, such as Kevlar (DuPont) and Twaron® (Teijin), are famous for their
use in bulletproof vests and other forms of ballistic protection, as well as for
cut resistance and flame retardance. Initially developed in the 1960s, aramids
are strong because their long molecular chains are fully extended and packed
closely together, resulting in high-tenacity, high-modulus fibers.[13]

Corrosion- and chemical-resistant, aramids are used in aerial and mooring
ropes and construction cables, and provide mechanical protection in optical
fiber cables.[14] Like carbon, aramid-composite materials make light aircraft
components and sporting goods, but aramids have the added advantages of
impact resistance and energy absorption.

LIQUID CRYSTAL POLYMER (LCP)

Although spun from different polymers and processes, LCPs resemble
aramids in their strength, impact resistance, and energy absorption, as well
as their sensitivity to UV light. Compared to aramids, Vectran (Celanese),
the only commercially available LCP, is more resistant to abrasion, has better
flexibility, and retains its strength longer when exposed to high temperatures.
Vectran also surpasses aramids and HMPE in dimensional stability and cut
resistance: it is used in wind sails for America's Cup races, inflatable struc-
tures, ropes, cables and restraint-lines, and cut-resistant clothing.[15] Because
it can be sterilized by gamma rays, Vectran is used for medical devices such
as implants and surgical-device control cables.[16]

HIGH-MODULUS POLYETHYLENE (HMPE)

HMPE, known by the trade names Dyneema (Toyobo/DSM) or Spectra
(Honeywell), is made from ultra-high molecular-weight polyethylene by a
special gel-spinning process. It is the least dense of all the high-performance

DECOMPOSITION TEMPERATURE

MS
PBO
LCP
HMPE (info)
P-Aramid
Carbon
Glass (info)
Polyester (info)
Nylon 6.6 (info)
Steel (info)

0 100 200 300 400 500
Degrees Celsius

DENSITY

MS
PBO
LCP
HMPE
P-Aramid
Carbon
Ceramic
Glass
Polyester
Nylon 6.6
Steel

0 1 2 3 4 5 6 7 8
grams per cm³

fibers, and the most abrasion-resistant. It is also more resistant than aramids,
PBO, and LCP to UV radiation and chemicals.[17] It makes for moorings and fish
lines that float and withstand the sun, as well as lightweight, cut-resistant
gloves and protective apparel such as fencing suits and soft ballistic armor.
In composites, it lends impact resistance and energy absorption to glass- or
carbon-reinforced products. HMPE conducts almost no electricity, making it
transparent to radar.[18] HMPE does not withstand gamma-ray sterilization and
has a relatively low melting temperature of 150°C (300°F)—two qualities that
preclude its use where high temperature resistance is a must.

POLYPHENYLENE BENZOBISOXAZOLE (PBO)

PBO fibers surpass aramids in flame resistance, dimensional stability, and
chemical and abrasion resistance, but are sensitive to photodegradation and
hydrolysis in warm, moist conditions.[19] Their stiff molecules form highly rigid
structures, which grant an extremely high tenacity and soft ballistic armor.
Apparel containing Zylon® (Toyobo), the only PBO fiber in commercial production, pro-
vides ballistic protection because of its high energy absorption and dissipa-
tion of impact. Zylon is also used in the knee pads of motorcycle apparel, for
heat-resistant work wear, and in felt used for glass formation.[20]

PIPD

PIPD, M5 fiber (Magellan Systems International), expected to come into
commercial production in 2005, matches or exceeds aramids and PBO in
many of its properties. However, because the molecules have strong lateral
bonding, as well as great strength along the oriented chains, M5 has much
better shear and compression resistance. In composites it shows good adhe-
sion to resins. Its dimensional stability under heat, resistance to UV radia-
tion and fire, and transparency to radar expands its possible uses. Potential
applications include soft and hard ballistic protection, fire protection, ropes
and tethers, and structural composites.[21]

HYBRIDS

A blend of polymers in a fabric, yarn, or fiber structure can achieve
a material better suited for its end use. Comfortable fire-retardant, anti-
static clothing may be woven primarily from aramid fibers but feature the
regular insertion of a carbon filament to dissipate static charge. Yarns for
cut-resistant applications maintain good tactile properties with a wrapping
of cotton around HMPE and fiberglass cores. On a finer level, a single fiber
can be extruded from two or more different polymers in various configura-
tions to exhibit the properties of both.

雙欄式格線

16. 用線條規範！

教學性的內容會包括諸多分離獨立的各區塊文字，因此若就可讀性而言，只在欄位間保留空白是不夠的。以這種情況來說，直線可做為區分欄位的分隔線。

此外可以藉由另一條橫線分隔box文字與內文，或將整個內文文字部分與書眉或頁碼區隔開來。但要注意：過多線條會讓頁面顯得呆板。

此處的垂直線條將不同的內容區隔在各自的欄位，有時搭配不同字型的變化，如粗體、全大寫、斜體、分數。

名稱

America's Test Kitchen Family Cookbook

客戶

America's Test Kitchen

藝術指導

Amy Klee

設計公司

BTD_{NYC}

頁面上方與下方的水平線條，能夠分隔內容，或是框出整個box。

NONFAT ROASTED GARLIC DRESSING

MAKES about 1 ½ cups
PREP TIME: 10 minutes
TOTAL TIME: 2 hours (includes 1 ½ hours roasting and cooling time)

To keep this recipe nonfat, we altered our usual technique for roasting garlic, replacing the oil we typically use with water.

2	large garlic heads
2	tablespoons water
	Salt
2	tablespoons Dijon mustard
2	tablespoons honey
6	tablespoons cider vinegar
½	teaspoon pepper
2	teaspoons minced fresh thyme, or ½ teaspoon dried
½	cup low-sodium chicken broth

1. Adjust an oven rack to the upper-middle position and heat the oven to 400 degrees. Following the photos on page 000, cut ½ inch off the top of the garlic head to expose the tops of the cloves. Set the garlic head cut side down on a small sheet of aluminum foil, and sprinkle with the water and a pinch of salt. Gather the foil up around the garlic tightly to form a packet, place it directly on the oven rack, and roast for 45 minutes.

2. Carefully open just the top of the foil to expose the garlic and continue to roast until the garlic is soft and golden brown, about 20 minutes longer. Allow the roasted garlic to cool for 20 minutes, reserving any juices in the foil packet.

3. Following the photo on page 000, squeeze the garlic from the skins. Puree the garlic, reserved garlic juices, ¾ teaspoon salt, and the remaining ingredients together in a blender (or food processor) until thick and smooth, about 1 minute. The dressing, covered, can be refrigerated for up to 4 days; bring to room temperature and whisk vigorously to recombine before using.

LOWFAT ORANGE-LIME DRESSING

MAKES about 1 cup
PREP TIME: 10 minutes
TOTAL TIME: 1 hour (includes 45 minutes simmering and cooling time)

Although fresh-squeezed orange juice will taste best, any store-bought orange juice will work here. Unless you want a vinaigrette with off flavors make sure to reduce the orange juice in a nonreactive stainless steel pan.

2	cups orange juice (see note above)
3	tablespoons fresh lime juice
1	tablespoon honey
1	tablespoon minced shallot
½	teaspoon salt
½	teaspoon pepper
2	tablespoons extra-virgin olive oil

1. Simmer the orange juice in a small saucepan over medium heat until slightly thickened and reduced to ⅔ cup, about 30 minutes. Transfer to a small bowl and refrigerate until cool, about 15 minutes.

2. Shake the chilled, thickened juice with the remaining ingredients in a jar with a tight-fitting lid until combined. The dressing can be refrigerated for up to 4 days; bring to room temperature, then shake vigorously to recombine before using.

Test Kitchen Tip: **REDUCE YOUR JUICE**

Wanting to sacrifice calories, but not flavor or texture, we adopted a technique often used by spa chefs in which the viscous quality of oil is duplicated by using reduced fruit juice syrup or roasted garlic puree. The resulting dressings are full bodied and lively enough to mimic full-fat dressings but without the chemicals or emulsifiers often used in commercial lowfat versions. Don't be put off by the long preparation times of these recipes—most of it is unattended roasting, simmering, or cooling time.

Salads 65

EASY JELLY-ROLL CAKE

MAKES an 11-inch log
SERVES 10
PREP TIME: 5 minutes **TOTAL TIME:** 1 hour

Any flavor of preserves can be used here. For an added treat, sprinkle 2 cups of fresh berries over the jam before rolling up the cake. This cake looks pretty and tastes good when served with dollops of freshly whipped cream (see page 000) and fresh berries.

- ¾ cup all-purpose flour
- 1 teaspoon baking powder
- ¼ teaspoon salt
- 5 large eggs, at room temperature
- ¾ cup sugar
- ½ teaspoon vanilla extract
- 1¼ cups fruit preserves
- Confectioners' sugar

1. Adjust an oven rack to the lower-middle position and heat the oven to 350 degrees. Lightly coat a 12 by 18-inch rimmed baking sheet with vegetable oil spray, then line with parchment paper (see page 000). Whisk the flour, baking powder, and salt together and set aside.

2. Whip the eggs with an electric mixer on low speed, until foamy, 1 to 3 minutes. Increase the mixer speed to medium and slowly add the sugar in a steady stream. Increase the speed to high and continue to beat until the eggs are very thick and a pale yellow color, 5 to 10 minutes. Beat in the vanilla.

3. Sift the flour mixture over the beaten eggs and fold in using a large rubber spatula until no traces of flour remain.

4. Following the photos, pour the batter into the prepared cake pan and spread out to an even thickness. Bake until the cake feels firm and springs back when touched, 10 to 15 minutes, rotating the pan halfway through baking.

5. Before cooling, run a knife around the edge of the cake to loosen, and flip the cake out onto a large sheet of parchment paper (slightly longer than the cake). Gently peel off the parchment paper attached to the bottom of the cake and roll the cake and parchment up into a log and let cool for 15 minutes.

MAKING A JELLY-ROLL CAKE

1. Using an offset spatula, gently spread the cake batter out to an even thickness.

2. When the cake is removed from the oven, run a knife around the edge of the cake to loosen, and flip it out onto a sheet of parchment paper.

3. Starting from the short side, roll the cake and parchment into a log. Let the cake cool seam-side down (to prevent unrolling) for 15 minutes.

4. Unroll the cake. Spread 1¼ cups jam or preserves over the surface of the cake, leaving a 1-inch border at the edges.

5. Re-roll the cake gently but snugly around the jam, leaving the parchment behind as you go.

6. Trim thin slices of the ragged edges from both ends. Transfer the cake to a platter, dust with confectioners' sugar, and cut into slices.

TYPE OF BEAN	AMOUNT OF BEANS	AMOUNT OF WATER	COOKING TIME
BLACK BEANS			
Soaked	1 pound	4 quarts	1½ to 2 hours
Unsoaked	1 pound	5 quarts	2¼ to 2½ hours
BLACK-EYED PEAS			
Soaked	1 pound	4 quarts	1 to 1¼ hours
Unsoaked	1 pound	5 quarts	1½ to 1¾ hours
CANNELLINI BEANS			
Soaked	1 pound	4 quarts	1 to 1¼ hours
Unsoaked	1 pound	5 quarts	1½ to 1¾ hours
CHICKPEAS			
Soaked	1 pound	4 quarts	1½ to 2 hours
Unsoaked	1 pound	5 quarts	2¼ to 2½ hours
GREAT NORTHERN BEANS			
Soaked	1 pound	4 quarts	1 to 1¼ hours
Unsoaked	1 pound	5 quarts	1½ to 1¾ hours
NAVY BEANS			
Soaked	1 pound	4 quarts	1 to 1¼ hours
Unsoaked	1 pound	5 quarts	1½ to 1¾ hours
PINTO BEANS			
Soaked	1 pound	4 quarts	1 to 1¼ hours
Unsoaked	1 pound	5 quarts	1½ to 1¾ hours
RED KIDNEY BEANS			
Soaked	1 pound	4 quarts	1 to 1¼ hours
Unsoaked	1 pound	5 quarts	1½ to 1¾ hours
LENTILS Brown, Green, or French du Puy *(not recommended for red or yellow)*			
Unsoaked	1 pound	4 quarts	20 to 30 minutes

每個步驟之間的留白空間使橫向排列的圖片及說明有所區隔，讓頁面清晰易讀。

水平線條也能用來編排版面。若頁面上有大量內容，橫線可以在主要內文以外的區域，分隔出頁碼或底部書眉的部分。

17. 利用整個空間

雙欄式的格線設計是一種清楚的架構，可使整個版面容易閱讀。圖片可以恰當地放在其中一欄，圖說則放在上方或下方。但這樣就好了嗎？一旦確定基本架構，其實就能在整個頁面上做變化。例如把圖片放大，拉成占兩欄，或是將圖說放在邊緣，都能讓整個頁面活潑不少，不只增加動感，也兼具條理。

名稱

Annual report

客戶

Cathedral Church of
St. John the Divine

設計公司

Carapellucci Design

在這則清楚易讀的報導中，圖片寬度並不一致。

State of the Cathedral

ALL annual reports are just a snapshot in time. But in the case of this great Cathedral, whose life is measured not in years, or even in decades, but now in centuries, each snapshot will be a small part of a very large album. That album documents the contributions of many generations to the building and the work of St. John the Divine.

But some snapshots, limited though they may be, will always stand out in that album: the laying of the cornerstone in 1892, for example, or the dedication of the Nave in 1941, the Sunday before Pearl Harbor. One launched a dramatic era in the Cathedral's life; the other capped one.

I believe that we are now at the beginning of one of the most exciting chapters in the Cathedral's long history. I would describe it as a coming to fruition of efforts in three major areas over the past few years that position us to do the Cathedral's great work more effectively. We are "building" this Cathedral in ways appropriate and necessary to our time: physically, financially, and strategically.

First, physically. Before the end of 2008, the post-fire restoration of the Cathedral will be complete. When we throw open the doors of the entire Cathedral for the first time in almost four years, those who enter will experience the magnificent space in a way no one has for many decades. The Cathedral is truly being "restored" to its original beauty. Our sacred space will shine with welcome—more ready than ever to offer a memorable, even life-changing experience.

The second major effort is financial, and its goal is to ensure that the restored condition of the Cathedral is maintained throughout this new century. As I write this, I can hear the construction of the AvalonBay Communities apartment project on the southeast corner of the Close. This real estate initiative, along with a pending lease agreement with Columbia University, guarantees the Cathedral a reliable income stream. This resource will not only help us maintain the Cathedral itself, but also strengthen programs and services that are an essential part of our mission.

But we are not depending on the real estate initiatives alone for the financial resources we shall need for the future. We are actively reaching out to more potential supporters in New York and beyond. Already we are seeing results from these efforts: as the following pages document, the number of donors to the Cathedral more than doubled from FY2006 to FY2007. The average gift increased by approximately one-third. I am confident that the combination of our restored space, our more solid financial foundation, and our renewed spirit will attract more and more donors in the coming years.

Finally, our strategic effort. We continue to make progress on the Strategic Plan adopted by the Board of Trustees in December 2005. In particular, we have made significant progress on Priority #4 of that Plan: "to implement a dynamic and cohesive marketing and communications strategy to position and focus the identity of a reinvigorated Cathedral in the public arena." For the past several months a Leadership Task Force, composed of Trustees and senior staff, has been working to address this priority. It has been truly inspiring to be part of this process. We have reviewed the Cathedral's rich and complex past and envisioned an exciting future. We understand in a deeper way the special and unique quality of the Cathedral's welcome, and we are ready to send this message of welcome out to the City and the world—warm and clear and strong.

With the coming together of these three vital efforts—the physical restoration of the Cathedral, a more secure financial foundation, and a clear intentionality in both our words and actions—the transformed Cathedral is ready to renew its work of transformation in this City, in this country, and in the world.

I am excited, and honored, to be part of it.

The Very Reverend Dr. James A. Kowalski
Dean

GROUND BREAKING CREW, SPRING 2007, LEFT TO RIGHT: *The Very Rev. Dr. James A. Kowalski, Cathedral Dean; Henry L. King, Esq., President, Cathedral Board of Trustees; The Rt. Rev. Mark S. Sisk, Bishop of the Episcopal Diocese of New York; Emily Youssouf, President, New York City Housing Development Corporation; Assemblymember Daniel O'Donnell; Fred Harris, Executive Vice President, AvalonBay; Shaun Donovan, Commissioner, New York City Housing Preservation Development; City Councilmember Melissa Mark Viverito; and Leslie Wyche, representing City Councilmember Inez Dickens.*

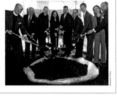

Worship & Ministry

WE are pleased to report that the Cathedral continued to make significant headway on several important fronts during fiscal 2006. Progress on the budget, real estate, restoration, strategic planning and staffing augur well for the strong and stable foundation that is crucial to the long-term well being of the Cathedral.

BUDGET

The Cathedral posted a modest budget surplus in fiscal 2006, the second consecutive year we were in the black. This positive achievement compares with three years of deficits that averaged nearly a million dollars.

Tight control of expenses has been a hallmark of Cathedral financial operations, and it is reaping benefits. It is a difficult battle that must be waged constantly, especially since several key and escalating items—insurance, electricity and fuel—are beyond our control.

REAL ESTATE

As the Cathedral maintains a tight rein on expenses, it is also several years into a real estate initiative to enhance revenue through the prudent development of two underutilized sites on the 11.3-acre Cathedral campus or Close. The sites are on the southeast corner of the Close at 110th Street and Morningside Drive and on the north side of the Cathedral on 113th Street between Amsterdam Avenue and Morningside Drive.

In fiscal 2005, the Cathedral reached an agreement that grants Columbia University a minimum of three-and-a-half years to exercise an option to lease and develop the parcel on 113th Street. The agreement may be extended up to an additional four-and-a-half years, terminating after eight years if Columbia has not exercised the option to lease the property.

The southeast site will be developed by AvalonBay Communities, Inc. is a publicly held real estate investment trust that develops, acquires and manages high-quality apartment communities throughout the United States. They will build a 300 unit residential rental building.

Just after the close of the fiscal year, the Cathedral agreed with AvalonBay Communities for the project to proceed as an 80/20 residential development.

Under this plan, 80% of the apartments (approximately 240) would be market rate and 20% (approximately 60) would be affordable. In order for this to be economically feasible, the Cathedral has committed to establishing a Housing Mission Fund that will contribute $200,000 annually to support the affordable component of the project for a thirty-year period.

The design plan for this project includes the creation of a large landscaped open space at the building's entry at the corner of Cathedral Parkway and Morningside Drive, making visual connection with Morningside Park, directly across the street. When the proposed building is finished, the corner will be transformed from a desolate, overgrown area to a well lit, open space that will be safer for pedestrians.

A portion of the revenue from these proposed development projects will be allocated to address critical core operating needs. In addition to the Mission Fund described above, significant amounts will also be earmarked to address deferred maintenance, and the rebuilding of

BELOW: *Rendering of proposed southeast corner building, left, as it will look from 112th Street & Morningside Park*

此頁面的變化包括拉寬圖片，以及使用不同的字型粗細。

ADULTS AND CHILDREN IN TRUST (A.C.T.)

Providing a safe place for children of working families to thrive has been the cornerstone of A.C.T. programs for 35 years. Children from 12 months to 14 years old come to the Cathedral to learn, play and grow.

A.C.T.'s Board of Advisors is composed of volunteers who reflect the program's ties to the community and loyalty to the A.C.T. program. They are involved in fundraising, allocating funds for scholarships, and strategic planning. The Members of the Board, which includes an attorney, an architect, an educator and non-profit professionals, are former A.C.T. parents, staff, and a former A.C.T. child. Several Board Members live in the Cathedral neighborhood and all have been associated with A.C.T. for many years. The A.C.T. Board of Advisors helps to connect the Cathedral to its neighbors and community, and assists in creating paths to the Cathedral that frequently result in A.C.T. families becoming involved in other Cathedral programs, be they spiritual, educational or artistic.

A new program of afternoon activities for toddlers and their parents was introduced this year to great reviews. The facilities provide safe space for play and learning by toddlers, and neighborhood families are introduced to the breadth of programs and activities at the Cathedral. A.C.T. maintains a child-friendly atmosphere in the Cathedral's undercroft, as evidenced by the success of its 36th summer camp that saw enrollment and revenues exceed expectations. A Department of Education contract to provide free universal pre-kindergarten continued to expand. Divine Children's parties remain a special attraction, and have increased in frequency as compared to the previous year.

A.C.T. offers a range of non-sectarian programs that enhance a child's ability to thrive in diverse communities. A.C.T.'s commitment to diversity and equality is reflected in the subsidies that are provided to about one-third of program participants.

THE CATHEDRAL SCHOOL

Every school-day morning, 266 children stroll down the Cathedral Close—past flower gardens, stands of trees, and peacocks—heading for another day at The Cathedral School.

The Cathedral School is a K–8 independent, coeducational school for children of all faiths, whose students have provided the Cathedral its children's choir for over 100 years. Cathedral's talented faculty, administration, and staff are deeply committed to excellence in education – to the intellectual, social, emotional, and moral development of each child and of the community as a whole. Attention to individual children is ensured through Cathedral's small class size: there are about 15 children in each class, and two classes per grade.

The Cathedral School's rigorous academic program is both traditional and innovative. The traditional approach means that, from their earliest years at the school, students are taught how to write clearly, read fluently, and compute basic math functions efficiently. Innovative teaching methods ensure full engagement and participation from all students.

At The Cathedral School, the focus is on an intellectually rigorous education, but students thrive because they are part of a truly cooperative community. From the very start, younger students interact with older students, developing important and lasting relationships. Cathedral students have a strong sense of community, loyalty, and tradition—a sense of belonging to a school that inspires them academically, encourages them morally, and rewards them with a rich educational experience to serve as a foundation for a lifetime of learning.

TEXTILE CONSERVATION LABORATORY

The Textile Conservation Laboratory was founded in 1981 to conserve the Cathedral's priceless sets of 17th century Italian Barberini and English Raphael tapestries. Today the Lab receives textiles from all over the world, from both public institutions and private collections.

One of the projects that the Lab worked on in the past year is particularly indicative of the many paths leading to, and from, the Cathedral. In April 1911, just as the choir, high altar and first two chapels were nearing completion, a gift of a set of altar linens was given to the Cathedral. Episcopal Deaconess Sybil Carter designed the laces especially for the Cathedral and worked with women of the Oneida tribe of Minnesota and Wisconsin to sew them. In 1904 Miss Carter founded the Sybil Carter Indian Mission and Lace Industry Association, with the belief that "...the best work of all our mission field is that which helps to make men and women self-supporting and self-respecting." All of the Association's proceeds were spent on training and paying Native American women to make lace, as well as for supplies. At the time of the donation, the New York Herald wrote, "This set of linen consists of twenty-five pieces, elaborated in the most exquisite hand made lace. It is the workmanship of American Indian women. These pieces of lace have been made after patterns in keeping with the design of the high altar itself. They have been five years in the making." In 2003 Ms. Debra Jenny of Wisconsin, who was researching the work of the Sybil Carter Indian Mission and Lace Industry, contacted the Lab. Ms. Jenny and Marlene Eidelheit, director of the Lab, soon identified exactly those laces that were created by the Oneida women trained by Miss Carter. In the summer of 2007 the ciborium cover lace from the Cathedral's set was included in the exhibit "Old Paths and New: Native American Art" at the Neville Public Museum in Green Bay, Wisconsin. Woody Webster, the son of one of the lead lace makers, and Josephine Webster came to the exhibit and displayed his mother's original prickings and bobbins used in making these laces.

Other projects that the Textile Conservation Laboratory worked on this past year:

- Completed conservation on *The Adoration of the Shepherds*, a Barberini tapestry.
- Completed and reinstalled a 16th century Flemish "Choo Fleur," large leaf verdure (garden) tapestry from the main reading room at the New York Academy of Medicine.
- Completed conservation on a 16th century Flemish "warrior" tapestry for a Renaissance exhibit at the Allentown Museum in Pennsylvania.
- Completed conservation on two 18th century tapestries from a Flemish "Life of Moses" series.
- Conserved and reinstalled "Diana and Her Infant," a 16th century Belgian tapestry from the Society of the Cincinnati in Washington, DC.
- Continued conservation on a tapestry from the French Beauvais workshop illustrating "The Toilette of Psyche" for the Philadelphia Museum of Art.

A Civil War-era flag before and after the Textile Conservation Laboratory's work.

2

3

版面整體的觀感乃取決於內容主題為何;比如說,各行各業的年度報告雖然內容皆不相同,但是呈現風格大多是直接了當。上頁這個版面很適合此非營利組織,因為一目了然,不拐彎抹角。

18. 以文字編排界定格線區域

好的設計能清楚呈現內容，並且與內容有關，從而使讀者產生共鳴。好的文字編排，無論出版用途為何，都會明白界定出區域。在版面上，可以有橫向或縱向的區塊，而且依然保有規律性。重點是要確定內容要能相互扣合。

確切來說，就是要確保讀者對內容能一目了然。此外，標題或書眉位置也要有所間隔。而且，還要注意圖說位置要對應到正確圖片，以便讀者參照，尤其是教學指南性的內容。

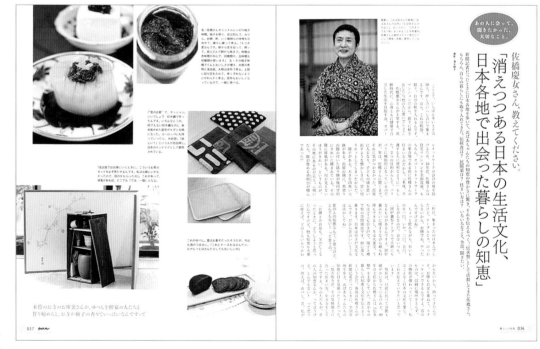

標題區域與內文有所區隔，有時在頁面右側，有時在頁面中心。文章段落以空間或線條隔開，圖說則出現在個別特定區域。

名稱
Croissant magazine

客戶
Croissant magazine

藝術指導與設計
Seiko Baba

《可頌》（Croissant）是一本日文雜誌，目標讀者為三十歲以上婦女，內容編排清晰又美觀。這本特別的雜誌為一種Mook形式，是由可頌編輯部發行的特刊。此雜誌的標題是Mukashi Nagara no kurashi no chie，意思是「古早生活的智慧」。

左・大根の二杯酢柚子香り漬け。こうしておくと、いつまでももう、いつ何どきうが来ても、慌てずに出せるの。お茶でもお酒でもおいしい。中・大根の皮はキンピラにすると。「ちょっとだけ砂糖を入れるとおいしいのよ。ほんのちょっとだけですよ」。大根の皮って一種取らないとダメよ。飛び上がっちゃうからで、お醤油をクラーっとまわしかけて、味は自分の好みなの」右・大根の葉は油揚げと炒めて。味付けははしょうゆ醤油です。この葉っぱは皮の本体は、37ページで見た大根。

「この酒は、いぐさの産地の九州は八代で作ってもらったの。夏、マットの上に敷いて寝れば涼やから、「ヨガにも使うし、巻いとけば蒲団にもならないし」ね

大根は、葉っぱから尻尾まで全部食べられるのよ。皮はキンピラにして、ね

薬用酒各種。「山椒の実、カリン、アロエ、ビワの葉、ニンニク、ナナカマド、クコ、クロモジ、菖蒲以外は、みんな薬用酒になります。効きますし、左から2つ目のアロエのお酒の作り方は、アロエの葉を皮を包丁でこそげ取り、1cmの厚さに切る。砂糖を同じくらいの厚さで入れる。レモンも同じくらいの厚さに切るモンを入れ、果実酒用焼酎を入れて、冷暗所で保存、漬けて2〜3か月したら飲める。

右・お客さん用の靴箱。玄関に靴が並びきらず、思いついた。来た人はこの袋に自分の靴を入れ、並べないように、袋も糸を、いろいろな色で作ったんです。上・下駄箱の戸は空気が通るような細工がある。

上左・押し寿司の押し箱。上右・輪島のお弁当箱と、曲げわっぱのお弁当箱は「輪、いきを使わないと薄く切れないんですって」。手拭・おつまみ入れ。「全部、お盆に並べると平らになって、上にものがのっかるの」

薬用酒なんて、台所の納戸にい〜っぱい！ 昔のものは、一つのものに効くんでなく、「効くんだとさ」、なんです

不同區塊內的字型能隔不同的內容。此處內文和步驟說明分別是在不同區域。

19. 結合怪異與一致性

最成功的格線設計，莫過於具備一致性、條理性、清晰和結構完備，然後還能令人覺得大開眼界。雙欄式格線可以設計為不同欄寬的欄位，為頁面增加視覺衝突和動感。儘管標新立異的變化能讓設計活潑起來，不過平穩的基本結構在提供清楚架構的同時，也能創造戲劇效果。

讓版面維持一致性的元素包括：

· 頁面最上方的章節標題區域

· 不管是在左頁還是右頁，內文出現的位置要一致，這對讀者來說，是非常重要的導引指標。

· 頁面下方的頁眉和頁碼，有助於引導讀者閱讀。

整個手冊是以一個主要版型來編排主文。主要的敘述文字，與輔助的訊息可以輕鬆找到。清楚的結構與具動感、色彩強烈的圖片形成對比。

名稱
Brochure for the Performing Arts Center, Purchase College

客戶
SUNY Purchase

設計公司
Heavy Meta

藝術指導
Barbara Glauber

設計者
Hilary Greenbaum

完美的版面結構，能允許跳tone的變化，使頁面更生動。

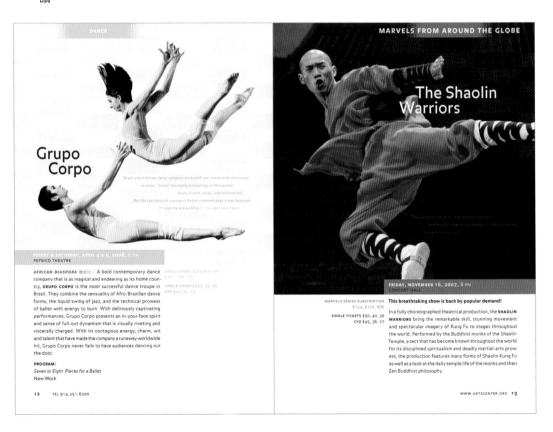

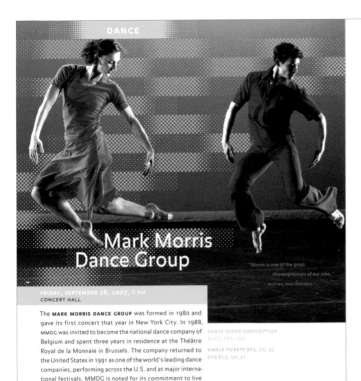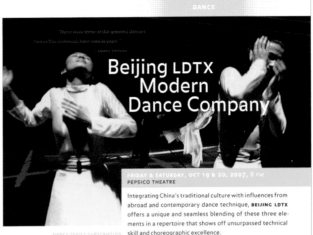

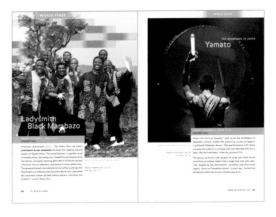

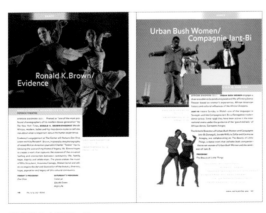

上圖：這個版面設計不僅結構完備，文字編排還有明確的階層關係。第一個標題較大，接下來重複出現在大小一致的box內，但字型較小。在色塊上，可找到日期和地點，但以簡明扼要的表達方式編排。有考慮到所有元素的相互關係，並且明顯區分階層。

左頁：大多數圖片是整頁水平置放，但文字和色塊壓上部分圖片，使頁面增添動感和戲劇成分。表演者名稱的擺放位置清楚易見，但出現在圖片不同區域，多了幾分質感和趣味。

顏色與內文和諧一致。

右圖：去背圖和空白處能讓頁面有所變化。

雙欄式格線

20. 版型變化

在一個版面上,可以結合數種格線和文字排版方式,這並無任何不妥。頁面上有不同的內容要編排時,即使採用清楚的雙欄式格線,也要稍加變化,才能讓頁面清晰且平衡。

名稱

2007-2008 HD Program Guide

客戶

The Metropolitan Opera

設計公司

AdamsMorioka, Inc.

創意指導

Sean Adams, Noreen Morioka

藝術指導

Monica Schlaug

設計者

Monica Schlaug, Chris Taillon

典雅、內斂卻有生氣的設計,能為整個平面設計注入年輕活力,也是一種永不退流行的藝術形式。

連續性的走文,如長篇報導或概要介紹,版面都採等寬的雙欄編排。

關於各項表演的介紹,開頭都選用大張又有戲劇效果的照片。

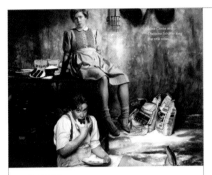

Alice Coote as Hansel and Christine Schäfer in the title roles.

GRETEL WAKES HANSEL,
and the two find themselves in front of a gingerbread house.

ACT II

Gretel sings while Hansel picks strawberries. When they hear a cuckoo calling, they imitate the bird's call, eating strawberries all the while, and soon there are none left. In the sudden silence of the woods, the children realize that they have lost their way and grow frightened. The Sandman comes to bring them sleep by sprinkling sand on their eyes. Hansel and Gretel say their evening prayer. In a dream, they see 14 angels protecting them.

ACT III

The Dew Fairy appears to awaken the children. Gretel wakes Hansel, and the two find themselves in front of a gingerbread

house. They do not notice the Witch, who decides to fatten Hansel up so she can eat him. She immobilizes him with a spell. The oven is hot, and the Witch is overjoyed at the thought of her banquet. Gretel has overheard the Witch's plan, and she breaks the spell on Hansel. When the Witch asks her to look in the oven, Gretel pretends she doesn't know how: the Witch must show her. When she does, peering into the oven, the children shove her inside and shut the door. The oven explodes, and the many gingerbread children the Witch had enchanted come back to life. Hansel and Gretel's parents appear and find their children. All express gratitude for their salvation.

IN FOCUS

Engelbert Humperdinck
HANSEL and GRETEL

PREMIERE: HOFTHEATER, WEIMAR, 1893

Originally conceived as a small-scale vocal entertainment for children, *Hansel and Gretel* outgrew its original design to become the most successful fairy-tale opera ever created. Like so many children's classics, *Hansel and Gretel* achieved greatness because it resonates with both adults and kids. The composer Engelbert Humperdinck was a protégé of the musical titan Richard Wagner, and the score of *Hansel and Gretel* is flavored with the sophisticated musical lessons he learned from his idol while maintaining a charm and a light touch that were entirely Humperdinck's own. The ancient tale of the young brother and sister who get lost in a dark forest and almost get eaten by an old witch became a classic of German literature in the famous collected stories of the Brothers Grimm. The opera acknowledges the darker features present in the story, yet presents them within a frame of grace and humor. Humperdinck's fellow composer Richard Strauss was delighted with the score from the start and conducted its world premiere. *Hansel and Gretel* has been internationally popular ever since and must be one of the very few operas that can boast equal acclaim from such diverse and demanding critics as children and musicologists.

THE CREATORS

Engelbert Humperdinck (1854–1921) was a German composer who began his career as an assistant to Richard Wagner in Bayreuth in a variety of capacities, including tutoring Wagner's son Siegfried in music and composition. Humperdinck

even composed a few minutes of orchestral music for the world premiere of Wagner's *Parsifal* (1882) when extra time was needed to effect a scene change. (This music is not included in the printed score of *Parsifal* and is no longer performed). *Hansel and Gretel* was Humperdinck's first complete opera and remains the foundation of his reputation. The world premiere of his later opera *Königskinder* took place at the Met and was one of the sensations of the company's 1910–11 season, following less than three weeks after the world premiere of Puccini's *La Fanciulla del West*. *Hansel and Gretel*, however, is the only one of Humperdinck's works to remain in the repertory. The libretto was written by his sister, Adelheid Wette (1858–1916), and is based on the famous fairy tale from the Grimms' collection. The brothers Jacob (1785–1863) and Wilhelm (1786–1859) Grimm were German academics whose groundbreaking linguistic work revolutionized the understanding of language development. Today, they are best remembered for editing and publishing collections of folk tales.

THE SETTING

In the libretto, the opera's three acts move from Hansel and Gretel's home to the dark forest to the witch's gingerbread house deep in the forest. Put another way, the drama moves from the real, through the obscure, and into the unreal and fantastical. In this production, which takes the idea of food as its dramatic focus, each act is set in a different kind of kitchen, informed by a different theatrical style: a D.H. Lawrence-inspired setting in the first, a German Expressionist one in the second, and a Theater of the Absurd mood in the third.

THE MUSIC

The score of *Hansel and Gretel* successfully combines accessible charm with subtle sophistication. Like Wagner, Humperdinck assigns musical themes to certain ideas and then transforms these themes according to new developments in the drama. Much of this development occurs in the orchestra, like the chirpy cuckoo, depicted by the winds in Act II, which becomes

為了區隔不同階層的內容，這裡是以有襯線和無襯線的不同字體來顯示其差異。（編按：有襯線的字體常見的為 Times New Roman，相對於中文字體為明體等；無襯線的字體常見的為 Arial，相對於中文字體為黑體等。）

若是要編排不同類型的內容，如問答形式，可使用雙欄式格線，問題欄較窄，回答欄較寬。

that Tristan is simply performing his duty. Isolde maintains that his behavior shows his lack of love for her, and asks Brangäne to prepare a death potion. Kurwenal tells the women to prepare to leave the ship, as shouts from the deck announce the sighting of land. Isolde insists that she will not accompany Tristan until he apologizes for his offenses. He appears and greets her with cool courtesy ("Herr Tristan trete nah"). When she tells him she wants satisfaction for Morold's death, Tristan offers her his sword, but she will not kill him. Instead, Isolde suggests that they make peace with a drink of friendship. He understands that she means to poison them both, but still drinks, and she does the same. Expecting death, they exchange a long look of love, then fall into each other's arms. Brangäne admits that she has in fact mixed a love potion, as sailors' voices announce the ship's arrival in Cornwall.

ACT II

In a garden outside Marke's castle, distant horns signal the king's departure on a hunting party. Isolde waits impatiently for a rendezvous with Tristan. Horrified, Brangäne warns her about spies, particularly Melot, a jealous knight whom she has noticed watching Tristan. Isolde replies that Melot is Tristan's friend and sends Brangäne off to stand watch. When Tristan appears, she welcomes him passionately. They praise the darkness that shuts out all false appearances and agree that they feel secure in the night's embrace ("O sink hernieder, Nacht der Liebe"). Brangäne's distant voice warns that it will be daylight soon ("Einsam wachend in der Nacht"), but the lovers are oblivious to any danger and compare the night to death, which will ultimately unite them. Kurwenal rushes in with a warning: the king and his followers have returned, led by Melot, who denounces the lovers. Moved

and disturbed, Marke declares that it was Tristan himself who urged him to marry and chose the bride. He does not understand how someone so dear to him could dishonor him in such a way ("Tatest Du's wirklich?"). Tristan cannot answer. He asks Isolde if she will follow him into the realm of death. When she accepts, Melot attacks Tristan, who falls wounded into Kurwenal's arms.

ACT III

Tristan lies mortally ill outside Kareol, his castle in Brittany, where he is tended by Kurwenal. A shepherd inquires about his master, and Kurwenal explains that only Isolde, with her magic arts, could save him. The shepherd agrees to play a cheerful tune on his pipe as soon as he sees a ship approaching. Hallucinating, Tristan imagines the realm of night where he will return with Isolde. He thanks Kurwenal for his devotion, then envisions Isolde's ship approaching, but the Shepherd's mournful tune signals that the sea is still empty. Tristan recalls the melody, which he heard as a child. It reminds him of the duel with Morold, and he wishes Isolde's medicine had killed him then instead of making him suffer now. The shepherd's tune finally turns cheerful. Tristan gets up from his sickbed in growing agitation and tears off his bandages, letting his wounds bleed. Isolde rushes in, and he falls, dying, in her arms. When the shepherd announces the arrival of another ship, Kurwenal assumes it carries Marke and Melot, and barricades the gate. Brangäne's voice is heard from outside, trying to calm Kurwenal, but he will not listen and stabs Melot before he is killed himself by the king's soldiers. Marke is overwhelmed with grief at the sight of the dead Tristan, while Brangäne explains to Isolde that the king has come to pardon the lovers. Isolde, transfigured, does not hear her, and with a vision of Tristan beckoning her to the world beyond ("Mild und leise"), she sinks dying upon his body.

CLOSE-UP

SCALING THE HEIGHTS

Deborah Voigt and **Ben Heppner** on how they'll ascend opera's Mount Everest—the title roles of *Tristan und Isolde*—with a little help from Maestro James Levine.

Debbie, you've only sung Isolde on stage once before, several years ago. Why the long interval?

Deborah Voigt: I first sang the part in Vienna five years ago. It came along sooner than I anticipated, but the circumstances were right and I decided to go ahead and sing it. When you sing a role as difficult as Isolde, people are going to want you to sing it a lot, and I didn't want to have a lot of it booked if it didn't go well. So I didn't book anything until the performances were over. The first opportunity I had after Vienna are the Met performances.

Ben, what makes you keep coming back to Tristan?

Ben Heppner: Before it starts, it feels like I'm about to climb Mount Everest. But from the moment I step on the stage to the last note I sing it feels like only 15 minutes have gone by. There is something so engaging about this role that you don't notice anything else. It takes all of your mental, vocal, and emotional resources to sing. And I like the challenge of it.

The two of you appear together often, and you've also both worked a lot with James Levine.

DV: Maestro Levine is so in tune with singers—how we breathe and how we work emotionally. I remember I was having trouble with a particular low note, and in one performance, he just lifted up his hands at that moment, looked at me and took a breath, and gave me my entrance. The note just landed and hasn't been a problem since.
BH: He has this wonderful musicality that is so easy to work with. As for Debbie, we just love singing together and I think that is really its own reward.

This *Tristan* will be seen by hundreds of thousands of people around the globe. How does that impact your stage performance?

DV: None of us go out to sing a performance thinking that it is any less significant than another, so my performance will be the same. But when you are playing to a huge opera house, gestures tend to be bigger. For HD, some of the operatic histrionics might go by the wayside.
BH: When the opera house is filled with expectant listeners—that becomes my focus. The only thing I worry about is that it's a very strenuous role, and I'm basically soaking wet from the middle of the second act on! ∎

21. 讓頁面看起來簡單

最成功的設計是看起來簡單，卻又不失變化。看起來開闊空曠的設計，能容納大量內容，尤其適合書本或目錄編排。

若內容有圖有文，要注意兩者比例以及各自需要多少空間。當圖說很長又涵蓋很多額外內容時，例如致謝欄、補充說明時，可以使用不同字型、縮小字型，或是變換各區塊間的空間，將圖說與主文分開來。

三欄式格線是可以解決版面結構問題的一個辦法。這種格線，乍看之下像單欄或雙欄設計。可以把其中兩欄併成一欄放入文字，並將文字放在頁面右側，如此就能讓內文看起來乾淨不雜亂，左邊大面積留白則可安排較長的圖說。

若圖說的文字較多，則圖說欄數可由一欄換成兩欄，讓圖片和圖說安排在同頁，才清楚好讀。使用三欄式格線，圖片可占一欄、兩欄或三欄，也可以填滿整個頁面（出血）。

名稱
Beatific Soul

客戶
New York Public Library/
Scala Publishers

設計公司
Katy Homans

本書是搭配展覽出版，展覽內容是介紹作家傑克·凱魯亞克，主要聚焦於他的生平、職業、藝術、日記與手稿。三欄式格線彈性極大，能涵蓋多種變化，使頁面看起來空間不擁擠、沉靜又簡單美觀。

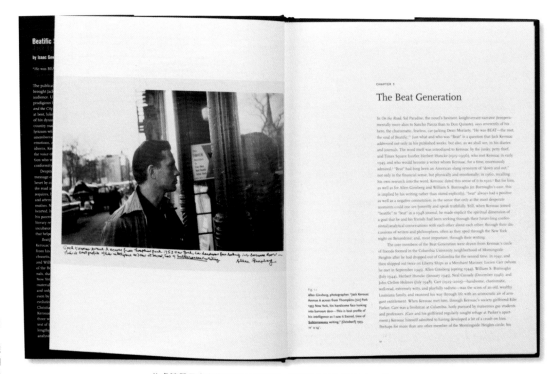

此處簡單又富有變化的三欄格線，能容納各種不同內容。使用有襯線字體的內文行距夠寬，因此容易閱讀。位於左欄的圖說使用無襯線字體，整體看起來更加清晰。這種頁面結構非常便於容納不同的內容文字。

Fig. 2.8
List of women, 1962. 10.75" h.
Kerouac's list of the women with whom he has had sex probably should be seen as a symptom of his obsession with statistics, as well as a reflection of his desire to objectify his partners. The largest numbers are recorded for "Edie" [Parker] (no. 1), his first wife; "Joan H.[averty]" (no. 51), his second wife; "Joan Adams [Vollmer]" (no. 23), who was to become William S. Burroughs's common law wife; and "Harlem" (no. 28), probably a pseudonym for Alene Lee, the African American woman whose affair with Kerouac became the subject of his novel The Subterraneans (1958). His Lowell High School sweetheart, Mary Carney, is almost certainly the woman whom he calls, in a tasteless quasi-pun, "Mary Filth," i.e., "carnal" (no. 14).

Fig. 2.9
"Lilith." Multicolored felt pens on paper, ca. 1964. 11" x 8.5".
Lilith is a female demon who appears first in ancient Mesopotamia and then in Judaic sources. Rabbinic lore ascribes to her the role of Adam's first wife, but the only mention of her in the Bible is in Isaiah. In the Kabbalah she is portrayed as a seductress who ensnares men in sin, and this is how she has been primarily portrayed in Western culture. In 1963, Kerouac replied to one of the questions that John Clellon Holmes had posed for an article he was writing on him: "Women. At present (1963) I banish them from my life, because of the dishonesty of their eventual motives. Their motives are—(your money, your baby replica, then you out of the way)."

As for Kerouac's relationship with his father, certainly his childhood memories were of a warm, vivid personality whom he adored, though they began to clash regularly after Kerouac began his studies at Columbia. Leo was an inveterate bettor on the horses, and in Kerouac's earliest surviving diary, the twelve year old casually notes in the entry for February 4, 1935, "Horses won but Pa got arrested with some other guys in the Jockey Club. Anyhow he made five bucks." This diary contains entries for the first months of 1935 and ends with a review of 1934, in a "Memoranda" section, which presents a brief history of his friendships with several boys, Mike Fournier, Eddy Sorenson, Bill Chandler, and George Apostolos (who would remain a lifelong friend), whom he had met from two to eight years previously. Bowling and shooting pool with these friends are often mentioned, which is understandable since, as he notes, "in September [1934], my father was elected to run the Pawtucketville bowling alleys." He also recalls the horse ("Daisy") that his father bought him but which had to be sold, after which Leo bought him a Collie/German Shepherd whom Kerouac named "Beauty."

After Leo lost his printing company during the Depression, he earned a livelihood as an occasionally independent job printer and as an employee of several New England printing firms, supplementing his income by managing the Pawtucketville Social Club. Appropriately enough, considering his love of horse racing, he printed the racing forms for regional race courses. That Leo successfully transmitted to Jack his love of horse racing, as well as of boxing and baseball, is apparent in the sports and horse racing scrapbooks (see, for example, fig. 2.10) that Kerouac maintained from 1935, when he was twelve, to 1937, and in his newssheets, which he "published" in 1937 and 1938. Kerouac also kept scrapbooks of college and professional sporting events, and "published" two typewritten newssheets on professional sports: Sports of Today (June 1937) and Sports: Down Pat (Fall 1937–Spring 1938), in the latter of which his primary topic was baseball, though he also included a few stories about horse racing. The issue "Strolling Along Flatbush" is devoted to the Brooklyn Dodgers's 1938 team. Kerouac concludes his favorable survey of the Dodgers by remarking that no one will be able to mock them with what was, apparently, a perennial, sarcastic question, "Is Brooklyn in the league this year?" since the Dodgers now have "the strongest team in years" and "should finish fifth or sixth, if not in the first division" (i.e., among the first five places).

Oddly, football, the sport at which Kerouac would excel and which would bind him to his father in solidarity against their imagined enemies, as well as allow Kerouac to become the agency of his father's professional misfortune, is not represented in the Archive by newspaper clippings about college or professional teams. Kerouac played football for his Junior High School, and by the time he entered Lowell High he had developed into a strong and elusive running back, as well as an occasional defensive back ("two-way" players were common then) who was known for his punishing tackles. He was somewhat short by the football standards of even that day (as an adult he stood five-foot-seven), but was muscular and agile. Although he did not start for the Lowell team, he made an impact in most of the games in which he played. He won his greatest high school football glory in a 1939 game, described in Vanity of Duluoz, against a strong Lawrence High School team in which he scored the game's only touchdown (see fig. 2.11).

三欄式格線能為長形圖片和大量圖說提供很好的架構。上圖左頁版面上，圖說占了原本的內文欄位，長形的圖片放在左欄；右頁則單純由文字占滿整個版面。

為了要有節奏感和清晰度，有時大張的圖片是自己占滿一整面。此處的圖片為傑克·凱魯亞克本人的打字稿，它就占了一整頁，與左頁沉靜的內文欄位相對照。

若版面內容為參考資料，如註解、索引等，會以三欄編排。

22. 用文字排編版設定欄位

文字編排有助於欄位設定。使用不同粗細、大小的字體，能有助於決定內容順序以及階層關係，此階層關係可以是橫向（標題、說明、內容），也可以是縱向（由左至右的各欄位）。不同的字型（如黑體）能區隔列表或內文，顯現它們與內文敘述文字或步驟做法的差異。標題字型加粗或在步驟說明加入編號，則有注意提醒之效，也能為頁面帶來生氣。細瘦的字體，可以不同字型呈現，適合做為頭註或附加訊息。清楚分隔的空間，能讓各種字型看起來不會糊在一起。

材料部份以無襯線字體編排，步驟指示則用有襯線字體。字體加粗的部分是為了強調內容。

名稱

Martha Stewart's Cookies

客戶

MSL Clarkson Potter

設計公司

Barbara deWilde

精美的照片和文字編排準確地傳達烘焙權威的高雅與品味。

Coconut-Cream Cheese Pinwheels

Rich cream cheese dough, coconut-cream cheese filling, and a topper of jam make these pinwheels complex—chewy on the outside, creamy in the center. Create a variety of flavors by substituting different fruit jams for the strawberry. MAKES ABOUT 2½ DOZEN

for the dough:

2 cups all-purpose flour, plus more for work surface

⅔ cup sugar

½ teaspoon baking powder

½ cup (1 stick) unsalted butter, room temperature

3 ounces cream cheese, room temperature

1 large egg

1 teaspoon pure vanilla extract

for the filling:

3 ounces cream cheese, room temperature

3 tablespoons granulated sugar

1 cup unsweetened shredded coconut

¼ cup white chocolate chips

for the glaze:

1 large egg, lightly beaten

Fine sanding sugar, for sprinkling

⅓ cup strawberry jam

1. Make dough: Whisk together flour, sugar, and baking powder in a bowl. Put butter and cream cheese into the bowl of an electric mixer fitted with the paddle attachment; mix on medium-high speed until fluffy, about 2 minutes. Mix in egg and vanilla. Reduce speed to low. Add flour mixture, and mix until just combined. Divide dough in half, and pat into disks. Wrap each piece in plastic, and refrigerate until dough is firm, 1 to 2 hours.

2. Preheat oven to 350°F. Line baking sheets with nonstick baking mats (such as Silpats).

3. Make filling: Put cream cheese and sugar into the bowl of an electric mixer fitted with the paddle attachment; mix on medium speed until fluffy. Fold in coconut and chocolate chips.

4. Remove one disk of dough from refrigerator. Roll about ⅛ inch thick on a lightly floured surface. With a fluted cookie cutter, cut into fifteen 2½-inch squares. Transfer to prepared baking sheets, spacing about 1½ inches apart. Refrigerate 15 minutes. Repeat with remaining dough.

5. Place 1 teaspoon filling in center of each square. Using a fluted pastry wheel, cut 1-inch slits diagonally from each corner toward the filling. Fold every other tip over to cover filling, forming a pinwheel. Press lightly to seal. Use the tip of your finger to make a well in the top.

6. Make glaze: Using a pastry brush, lightly brush tops of pinwheels with beaten egg. Sprinkle with sanding sugar. Bake 6 minutes. Remove and use the lightly floured handle of a wooden spoon to make the well a little deeper. Fill each well with about ½ teaspoon jam. Return to oven, and bake, rotating sheets halfway through, until edges are golden and cookies are slightly puffed, about 6 minutes more. Transfer sheets to wire racks; let cool 5 minutes. Transfer cookies to rack; let cool completely. Cookies can be stored in single layers in airtight containers at room temperature up to 3 days.

soft *and* chewy • **61**

別出心裁地安排頁面各元素，可以增添趣味。使用不同字型做為強調，能讓版面變得生動，讓讀者覺得有趣好玩又能學到東西。

23. 避免過於擁擠

設計多個欄位時，未必要把所有空間都填滿。最好能空下幾欄留白。因為留白的空間能引導讀者視線瀏覽頁面，不費力就找到某個特定報導、圖片或商標。不同粗細的線條能幫助編排內容，讓頁面有活力。

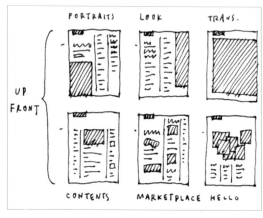

初稿就已呈現空間概念。

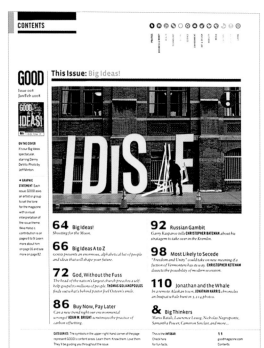

名稱
Good magazine issue 008

客戶
Good Magazine, LLC

設計公司
Scott Stowell

設計者
Open

留白的空間以及幽默搶眼的設計，能讓讀者願意瀏覽「讓地球變得更美好」這類理想遠大的主題內容。

目錄頁常常很難分配空間。上圖的頁面不會雜亂無章，讀者輕易就能找到雜誌這期的主題。版面編排使用了各種大小和粗細的字體，使頁面既平衡又吸引人。右上方的圖示則在整本雜誌中不斷出現。

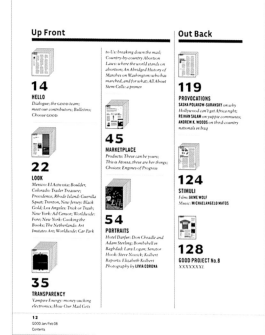

此頁包含五種層次的內容，由於頁面留白足夠，排版乾淨俐落，整體十分清晰好讀。

運用直線及巧妙的編排方式，可以把各種訊息按類型劃分。

在此大篇幅頁面上，文字編排豪邁，與滿版的圖片形成對比。

HELLO
: dialogue

Dear GOOD First off, GOOD has become my new favorite magazine and I see it catching on everywhere, so great job. However, I'm contacting you to be a pest about running Fiji Water ads. I know a lot of people who are eager to do right and think that Fiji water is the way to go. But shipping plastics to Fiji and then shipping those same bottles made heavy with water back across the globe has a pretty negative carbon footprint. I consider their ads to be fraudulent in that they mislead consumers. I think you guys are better than that.

THEA AGE
Chicago, Illinois

Dear GOOD In Morgan Clendansel's article "Get a Life" there are some things to note about his experience: Morgan seems typical of those who get an account in Second Life, stumble around for a couple of hours, try to find places to go, get fooled into going to what the search results return as "popular" places (venues that hire people to sit and do nothing so their places appear most "popular"), and leave wondering what it's all about. I did a profile search on Clendansel's avatar, "Morton" and saw that Morton belongs to zero groups in Second Life. The group is the basic social unit; without groups you are stumbling around a vast space alone or subject to random encounters.

There really is a high attrition rate in Second Life, because there are steep challenges to the new-user experience. New, privately-created orientation experiences are helping to reduce that attrition. The 40,000 users logged on when Clendansel was there are a small number relative to the entire internet, but compare that to 4,000 logged on just a year ago. When I did something as simple as joining the group called "Things to Do," which sends out notices of real, interesting, entertaining things to do in Second Life, I didn't have to rely on stumbling around or searching for "popular places"; I ended up meeting a variety of people from around the world. Unlike Morton, I've never felt like there was "no one in Second Life at all."

When Clendansel writes "Frankly, virtual sex is the first thing that comes to mind when you think of a virtual world," he reveals the fact that, frankly, sex may be the first thing Clendansel thinks about. There are plenty of others who are there for other pursuits. When Clendansel, who confesses to playing computer games online, is actually called upon to co-create the experience, he turns tail and joins the chorus of naysayers who don't really want to take the time to make this experience all it has the potential of becoming. I invite Morton back to Second Life for a less isolated view of the place. Kiwini Oe has offered friendship, Morton, so log back on and see what you're missing.

KIWINI OE
Berkeley, California

Dear GOOD Bruce Bueno de Mesquita's science of game theory ("The New Nostradamus") or rational choice is too much like Isaac Asimov's psychohistory in the *Foundation* series for my liking. The line between prediction and mindfuck is too thin as it is in this "let me think for you" world. If the "thinkers" who can pay for his services intrude even more into our collective consciousness, then free will and the real chance to exercise it may be out the window forever. Even the name "rational choice" seems to have been run through a machine to soften the harshness of this science. When we realize that gamesmanship is still such a great part of game theory, by whatever name, then such choices may not seem so rational.

We may be astounded at the accuracy, which only proves the math. It does not prove the ethos. It may actually be a great tool, but in the hands of corporations and governments, even the best tools can become weapons. So the question remains: Who will guard the guardians of rational choice?

WILLSEA
via our website

Dear GOOD I learned from your last issue that the best way to get published in GOOD is to say something critical about it. However, I must say I haven't had the opportunity to read something that roused me on a negative way, at least not in your last issue. I got my GOOD by volunteering at the Los Angeles event at the Natural History Museum. As a member of City Year, I'm eternally grateful to the Goldhirsh Foundation's support and what GOOD magazine seeks to do. But I'm even more grateful for the article entitled "Urban Entertainment Needs to Change Its Tactics" by Benjamin Nugent. I had that feeling you get when you discover "I'm not the only one that feels this way!" It sounds cliché, but it was an "aha" moment. Honestly, I can't say that it was what I expected to find, but I appreciated it. There are few places where Nugent's perspectives can be heard. Thanks for the "truthiness" of that article. (Yes, I also read "Mark Peters on the Colbert suffix.")

CRYSTAL MARIE GRANT
Spartanburg, South Carolina

Dear GOOD Probably one of the funniest quotes I have ever read. "In the West, heavy metal is generally associated with lowlifes and trailer trash," says Aukje Dekker, "but the situation in Egypt is completely reversed. These kids are the children of diplomats and other well-off Egyptians." ("Rock The Casbah.")

I don't know what disturbs me more; this kid's misguided interpretation that metal in the West is associated only with lowlifes or that somehow coming from a pedigreed background makes metal cool. In the West (and most of the civilized world) metal is the music of the youth, period. It knows no class lines and in the last decade has proven that it knows no color. Metal is the expressive voice of teen angst.

Being children of well-to-do diplomats somehow takes some of the edge off of what is and should be edgy music. I don't know—visualizing some disgustingly wealthy kids rocking out on their high-ticket instruments in their dad's mansion seems to lack a certain credibility in my book.

LOFAT
via our website

Now you can find us in:

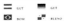

☐ GUT ☐ GUT
☐ BOM ☐ BUENO

THANKS to everyone who wrote to GOOD in response to our issue

GOOD reserves the right to edit letters for length and clarity. To make your voice heard, send us a letter, email us at letters@goodmagazine.com, or comment on an article at goodmagazine.com.

GOOD

OWNER / FOUNDER Ben Goldhirsh

PUBLISHER / FOUNDING EDITOR Max Schorr
CREATIVE DIRECTOR Casey Caplowe
EDITOR IN CHIEF Zach Frechette

DEPUTY EDITOR Morgan Clendansel
FEATURES EDITOR Siobhan O'Connor
EDITOR AT LARGE Jamie Wolf
SENIOR EDITOR Peter Alsop

PHOTO EDITOR Joaquin Trujillo
ASSISTANT TO THE PHOTO EDITOR Arnel Richmond

ASSISTANT EDITOR Patrick James
PROVOCATEURS Andrew Woods
EDITORIAL ASSISTANT Noelle Bredart
STAFF WRITERS Adam W. Bright
Matt Schwartz

COPY EDITOR Kate Norris
RESEARCH Paige Worthy, Merry Zde

PRESIDENT, NEW MEDIA Craig Shapiro
DIRECTOR OF BUSINESS DEV, NEW MEDIA Jay Ku
WEB VIDEO DIRECTOR Lindsay Utz
SENIOR VIDEO PRODUCER Morgan Currie
ASSOCIATE WEB EDITOR Andrew Price

DESIGN DIRECTOR Scott Stowell
DESIGN Open, N.Y.
Robert A. Di Ieso, Jr.
Gary Fogelson
Sim'Can Ozcan
Ryan Thacker

ART DIRECTOR, CREATIVE SERVICES Atley G. Kasky

SPECIAL THANKS Mark Barker, Gemma Corsano, Jonathan Greenblatt, Clair Holt, Hotel San Jose, Iris Ichishita, Bobby Johns, Max Joseph, Liz Lambert, Steve Lufton, Alissa Neal, Jocelyn Nubel, Josh Richman, Kate Rodler, Charlie Shelley, Dedra Smith, Ellen Spiro, Noel Waggener

CHIEF OPERATING OFFICER Michael Danenberg
ASSOCIATE PUBLISHER Albert Gore
ADVERTISING MANAGER Brent Sanet
MAGAZINE ADVISOR Joan McCraw

MARKETING DIRECTOR Liza Vadnai
NONPROFIT
PARTNERSHIPS DIRECTOR Dan Mitchell
EVENTS DIRECTOR Carol Cho
WEST COAST MARKETING MANAGER Marchelle Bradanini
RESEARCH CONSULTANT David Lehmkuhl

CIRCULATION DIRECTOR Natasha Kaufsky
CIRCULATION MANAGER Christine Sots
CIRCULATION ASSISTANT Dana Flax
FULFILLMENT ASSISTANT Jason Jude Chan
CUSTOMER SERVICE Natalie Edwards
CIRCULATION CONSULTANT Holly Wheswell
NEWSSTAND CONSULTANTS Rich Rhodes & Howard Eisenberg
CONSULTING Corag Marketing Group
MARKETING MANAGER Kathleen Montgomery
PUBLIC RELATIONS Galloway Media Group
goodpress@gallowaymediagroup.com
(212) 260-3708

MOTION PICTURES Bristol Baughan, Kenneth Garcia, Zach Miller, Gabe Reich

HEAD OF BUSINESS AFFAIRS Nuta Greenwald
OPERATIONS MANAGER Chris Butterick
ASSISTANT TO THE FOUNDER Salome Heusel
OPERATIONS COORDINATOR Melissa Hunter

INTERNS Rosalind Adams, Amanda Charlwood, Adriana Dermenjyan, Caitlin Grath, Sarah Imam, Everett Pelayo, Paul Pencznier, Kelly Rosen, Adam Saewitz, Molly Smith, Rose Surnow, Ruth Testomichael, Aung Moe Win, Eva Wong, Nashwa Zaman

BIG IDEAS!

Q
QUANTUM HIPPIES

Quantum mechanics is all about the relationship between matter and energy. So it's not hard to imagine why the science has been co-opted by a subculture of bong-toting academe—expand your mind, anyone? Scholars (cough) like Daniel Pinchbeck have struck mono-atomic gold with a prophetic philosophy that marries quantum theory and Ayahuasca-induced hallucination, all in an effort to come to grips with what rational materialism neglects, the inexplicable nature of being.

$$\Delta x \, \Delta p \geq \frac{\hbar}{2}$$

= whoa.

We see evidence every day—at every grade level, and in urban and rural communities all across the country—that when children facing the challenges of poverty are given the opportunities they deserve, they excel. This is the truth, and yet those who believe that it is impossible for schools to overcome the challenges of poverty consider it a radical idea. This is the idea I'd like to see our nation's leaders embrace—the idea that with a new approach to education, we can ensure that all of our nation's children, regardless of where they are born, have the opportunity to attain an excellent education.

Wendy Kopp is the director of Teach For America (one of GOOD's nonprofit partners)

BIG THINKER
WENDY KOPP

RUSSIAN DEMOCRACY

R

Russian Gambit

Garry Kasparov, the Russian presidential candidate and former chess grandmaster, is trying to keep Vladimir Putin in check.

interview by
CHRISTOPHER BATEMAN

illustrations by
DARREN BOOTH

BIG Christopher Bateman is an editorial associate at Vanity Fair. He lives in New York.

偉大的想法？要配上大字母！大型的字母有趣地標示出文章的開頭，標題也玩了文字遊戲。出現在目錄頁的圖示固定放在頁面右上方，但只會放符合該文類別的圖示。

24. 調低欄位

滿 版的三欄式走文可能會讓版面太擁擠。能讓讀者繼續讀下去，又不至於望之生畏的好方法，就是將頁面欄位調低，如此一來，整個版面會看起來乾淨且具流動感。

調低的欄位還可讓設計者替標示性的訊息保留出清晰的空間，如書眉和頁碼、版面標題、註腳和照片等。

Pew Environment Group

Halloween 1948 was all trick and no treat in Donora, Pennsylvania. In the last week of October, this town of 14,000 in the western part of the state underwent a weather event called a "temperature inversion," trapping at ground level the smog from local metal factories.

名稱
Pew Prospectus 2008

客戶
The Pew Charitable Trusts

設計公司
IridiumGroup

編輯
Marshall A. Ledger

助理編輯／企畫
Sandra Salmans

此為非營利組織的刊物，版面雖然中規中矩，卻不失雅緻。

變化能為設計增添層次，因此在設計開頭介紹的文字時若能更有彈性，增強頁面對比，也是個好點子。此外，讓標題說明文字的字型有別於其他主要內文的字型，也能增添特色。

First spread (pages 22–23)

22

Pew Prospectus 2008
Culture

23

Culture

Change was sweeping the arts scene in 1948, with an impact that would not be fully realized for years. American painters led the way into abstract expressionism, reshaping both the visual arts and this country's influence on the art world.

Meanwhile, technology was setting the stage for revolutions in music and photography. The LP record made its debut, and the Fender electric guitar, which would define the rock 'n roll sound in the next decade and thereafter, went into mass production. Both the Polaroid Land camera, the world's first successful instant camera, and the first Nikon went on sale.

In New York, the not-for-profit Experimental Theatre, Inc., received a special Tony honoring its path-breaking work with artists such as Lee Strasberg and Bertolt Brecht. But in April it was disclosed that the theatre had run up a deficit of $20,000—a shocking amount, given that $5,000 had been the maximum allocated for each play—and in October The New York Times headlined, "ET Shelves Plans for Coming Year."

Apart from its miniscule budget, there is nothing dated about the travails of the Experimental Theatre. The arts still struggle with cost containment and tight funds. But if the Experimental Theatre were to open its doors today, it might benefit from the power of knowledge now available to many nonprofit arts organizations in Pennsylvania, Maryland and California—and, eventually, to those in other states as well. Technology, which would transform music and photography through inventions in 1948, is providing an important tool to groups that are seeking to streamline a grant application process that, in the past, has been all too onerous.

That tool is the Cultural Data Project, a Web-based data collection system that aggregates information about revenues, employment, volunteers, attendance, fund-raising and other areas input by cultural organizations. On a larger scale, the system also provides a picture of the assets, impact and needs of the cultural sector in a region.

The project was originally launched in Pennsylvania in 2004, the brainchild of a unique collaboration among public and private funders, including the Greater Philadelphia Cultural Alliance, the Greater Pittsburgh Arts Council, The Heinz Endowments, the Pennsylvania Council on the Arts, Pew, The Pittsburgh Foundation and the William Penn Foundation. Until then, applicants to these funding organizations had been required to provide similar information in different formats and on multiple occasions. Thanks to the Pennsylvania Cultural Data Project, hundreds of nonprofit arts and cultural organizations throughout the state can today update their information just once a year and, with the click of a computer mouse, submit it as part of their grant applications. Other foundations, such as the Philadelphia Cultural Fund, the Pennsylvania Historical and Museum Commission and the Independence Foundation, have also adopted the system.

So successful has the project been that numerous states are clamoring to adopt it. In June, with funding from multiple sources, Maryland rolled out its own in-state Cultural Data Project. The California Cultural Data Project, more than five times the size of Pennsylvania's with potentially 5,000 nonprofit cultural organizations, went online at the start of 2008, thanks to the support of more than 20 donors. Both projects are administered by Pew.

As cultural organizations in other states enter their own data, the research will become exponentially more valuable. Communities will be able to compare the effects of different approaches to supporting the arts from state to state and city to city. And the data will give cultural leaders the ability to make a fact-based case that a lively arts scene enriches a community economically as well as socially.

The Cultural Data Project is not the first initiative funded by Pew's Culture portfolio to go national or to benefit from state-of-the-art technology. For example, the system used by Philly-FunGuide, the first comprehensive, up-to-date Web calendar of the region's arts and culture events, has been successfully licensed to other cities.

In addition to the Cultural Data Project, another core effort within Pew's Culture portfolio is the Philadelphia Center for Arts and Heritage and its programs, which include Dance Advance, the Heritage Philadelphia Program, the Pew Fellowships in the Arts, the Philadelphia Exhibitions Initiative, the Philadelphia Music Project and the Philadelphia Theatre Initiative. Since the inception of the first program in 1989, these six initiatives have supported a combined total of more than 1,100 projects and provided more than $48 million in funding for the Philadelphia region's arts and heritage institutions and artists.

Through its fellowships, Pew nurtures individual artists working in a variety of performing, visual and literary disciplines, enabling them to explore new creative frontiers that the marketplace is not likely to support. The center also houses the Philadelphia Cultural Management Initiative, which helps cultural groups strengthen their organizational and financial management practices.

Almost from the time it was established, Pew was among the region's largest supporters of arts and culture. While it continues in this role, committed to fostering nonprofit groups' artistic excellence and economic stability, and to expanding public participation, Pew—like the arts themselves—has changed its approach with the times.

Marian A. Godfrey
Managing Director
Culture and Civic Initiatives

Second spread (pages 98–99)

98

Pew Prospectus 2008 MILESTONES 2007

99

2007 Milestones

Each year, we join with excellent organizations to produce work that exemplifies exactly what we mean in stating that Pew serves the public interest. On these pages, we highlight the results of some of the Pew-supported work that made a difference in 2007.

Environment

Health and Human Services

Pew Center on the States

25. 改變大小

改變照片和圖片的大小，能為內容增色不少、加分許多。若所有元素都大小一樣，頁面會很清楚，但也會極度無趣。若是可以有大小不一的變化，就會改善許多。

名稱
Martha Stewart Living

客戶
Martha Stewart Omnimedia

設計公司
Martha Stewart Living

創意總監
Gael Towey

清楚的步驟說明圖和完成圖，是放在格式固定卻有彈性的版面上。

Handbook How-Tos

HOW TO
WASH, DRY, AND STORE LETTUCE

1. Fill a clean basin or a large bowl with cold water, and submerge the lettuce leaves completely. (For head lettuce, first discard the outer leaves; they're most likely to harbor bacteria. Chop off the end, and separate the remaining leaves.) Swish the leaves around to loosen dirt.

2. Once sediment has settled, lift out the lettuce, pour out the dirty water, and re-fill the bowl with clean water. Submerge the lettuce again, and continue swishing and refilling until there are no more traces of dirt or sand in the bowl. You may need to change the water 2 or 3 times.

3. Dry the lettuce in a salad spinner until no more water collects at the bottom of the bowl. Alternatively, blot the leaves between layered paper towels or clean dish towels until no water remains.

4. If you plan to store the lettuce, arrange the dry leaves in a single layer on paper towels or clean dish towels, roll up, and seal inside a plastic bag. Lettuce can be stored this way in the refrigerator for 3 to 5 days. To prevent it from browning rapidly, don't tear the leaves into smaller pieces until you're ready to use them.

SOAK AND SPIN THE LEAVES

STORE IN A TOWEL

HOW TO
IRON A BUTTON-FRONT SHIRT

For easier ironing and the best results, start with a thoroughly damp shirt. Mist the shirt with water using a spray bottle, roll it up, and keep it in a plastic bag for 15 minutes or up to a few hours. (If you can't iron the shirt sooner, refrigerate it in the bag so the shirt won't acquire a sour smell.) Most of the ironing will be on the wide end of the board. If you're right-handed, position the wide end to your left; if you're left-handed, it should be on your right.

1. Begin with the underside of the collar. Iron, gently pulling and stretching the fabric to prevent puckering. Turn the shirt over, and repeat on the other side of collar. Fold the collar along seam. Lightly press.

2. Iron the inside of the cuffs; slip a towel under the buttons to cushion them as you work. Iron the inside of the plackets and the lower inside portion of the sleeves, right above the cuffs. Iron the outside of the cuffs.

3. Drape the upper quarter of the shirt over the wide end of the board, with the collar pointing toward the narrow end of the board, and iron one half of the yoke. Reposition, and iron the other half.

4. Lay 1 sleeve flat on the board. Iron from shoulder to cuff. (If you don't want to crease the sleeve, use a sleeve board.) Turn the sleeve over, and iron the other side. Repeat with the other sleeve.

5. Drape the yoke over the wide end of the board, with the collar facing the wide end, and iron the back of the shirt.

6. Drape the left side of the front of the shirt over the board, with the collar pointing toward the wide end; iron. Repeat with the right front side, ironing around, rather than over, buttons. Let the shirt hang in a well-ventilated area until it's completely cool and dry, about 30 minutes, before hanging it in the closet.

62

清楚呈現內容或步驟的一個方法，便是加上圖解，以及食譜或手作物的完成照片。圖片會很有幫助，而且大小不一的尺寸能避免頁面看起來死氣沉沉。

下頁右圖：此例的文字編排有其功能性，而且著重細節，整體頁面呈現細緻又不會精美到難以親近。BOX內的補充訊息，引導讀者注意食譜以外的重要訊息。

SAUTÉED SOLE WITH LEMON
SERVES 2

Gray sole is a delicately flavored white fish. You can substitute flounder, turbot, or another type of sole.

- ½ cup flour, preferably Wondra
- 1 teaspoon coarse salt
- ½ teaspoon freshly ground pepper
- 2 gray sole fillets (6 ounces each)
- 2 tablespoons unsalted butter
- 2 tablespoons olive oil
- 2 tablespoons sliced almonds
- 1½ tablespoons chopped fresh parsley
 Finely chopped zest and juice from 1 lemon, plus wedges for garnish

1. Combine flour, salt, and pepper in a shallow bowl. Dredge fish fillets in flour mixture, coating both sides, and shake off excess.

2. Melt butter with oil in a sauté pan over medium-high heat. When butter begins to foam, add fillets. Cook until golden brown, 2 to 3 minutes per side. Transfer each fillet to a serving plate.

3. Add almonds, parsley, zest, and 2 tablespoons juice to pan. Spoon over fillets, and serve with lemon wedges.

HARICOTS VERTS
SERVES 2

- Coarse salt, to taste
- 8 ounces haricots verts
- 2 tablespoons extra-virgin olive oil
 Freshly ground pepper, to taste
- 1 bunch chives, for bundling (optional)

1. Bring a pot of salted water to a boil. Add haricots verts, and cook until bright green and just tender, 3 to 5 minutes. Drain, and pat dry. Transfer to a serving bowl.

2. Toss with oil, salt, and pepper. Tie into bundles using chives.

HOW TO BUNDLE GREEN BEANS
..

1. Cook haricots verts. Drain, and pat dry. Let stand until cool enough to handle.

2. Lay a chive on a work surface. Arrange 4 to 10 haricots verts in a small pile on top of chive. Carefully tie chive around bundle. Trim ends of chive if desired.

QUICK-COOKING CLASSIC Seared sole fillets glisten beneath a last-minute pan sauce made with lemon, parsley, and almonds. The resulting entrée, served with blanched haricots verts, is satisfyingly quick yet sophisticated.

26. 從直而細出發

維持頁面或螢幕頁面乾淨、有條理是極為重要，但不斷重複相同元素、一成不變，會讓讀者無聊，感到不耐，這點也同樣要避免。讓

文字跟著圖形走，可以避免陷入這種困境。變化有助於突顯主要內文，而非弱化。

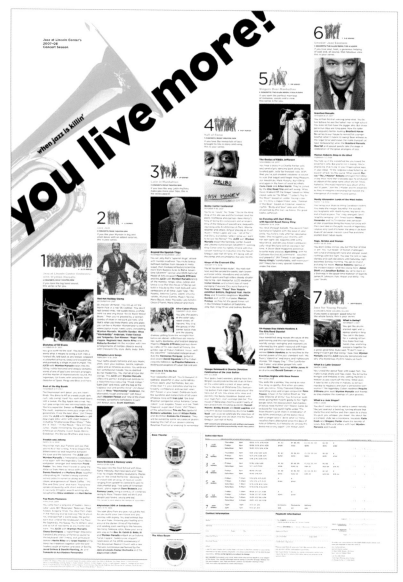

名稱

Program schedule

客戶

Jazz at Lincoln Center

設計公司

Bobby C. Martin Jr.

透過大膽的編排設計，大量訊息也顯得生動活潑起來。

此版面涵蓋了非常大量的訊息。欄位順著小號形狀設計，令人十分驚艷，為本身就已很吸引人又活潑的一覽表更添生氣。而文字編排上，時程表可說是具備平衡感、節奏和功力的精采設計。

多欄位的格線可以為box提供清楚的架構，讓box在頁面上扮演多樣角色。這裡的box放入了內文訊息，而且把box壓在在照片上，營造出另一種展演訊息空間的層次感，此外，這些box也編排得很有節奏感，佈滿在整個頁面上。

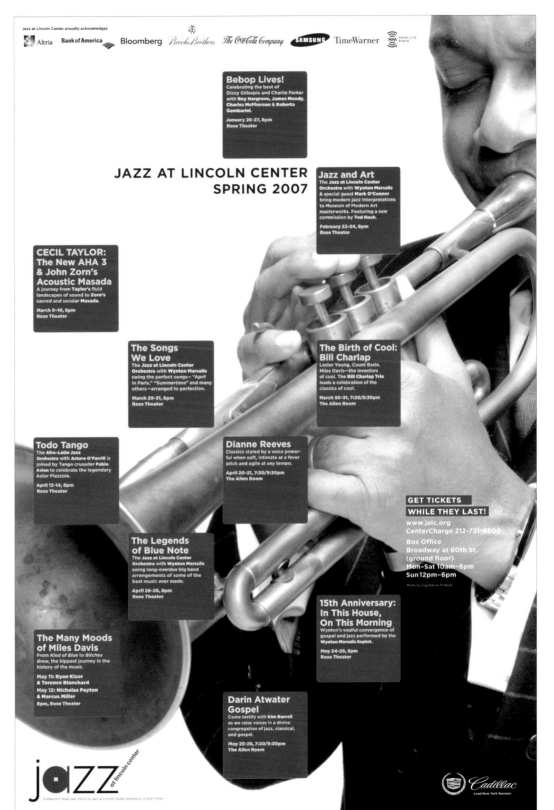

27. 混搭呈現

字的粗細、大小、質感、形狀、規模、空間、顏色等,這些在設計時都可結合起來,使頁面看起來活力十足、變化多樣又不雜亂。不妨選一種穩固的格線設計做為基礎,除了可以排入許多圖片和標題以外,還可有空間再加一兩張圖片或標題。字型的粗細大小、圖片大小和形體的動態感,能吸引讀者目光,卻又不致犧牲文字的可讀性。

此雜誌頁面大膽使用五欄的格線,不但框出了頁面的架構,並得以放入各種形狀、大小不同的文字與圖片。頁面架構在圖片四周留白空間的襯托下顯得十分穩固。

名稱
Metropolis magazine

客戶
Metropolis magazine

創意指導
Criswell Lappin

整齊的格線設計能讓在地作品展露光彩。頁面下方是選用穩固的多欄式格線,為版面上各種大小、粗細和顏色的編排提供一個穩定的基礎。

儘管排版上只有黑色外加幾個顏色,但透過使用粗體、如模版印出的字型,搭配較小字型和粗細變化,能增添質感。而粗細不同的直線也讓頁面更有設計感。

下頁右圖:直線線條加在每張椅子去背圖片的底端。

Page 1 (top left)

REGIONAL CRAFTS HOUSEWARES + ARCHITECTURE NORTH CAROLINA

By
BELINDA
LANKS

HANDMADE HOME

A crafts group enlists local artisans to create a one-of-a-kind dwelling.

AKIRA SATAKE

CERAMICS

Satake produces functional ceramic pieces—from vases, platters, and bowls to decorative tiles—with a refined Japanese aesthetic.

FATIE ATKINSON

FURNITURE

Employing a steam-bending technique, Atkinson can make this chair out of any open-pored wood, including hickory, ash, and white or red oak (shown).

BARBARA ZARETSKY

TEXTILES

Zaretsky creates earth-toned patterns using natural fibers, plant dyes, and textile paints.

HandMade in America has been fervently promoting craft in Western North Carolina since 1993, but this year marks the nonprofit's first foray into real estate. In a novel collaboration, the group has partnered with private developer Biltmore Farms to construct the HandMade

Home, a 3,700-square-foot model in Asheville showcasing the work of 100 local craftspeople. The house, which broke ground last September, is expected to meet the green-building standards of North Carolina's Healthy Built Homes program and fetch $2.25 million when it makes its debut

in October as part of the city's annual "Parade of Homes."

Founding executive director Becky Anderson hopes the project will spur other developers, architects, and homeowners to tap the region's greatest resource: the 4,500 resident artisans making everything from furniture and

lighting fixtures to tableware and rugs (examples shown above).

"We want to become the center of handcrafted homes," she says. To make it easy, HandMade in America has produced directories featuring the work of and contact information for the craftspeople in its network. But Ben

Brown, the project's publicist, recommends that people considering such an undertaking think smaller. "This is the first project of its kind, and it will probably be the last," Brown says. "With one hundred independent-minded artists involved, people are ready to shoot each other." ○

Page 2 (top right)

PEWABIC

The designer for Brookside School at Cranbrook (top) in Bloomfield Hills, and Detroit's Comerica Park stadium (above) were custom-made by the pottery's in-house team.

MOTAWI

The Frank Lloyd Wright Collection includes Avery (left) and Cornetti (below). Also shown: Waitrose (above) and amaryllis (right), an adaptation of a Louis Sullivan design.

DAVID ELLISON

Sold by Country Floors, the Apollo Plaque (above) is a reinterpretation of historic details found on buildings in New York's Flatiron District.

Eastern Michigan is home to one of the most active crafts movements in the country.

REGIONAL CRAFTS TILE MICHIGAN

By
EVA
HAGBERG

MOTOR CITY GLAZE

"We'd start doing these tile shows that were just tile, and we'd think, How could anyone make a living at this?" says Marcia Hovland, part of a loose-knit group of Michigan-based tile-makers, reminiscing about the good old days before the tile industry took off. "And now

everyone is doing really well." Hovland is one of the artisans who came up through Detroit's famed Pewabic Pottery—a tile factory, exhibition space, and educational facility. She studied there with David Ellison—a name that comes up again and again in conversation with these eastern-

Michigan tile fiends—and realized that she could turn her painting and design background into a whole new bag of (ceramic) chips.

Karin Motawi runs Motawi Tileworks out of Ann Arbor with his sister, Nawal. The company makes historically influenced pottery in line with the types of

things that were produced in the earliest days of Pewabic in the 1900s. "We're literally plowing through the history books and the source books, the old catalogs," he says. "We're trying to re-create the lost craft." As the official Frank Lloyd Wright licensee, it's reproducing just fine.

Motawi Tileworks operates on a relatively tiny scale—it produces 18,000 square feet of tile a year, a drop in the bucket—and so do many of its local cohorts, which is why they're so happy to know Joseph Taylor, president of the Tile Heritage Foundation, which works to raise the historic craft's profile. "They are like tile cheerleaders," Motawi says. ○

Page 3 (bottom left)

REGIONAL CRAFTS SEATING NEW YORK

BROOKLYN'S OWN

BROOKLYN

A crafty, DIY-inspired furniture movement emerges in New York's most creatively vibrant borough.

ELUCIDESIGN

DANISH CHAIR

Inspired by the Scandinavian classics, this Chris Jambs–designed piece is made of maple and uses a hand-silkscreened towel for the back and seat.

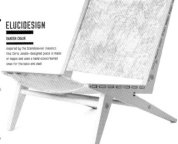

WÖD

WÖD CHAIR

The dining-room chair designed by Corey Springer and Eric Ervie in 2006, comes in a variety of woods, including cherry (shown), walnut, and maple.

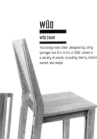

UHURU DESIGN

DR METAL ARMCHAIR

Designed by Jason Horvath, this lounge chair consists of a one-inch-by-two-inch steel frame and upholstered cushions available in custom colors and patterns.

Far from the maddening crowds of the contemporary-furniture scene, a small group of intrepid designers is sprouting like trees in Brooklyn. Aesthetically, they're all over the map. Scrapile (from Greenpoint) is known for the pun it's named after: a scrap pile of locally sourced wood that designers Bart Bettencourt and Carlos Salgado turn into a building material; each block incorporates everything from walnut to ply-

wood and is then processed through a labor-intensive layering method. Uhuru, founded by Bill Hilgendorf and Jason Horvath, offers a line of sleek, multimaterial pieces, all of which, if viewed through a larger lens, are just as sustainable.

These firms got started about four years ago, and they join the older guard Elucidesign, founded in 2001, and City Joinery, which set up shop in 1995. Elucidesign's

Redpoint collection is a beautifully spare series of pared-down pieces; City Joinery's range and look is broader and heavier.

These firms may not share a look, but they do share a sensibility shaped by their size, scale, and voluntary outsider status in

the design world. "We're in this straddling position," City Joinery's Jonah Zuckerman says. "We care a lot about design, but we also care a lot about craft." Horvath brings up a similar tension: "We don't want to be this big furniture company that does

production overseas, but we don't want to be just building furniture in Red Hook." He shouldn't worry too much. His company and his compatriots are part of a new phenomenon—the rise of the artisan designer, Brooklyn division. ○

Page 4 (bottom right)

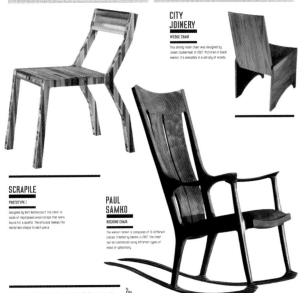

CITY JOINERY

WEDGE CHAIR

This dining-room chair was designed by Jonah Zuckerman in 2007. Pictured in black walnut, it's available in a variety of woods.

SCRAPILE

PROTOTYPE I

Designed by Bart Bettencourt, the chair is made of repurposed wood storage that were bound for a landfill. The process makes the materials unique to each piece.

PAUL SAMKO

ROCKING CHAIR

The walnut rocker is composed of 15 different pieces. Created by Samko in 2007, the chair can be customized using different types of wood or upholstery.

By
EVA
HAGBERG

28. 控制各種元素

以研究報告的版面來看,多欄式格線設計非常適合編排大量各種事實陳述的元素。只要詳盡規劃,便能將內容以多種方式分類。結合欄位、直線、不同大小的字體、字型及顏色等,能有效編排這類專業性內容。

粗的橫條是以黑色直線加粗加寬,這裡頭涵蓋標題、作者、地點與logo。標題下方的橫條有時會中斷,是為了讓每個欄位之間還各有一點空隙。

名稱
Poster

客戶
NYU Medical Center

設計公司
Carapellucci Design

設計者
Janice Carapellucci

這份紐約大學醫學中心的文宣編排是清楚處理內容層次關係很好的範例。事實的陳述和研究發現皆十分容易閱讀。每種訊息都確實區分,行距和各元素間的空間比例都完美又適合閱讀。雖然訊息非常多,但每個段落還是容易閱讀,即使讀者並非專業醫生也讀得下去。

字體大小與行距的變化,區別出研究資料與結論部分。圖說是以形成對比的黑體編排,可簡要重述事實。縱向直線區隔欄位中各段主文內容,讓版面更清楚易讀。

Evaluation of the Abdomi
Branches Using an Intrav
in the Inferior Vena Cava

Background

Ultrasound evaluation of the abdo-minal aorta and its branches is usually performed transabdominally. Not infrequently, the image quality is suboptimal. Recently, an intra-cardiac echocardiography (ICE) probe has become commercially available (Acuson, Mountain View CA, Figure 1). These probes are usually inserted intravenously (IV) and advanced to the right heart for diagnostic and monitoring purposes during procedures such as ASD closure and pulmonary vein isola-tion (Figure 2). Because of the close anatomic relation between the abdominal aorta (AA) and the inferior vena cava (IVC), we hypo-thesized that these probes would be useful in the evaluation of the AA and its branches.

Figure 2: The ICE probe is plac
heart for imaging during PFO c
pulmonary vein isolation.

The ICE probe can be a
into the inferior vena ca
enabling high quality im
the abdominal aorta (Fi

Figure 3: The position of the IC
IVC allows for excellent image
Doppler flow interrogation of t
aorta and its branches (renal a
celiac axis) and the diagnosis
such as renal artery stenosis a
aortic aneurysm.

Figure 1: ICE probe (AcuNav, Acuson)

·ta and its ·Echo Probe

Carol L. Chen, MD
Paul A. Tunick, MD
Lawrence Chinitz, MD

Neil Bernstein, MD
Douglas Holmes, MD
Itzhak Kronzon, MD

*New York
University
School of
Medicine
New York, NY
USA*

NYU Medical Center

Methods

Fourteen pts who were undergoing a pulmonary vein isolation procedure participated in the study. In each pt, the ICE probe was inserted in the femoral vein and advanced to the right atrium for the evaluation of the left atrium and the pulmonary veins during the procedure. At the end of the procedure, the probe was withdrawn into the IVC.

Results

High resolution images of the AA from the diaphragm to the AA bifurcation were easily obtained in all pts. These images allowed for the evaluation of AA size, shape, and abnormal findings, such as atherosclerotic plaques (2 pts) and a 3.2 cm AA aneurysm (1 pt). Both renal arteries were easily visualized in each pt. With the probe in the IVC, both renal arteries are parallel to the imaging plane (Figure 4), and therefore accurate measurement of renal blood flow velocity and individual renal blood flow were possible.

Figure 4: Two-dimensional image with color Doppler, of the abdominal aorta at the level of the right (Rt) and left (Lt) renal ostia. Note visualization of the laminar renal blood flow in the right renal artery, toward the transducer (red) and the left renal artery, away from the transducer (blue).

Calculation of renal blood flow:
The renal blood flow in each artery can be calculated using the cross-sectional area of the artery ($\pi r2$) multiplied by the velocity time integral (VTI, in cm) from the Doppler velocity tracing, multiplied by the heart rate (82 BPM in the example shown).

Figure 5

Figure 6: Pulsed Doppler of the right renal artery blood flow. The diameter of the right renal artery was 0.65 cm, and the VTI of the right renal blood flow was 0.19 meters (19 cm). Therefore the right renal blood flow was calculated as 516 cc/minute.

Figure 7: Pulsed Doppler of the left renal artery blood flow. The diameter of the left renal artery was 0.51 cm, and the VTI of the left renal blood flow was 0.2 meters (20 cm). Therefore the left renal blood flow was calculated as 334 cc/minute.

The total renal blood flow (right plus left) in this patient was therefore 850 cc/min. (average normal = 1200 cc/min.)

Conclusions

High resolution ultrasound images of the AA and the renal arteries are obtainable using ICE in the IVC. The branches of the abdominal aorta can be visualized and their blood flow calculated. Renal blood flow may be calculated for each kidney using this method. This may prove to be the imaging technique of choice for intra-aortic interventions such as angioplasty of the renal arteries for renal artery stenosis, fenestration of dissecting aneurysm intimal flaps, and endovascular stenting for AA aneurysm.

29. 翻譯確實，清楚最重要

步驟說明絕對要清楚明確。即便讀者看不懂內文所使用的語言，也能因清楚的排版方式照著做。藉由諸多標號的步驟和圖片，頁面清楚而不混淆。拍攝內容的選擇，以及讓照片清楚呈現，整體頁面就會看起來讓人愉悅、很容易閱讀。

名稱

Kurashi no techo (Everyday Notebook) magazine

客戶

Kurashi no techo (Everyday Notebook) magazine

設計者

Shuzo Hayashi, Masaaki Kuroyanagi

這篇教人手作的文章，結合西方的圖像——查理布朗和午餐袋，與東方的直排走文。

PEANUTS © United Feature Syndicate, Inc.

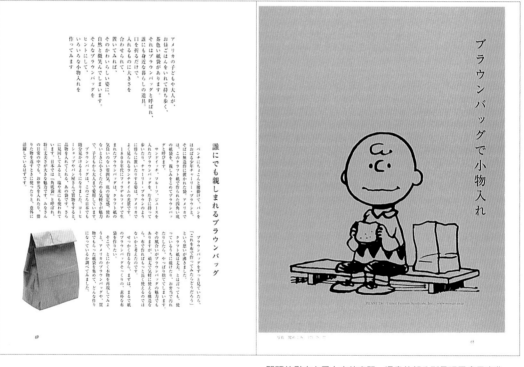

開頭的引文占了上方的空間。漫畫的部分則呈現了多元文化。

虛線框出的box，讓各個箭頭指示的內容可以有所區隔。頁面上的每個部份，都清楚位在明確劃分的格線內。

數字清楚標示出過程中的每個步驟，另外還以圓框的小型數字標示出分解動作。每個元素都安排得井然有序，並搭配清楚圖示，讓喜歡手作的人，即使不懂該語言，也能完成作品。各步驟之間的空間和相對大小，連同精美的照片，讓繁複的步驟看起來沒那麼嚇人。

布のブラウンバッグを考案しました

ブラウンバッグを手にとって観察するうちに、特徴が見えてきました。この魅力を布で生かすために、布製のブラウンバッグを考案しました。どんな工夫が必要だろう。紙袋らしさを素朴に作るのも、使うのもとても気軽な布製のブラウンバッグを、何度も何度も試作を重ね、考案しました。作り方を合わせてここに紹介します。

再現したい、紙袋の魅力は何だろう？

●素材感と自立すること
紙袋の魅力は、クラフト紙特有の風合い。また、紙が一度折れば折り目がつきます。なにより、底が安定し、自立するのが魅力です

●開くと一枚の長方形
分解してみると、日本製は袋底の角、アメリカ製は真ん中でのり付けされていました。底の貼り方にいくつか種類がありましたが、どちらも、開くと一枚の長方形です

●とても丈夫なバッグが出来る
たいていのものは、紙よりも丈夫につくれます。ハリもあります。その問題を解消してくれる生地が防水キャンバス地です。自立することも、丈夫なバッグになりました

●型紙は必要ありません
開いた紙がそのまま型紙として使えるので、タテ、ヨコ、マチの寸法を測って、身近に取られず、すぐに作れます。製図の手間がかからず、サイズ変更も簡単です（→74型紙）

●縫うのも二カ所、簡単です
縫うのも二カ所、そのまま型紙として使えるので、タテ、ヨコ、マチの寸法を測って、たった二同縫うだけです。この分だけの作りで30分ほど。裁縫が苦手

●のり付けが二カ所
のり付けが二カ所、ブラウンバッグは手で開くと二カ所、布をパタパタ折りながら、ヨコの二カ所ののり付けされているだけ。この分だけののり付け分を縫い合わせて作るときにも楽になりそうです。という人にもおすすめです。

そんな、便利なバッグの作り方をお教えします ←

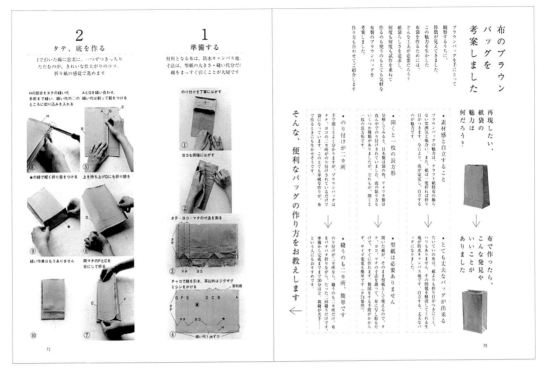

70

1 準備する

材料となる布は、防水キャンバス地。寸法は、型紙の大きさ・縫い代分だけ線をまっすぐ引くことが大切です

① のり付けを丁寧にはがす
② ヨコも同様にはがす
③ タテ・ヨコ・マチの寸法を測る　マチ
④ チャコで線を引き、耳以外はジグザグミシンをかける　耳利用
G F E　D C B　A
マチ ☆ ☆
縫い代1cmずつ　H

2 タテ、底を作る

1で引いた線に忠実に、一つずつきっちりたたむのが、きれいな仕上がりのコツ。折り紙の感覚で進めます

⑤ AとGを縫い合わせ、縫い代は割って節をつける
⑧ Hの部分をタテに縫い代手前まで縫い、縫い代の○のところに切り込みを入れる
⑨ ★の線で軽く折り目をつける
⑥ 上を持ち上げDにも折り節をつける
⑩ 縫い作業はもうありません
⑦ 両マチのFとCを谷にして折る

71

毎日使えるブラウンバッグ完成

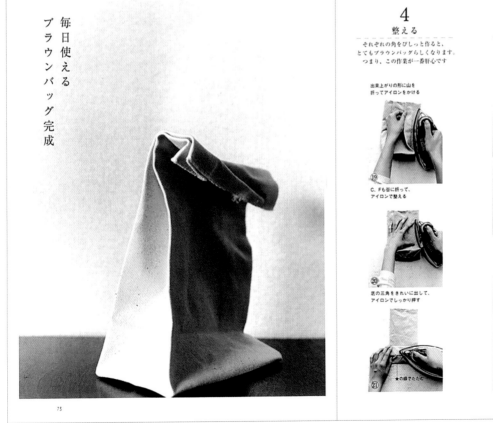

73

4 整える

それぞれの角をびしっと作ると、とてもブラウンバッグらしくなります。つまり、この作業が一番肝心です

⑲ 出来上がりの形に山を折ってアイロンをかける
⑳ C、Fも谷に折って、アイロンで整える
㉑ 底の三角をきれいに出して、アイロンでしっかり押す　★の線でたたむ

3 ひっくり返す

出来上がり間近です。3まででマチをしっかり作って一気にひっくり返します。少し力のいる作業です

⑪ 中に手を入れて
⑮ 左手で底をつかみ、右手で布を押し込んで
⑫ 手を側面にはわせ、裏まで入れて
⑯ 布を裏へ詰め込んでいく
⑬ マチ部分を確認したら　★の線が案内線
⑰ 左手は底をつかんだまま、右手で耳を引っ張る
⑭ 指でつまんで、マチと角をしっかり出す。反対も同様に
⑱ ひっくり返したら大まかに整える

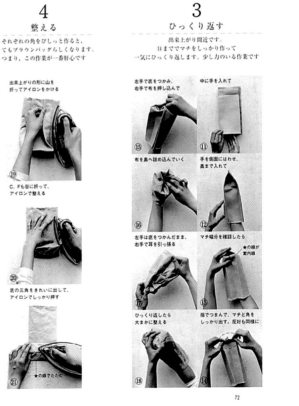

72

30. 網站設計要點

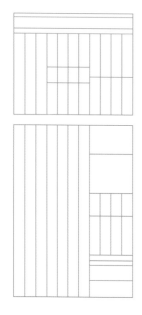

為了涵蓋大量訊息，大型網站會使用格線設計來編排。畫面上空間會被分割成數塊，以便於放入內容。首先須檢視所有條件限制，然後考慮螢幕邊界和工具列，如螢幕操作工具列與瀏覽器。就像平面印刷品一樣，網站設計會將所有會在這個空間裡的元素考慮進去。對許多網站來說，要考慮的部分包括廣告、影音，以及許多主標題、副標題、撰稿人姓名、列表和連結等一堆複雜的項目。這就是為什麼清晰的編排會十分重要的原因。

螢幕大小

使用者的螢幕大小各不相同，因此許多設計者會設定一個主要頁面，選定特定畫素的寬度與深度，以順應使用者在小螢幕的畫面讀取。儘管電腦螢幕近年來愈做愈大，但小型的平板電腦設備問世，又讓螢幕大小有了新的轉變。要設計出同時適合較大以及較小螢幕的網頁實屬困難，設計者常會使用標準尺寸，而主頁面的背景則選用單色或直接用白色。

名稱
nytimes.com

客戶
The New York Times

設計公司
The New York Times

設計指導
Khoi Vinh

此網站的設計以傳統清楚又美觀的版面來編排新聞訊息，並以一些細節部分、有襯線字型搭配無襯線字型的交相變化，以及用顏色標出報導重點和時間等，讓版面的設計感更為明顯。

簡明的結構提供了空間，容納操作欄位、報導、大小不同的圖片、廣告和影音。

紐約時報藝術設計總監Khoi Vinh認為，「單元是規劃格線設計的基礎單位」。「欄位可將類別分組整合，形塑頁面所呈現的結構。」他表示，單元最好是三或四的倍數，十二因同為兩者倍數，所以是最理想的數字。即便計算數據並不會顯示在頁面上，但卻提供網站版面穩固的基礎，讓各單元和欄位都可以有準確的規範。

一旦設計者將各類訊息整合成多個欄位，這時很重要的是，在文字左或右側設計額外空間或插頁，不管所放入的內容是圖片、還是僅有文字，或box內文字，都能讓頁面呈現整齊一致。

• Wed to Strangers, Vietnamese Wives Build Korean Lives

U.S. »
• Art and History Clash in San Francisco
• Mayor Seeks Job Switch, but Response Is Lukewarm
• In Boston, Residents Seek Face-to-Face Advice to Avoid Foreclosure

POLITICS »
• Political Memo: Iraqi Offensive Revives Debate in Campaigns
• Clinton Shouldn't Feel Forced to Quit Race, Obama Says
• Endorsement of Obama Points Up Clinton Obstacles

N.Y. / REGION »
• Fuller Picture Emerges of Paterson's Aid to Hospital That Employed His Wife
• 9/11 Lawyer Made Name in Lawsuit on Diet Pills
• City Subpoenas Creator of Text Messaging Code

SCIENCE »
• Not a Mercury or Saturn, but It Goes Way Off Road
• Ideas & Trends: Edison ...Wasn't He the Guy Who Invented Everything?
• G. David Low, 52, Astronaut and Aerospace Executive, Dies

HEALTH »
• Insure Me, Please: The Murky Politics of Mind-Body
• The World: The Drug Scare That Exposed a World of Hurt
• In Deep-Dish Pizza Land, a Thinner Blue Line

EDUCATION »
• A Different Kind of Student Exam
In Deep-Dish Pizza Land, a Thinner Blue Line

EDUCATION »
• A Different Kind of Student Exam
• Students of Virginity
• Harlem to Antarctica for Science, and Pupils

REAL ESTATE »
• That 6% Is Getting Harder to Earn
• Living in Turtle Bay: In the Many Enclaves, One Neighborhood
• Streetscapes | Willoughby Street, Brooklyn: One Owner, Two Markedly Different Designs

on Defaults
• Foreclosure Machine Thrives on Woes

TECHNOLOGY »
• Novelties: Coming Soon, to Any Flat Surface Near You
• Ping: Thinking Outside the Company's Box
• City Subpoenas Creator of Text Messaging Code

SPORTS »
• Midwest Region: Davidson Seeks Final Four and Savors Moment
• Women's Tournament: Moore Leads UConn into Regional Semis
• Women's Tournament: Elite Women Prove That A&M No Longer Stands for 'All Male'

TRAVEL »
• Pondicherry's French Connection
• Spring Break | San Francisco: Alleys for Cool Cats
• Twenty-Five Square Miles Surrounded by Reality

DINING & WINE »
• Food: The Way We Eat: Just Grate
• Home Work: The Joy of (Still) Cooking
• Ideas & Trends: Ode to an Onion Ring, and Other Fast Food in the Slower Lane

HOME & GARDEN »
• Dream Works
• Away: Guatemala as Muse and Base for a Writer
• Your Second Home | Outdoor Fireplaces: A Little Warmth, at a Cost

FASHION & STYLE »
• Sisters in Idiosyncrasy
• Vows: Lisa Sette and Peter Shikany, at a Cost

FASHION & STYLE »
• Sisters in Idiosyncrasy
• Vows: Lisa Sette and Peter Shikany
• Why Blog? Reason No. 92: Book Deal

AUTOMOBILES »
• Not a Mercury or Saturn, but It Goes Way Off Road
• Behind the Wheel | 2008 Scion Xd and Xb: Cars So Hip That It Hurts
• Motoring: Not All Odometers Are Created Equal

• Letters: When Parents Say No to Vaccines

ARTS »
• Art: The Topic Is Race; the Art Is Fearless
• A Veteran MAD Man Remains in the Fold
• Film: The Bold and the Bad and the Bumpy Nights

MOVIES »
• Film: The Bold and the Bad and the Bumpy Nights
• Tackling Directing and George Clooney
• Film: Another Red Balloon Alights in Paris

THEATER »
• Fancy Digs, Still Tricky Enough for Art
• Theater: From Page to Stage, Experienced Guides Showing the Way
• Theater Review | 'Juno': A Mother Whose Life Song Is About Tenement Nightmares, Not Broadway Dreams

BOOKS »
• 'The Appeal,' by John Grisham: Uncivil Action
• 'The Stone Gods,' by Jeanette Winterson: She, Robot
• 'Elegy: Poems,' by Mary Jo Bang: In Memoriam

WEEK IN REVIEW »
• Bad Dreams: Alley Fighters
• Insure Me, Please: The Murky Politics of Mind-Body
• The World: The Drug Scare That Exposed a World of Hurt

MAGAZINE »
• A Case of the Blues
• Students of Virginity
• Changing the Rules of the Games

MAGAZINE »
• A Case of the Blues
• Students of Virginity
• Changing the Rules of the Games

T MAGAZINE »
• Short Film | Episode 10 Starring Josh Lucas
• Magazine Food | Cheese on Seafood Pasta
• Perfume Review | Diesel's Big Bang

3. Frank Rich: Hillary's St. Patrick's Day Massacre
4. 36 Hours in Berkeley, Calif.
5. Nicholas D. Kristof: 'With a Few More Brains ...'
6. Asking a Judge to Save the World, and Maybe a Whole Lot More
7. Maureen Dowd: Surrender Already, Dorothy
8. Spring Break | San Francisco: Alleys for Cool Cats
9. Students of Virginity
10. Dith Pran, 'Killing Fields' Photographer, Dies at 65

Go to Complete List »

Blogs
Cartoons / Humor
Classifieds
College
Corrections
Crossword / Games
Learning Network
NYC Guide
Obituaries

On This Day
Personals
Podcasts
Public Editor
Sunday Magazine
T Magazine
Video
Weather
Week in Review

ABOUT US
About the NYT Co.
Jobs at the NYT Co.
Online Media Kit

SERVICES
Theater Tickets
NYT Store
NYT Mobile

HELP

NYTIMES.COM
Your Profile
E-Mail Preferences
Purchase History

NEWSPAPER
Get Home Delivery
Customer Care
Electronic Edition
Community Affairs

SERVICES
Theater Tickets
NYT Store
NYT Mobile

HELP
Site Help
Privacy Policy

NEWSPAPER
Get Home Delivery
Customer Care
Electronic Edition
Community Affairs
Events

Add New York Times headlines to your site
Add New York Times RSS Feeds 🔲 RSS

Get home delivery of The New York Times, as little as $3.25 a week.

31. 分門別類

有時候內容會交叉出現在圖表和單元裡。若內文較為複雜,則要顧慮到清晰度、可讀性、空間使用和變化度。將複雜內文拆成幾塊明確的段落,就能讓版面安排較為清楚。

可使用單元式格線的情況包括:

· 有太多獨立的段落,不太需要或不太可能全部一起閱讀。
· 想將所有內容都放進差不多大小的空間。
· 想呈現一致(或接近一致)的版型。
· 各類文字以數字編號或以日期開頭,且內容量大致相同。

將內文分類也須考慮搭配符合內容的排版設計。對於解釋性的內文,變換字體大小和粗細有助於讓版面清楚易懂。就像在其他原則中所提到的,有限度地變換字型,能讓內文易懂又不至於無趣,新奇又不至於毫無頭緒。

下頁右圖:在這些條列的小祕訣中,每項周圍都留有相當的空白,而文字多寡則決定了box大小。每條粗線能分隔各項祕訣,又不至於干擾到box內容的文字敘述,結果形成了一個個補充欄,裡頭放入許多說明內容。

不論是哪種語言,符號都有標示標題、提醒注意的功用,而字體大小粗細也會顯示出文字的閱讀順序。

就數字編號來說,正如同字體大小和粗細能讓版面看起來有變化,阿拉伯數字和日文漢字是可以增添頁面變化,讓有用或甚至不太常見的訊息,比較平易近人。祕訣七的翻譯是「天氣愈來愈乾。從外面回到家,記得先漱漱口。先在洗臉槽旁放個玻璃杯會很方便。」

名稱

Kurashi no techo (Everyday Notebook) magazine

客戶

Kurashi no techo (Everyday Notebook) magazine

設計者

Shuzo Hayashi, Masaaki Kuroyanagi

這是一本教讀者動手做的雜誌,其特色之一,是以低調的方式條列居家生活的小祕訣。

●暮らしのヒント集

今日はなにを

ここにならんでいるいくつかのヒントのなかで、ふと目についた項目を読んでみてください。たぶん、ああそうだったということになるでしょう

1 テーブルにコップを置くときは、静かに置くことを心がけましょう。やさしいしぐさが気持ちをやわらげます。

2 組み立て式の椅子やテーブルのネジは、意外とゆるんでいるものです。締めなおしておきましょう。

3 暮らしには笑顔が大事です。いろいろあっても、にっこり笑顔を忘れずに。

4 一年使った枕を新しいものに替えてみましょう。新しい気持ちで眠りにつけるでしょう。

5 今日こそゆるんだ水道のパッキンを取替えましょう。家中の蛇口をチェックします。

6 毎日の暮らしのなかで見て見ぬふりはやめましょう。そういう癖を身につけてはいけません。

7 空気が乾燥してきます。外から帰ったらすぐにうがいができるように、洗面所のコップをきれいにしておきましょう。

8 朝、目が覚めたら、ベッドの中で今日一日、何をするかを考えます。することがたくさんあれば、うかうかしていられず、すぐ起きるでしょう。

9 どんなことでもまずはお金を使わずにできるお金を使わずにできることを考えてみましょう。それが工夫の一歩になります。

10 言いたいことを言った後は、笑顔で接することが大事です。険悪にならないように、まわりに気を使いましょう。

11 日曜日の朝、天気が良かったら、外でご飯にしませんか。ごく簡単なお弁当を近所の公園などで食べるのです。散歩もかねて気分も変わります。

12 風邪をひいて、お風呂に入れないときは、足だけでも洗って、温めましょう。さっぱりして気分がよくなります。

13 今日は一歩ゆずってみましょう。その一歩がそのまま新しい一歩を進めるちからになるものです。

14 裁縫箱を整理しましょう。さびた針やよれた糸は処分して、新しいものに取替えます。

15 今夜は粗食デーにしましょう。味噌汁にお漬物とか、ありあわせのおかずで間に合わせます。明日は今夜の分もごちそうにしましょう。

16 冷蔵庫が夏の設定になっていませんか。気温も下がったし、あけての回数も減ってきたので、あけての回数も減ってきたので、調節しておきます。

17 虫歯があったら、いますぐ治しておきましょう。年末年始のお医者さんが休みのときに痛くなったら大変です。

18 手紙ばさみを買ってみましょう。とても便利なので、毎日届く郵便をさっさと片づけられます。

19 今日は一日、お年寄りのお相手をつとめましょう。お茶を飲みながら、ゆっくりと昔話を聞いてあげたり、一緒に出かけたりします。

20 毎日を心地よく過ごすには、あまりに潔癖すぎてもいけません。よごれやけがれも受け入れてこそ暮らしがあるのです。人との関係も同様です。

21 きびしい肌寒さをおぼえる夜になりました。ことにお年寄りにはひざ掛けか、肩掛けを一枚、早めに用意してあげましょう。

22 しめきりの窓をあけて、敷居のゴミを払いましょう。アルミサッシの溝など、ほこりがつまっているものです。

23 洋服ダンスの防虫剤は大丈夫でしょうか。においはしていても、中身はもうなくなっていることが案外多いものです。

24 新しいチャレンジは自分で決めるものです。ひとに惑わされて後悔しないように。

25 ガス台の下やすきまを掃除しましょう。意外に汚れているものです。きれいになると気持ちよく料理ができるでしょう。

32. 留點喘息空間

不是所有的單元都要填滿。採用單元式格線能精準算出內容可增加的範圍，讓設計者得以規劃處理諸多細節。單元式格線可以在頁面上顯示出來，也可以隱藏起來。單元還可大可小。單元可以形成一個穩固的結構，放進字型、字母、顏色或裝飾花邊。除此之外，也可以讓這些單元完全留白，不加任何東西。

名稱
Restraint Font

客戶
Marian Bantjes

設計公司
Marian Bantjes, Ross Mills

手繪的文字編排讓數字的部分加添了數位化的感覺。

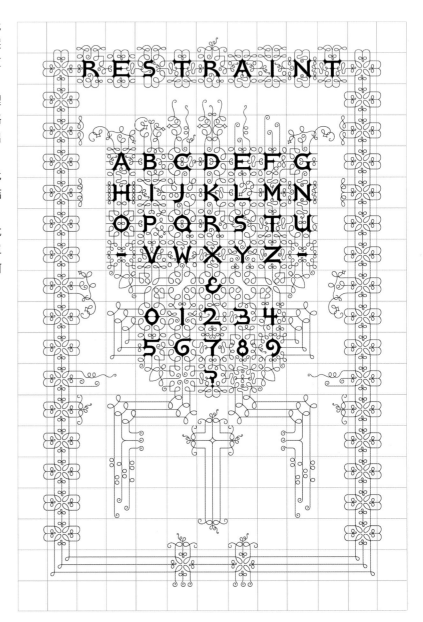

開章頁主要是用來放章節名或書名，而非內文。如果在開章頁用比較小的字體，就會特色盡失，變得不易閱讀。

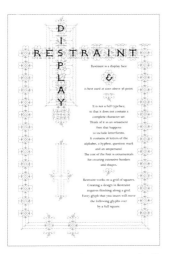

在頁面中央的單元放入內容,而讓周邊的單元留白,可讓外圍的空間變為一種邊框。

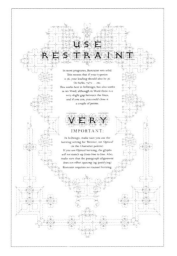

另一種做法是將單元做為邊框,留出中間的空間。不管是哪種方式,邊框可以使版面和諧一致,不會雜亂無章。

這份最終使用者認證條款的文字排版美觀大方,條款內容恰好也是使用Restraint字型。

RESTRAINTS

Font Software Product License
End-User License Agreement (EULA)
(page 1 of 2)

❋ PLEASE READ ❋
Some restrictions apply to the use of this software

The 'Restraint' typeface (Font Software) and designs contained therein is protected by copyright laws and international copyright treaties, as well as other intellectual property laws and treaties. The Font Software is licensed, not sold. This license is only valid when the licensee has been listed below and this agreement is signed by a representative of Tiro Typeworks. Please retain copies of this agreement.

Whereas 'Tiro Typeworks' is represented by one or both of the following individuals:
William Ross Mills of Galiano Island, British Columbia, Canada. DBA Tiro Typeworks and
John Hudson of Gabriola Island, British Columbia, Canada. DBA Tiro Typeworks

Subject to the foregoing, Tiro Typeworks grants (hereafter the 'licensee') :
M E Tondreau
611 Broadway
Room 511
New York, NY 10012
United States

a perpetual non-exclusive license to use the Restraint Font Software with the following terms and conditions:

1. ACCEPTANCE OF TERMS
Installation and use of this Font Software constitutes acceptanceof the terms of this licence agreement.

1.1 You acknowledge that the Font Software is the intellectual property of Tiro Typeworks and/or designers represented by Tiro Typeworks and contains copyrighted material authored by Tiro Typeworks and/or designers represented by Tiro Typeworks. The term Font Software shall also include any updates, upgrades, additions, modified versions, and development copies of the Font Software licensed to you by Tiro Typeworks. The media itself is and shall remain the property of Tiro Typeworks. Expanded versions, subsets or other derivatives of this design may also exist under other names and be distributed by Tiro Typeworks or other licensed Distributors.

2. GRANT OF LICENSE.
This document grants you the following rights:

2.1 INSTALLATION AND USE.
You may install and use the Font Software on up to five computer hard drives or other storage devices and up to two physical output devices (e.g. printers, imagesetters) based at one single geographical location stipulated by the licensee (laptops may be considered 'based' at a single location). The Font Software may not be used by more than five users on a network. Extended licenses may also be purchased, in which case a new license agreement will be drafted to reflect the new conditions.

For the sole purpose of data backup, additional backup copies of the Font Software may be made.

2.2 FAIR USE.
You may use the Font Software in most personal and commercial applications. However, under this license, you may not use the font software:

a) for the creation of logos or identities (including movie titles)

b) for the creation of signage or architectural details.

c) for the creation of advertising campaigns which includeoutdoor advertising (billboards, bus shelters, etc.) or television advertising, wherein the designs contained in the Font Software comprises the sole or major design element.

d) to manufacture products wherein the designs contained in the Font Software comprises the sole or major design element, including but not limited to T-shirts, jewellery, fridge magnets, greeting cards, ceramics, posters for sale, etc.

If you wish to use the Font Software for any of the above, please contact us at restraint@tiro.nu for additional licensing or royalty fees. If in doubt, ask.

2.3 MODIFICATION.
You are not allowed to without written approval granted by Tiro Typeworks:

a) modify and/or re-compile the Font Software: this includes generating or re-compiling the Font Software from any font design program. (where a 'font design' program is any piece of software capable of reading and re-compiling any standard font format),

b) adapt modules, produce sub-sets or supersets or alter any internal font data thereof for your own developments,

c) put the software solutions embodied in the Font Software to any commercial use other than operating your own computer(s) or output device(s), or

d) merge, ship or embed the Font Software with other software programs.

PLEASE CONTACT TIRO TYPEWORKS OR A LICENSED DISTRIBUTOR IF THERE ARE SPECIFIC MODIFICATIONS THAT YOU REQUIRE.
We acknowledge that no typeface can solve all problems and accept that some clients may wish to have modifications made to suit their particular needs. We would be happy to help with this and no one knows better the typefaces you are licensing, so please ask first.

33. 要理性

若將單元格線視為一種圖表形式，好像看起來會很複雜，但實則不然，而且每個單元也不一定要填滿。這要看有多少內容要放進版面，可以設計一個單元加上數個大型box，把圖片及重要的訊息，如目錄或其他索引訊息放入。

照片中呈現若干單元，搭配左下角單元式的Flor商標。

名稱
Flor Catalog

客戶
Flor

設計公司
The Valentine Group

如同這本型錄所展示的地板磁磚一樣，若要理性分隔空間，並將頁面加以劃分，以便編排為步驟型指南，那麼單元式格線是最完美的選擇。

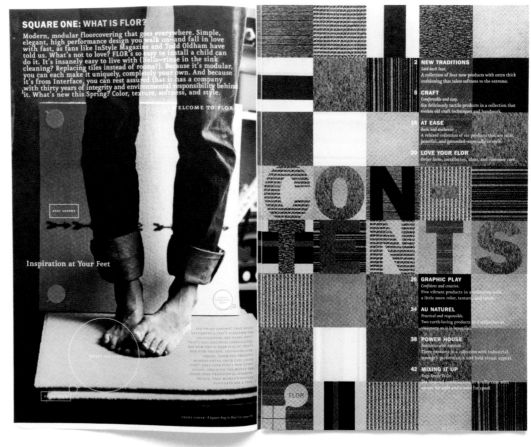

此目錄頁的頁面分割成一個個box，便於閱讀，也容易按顏色瀏覽。

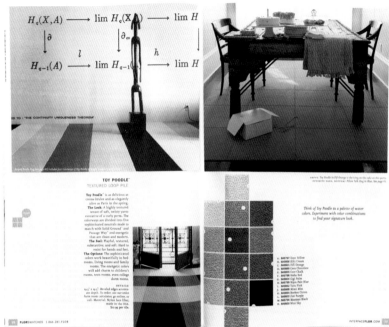

樣本色塊、拍攝技巧高超的藝術照片和留白的空間，三者互相輝映。

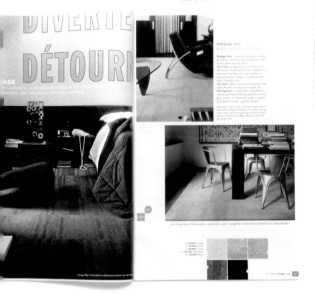

Flor的計算表基本上就是以單元構成的圖表。

ROOM FEET APPROX	7'	9'	11'	12'	13'	15'	17'	18'	20'	22'	23'	25'	27'
4'	12 TILES	16	19	21	22	26	29	30	34	37	39	42	45
5'	15	19	23	26	28	32	36	38	42	46	48	52	56
7'	21	27	32	35	38	44	50	53	58	64	67	73	78
9'	27	34	41	45	49	56	64	67	75	82	86	93	100
11'	32	41	50	55	59	68	77	82	91	100	104	113	122
12'	35	45	55	60	65	75	84	89	99	109	114	124	133
13'	38	49	59	65	70	81	91	97	107	118	123	134	144
15'	44	56	68	75	81	93	105	111	124	136	142	154	167
17'	50	64	77	84	91	105	119	126	140	154	161	175	189
18'	53	67	82	89	97	111	126	133	148	163	170	185	200
20'	58	75	91	99	107	124	140	148	165	181	189	205	222
22'	64	82	100	109	118	136	154	163	181	199	208	226	244
23'	67	86	104	114	123	142	161	170	189	208	217	236	255
25'	73	93	113	124	134	154	175	185	205	226	236	256	277 TILES

34. 投給規律的世界一票

在編排內文的同時，其實也在呈現內容的階層關係。選票單的編排算是極具挑戰性而且兼具社會責任的設計，各種複雜的訊息會在版面上爭相出現。設計時要考慮到閱讀大眾的背景形形色色，因此必須讓選項看起來清楚明瞭。

名稱

Guidelines for Ballot and Election Design

客戶

The U.S. Election Assistance Commission

設計公司

AIGA Design for Democracy; Drew Davies, Oxide Design Company, for AIGA

www.aiga.org/design-for-democracy

設計的宗旨是讓選項簡單易懂，版面簡明清晰。

使用單元格線來確保每個姓名和選項都十分清楚。簡明、清晰又好讀的有襯線字型成功傳達了選票的重要性及嚴肅性。變換字體粗細使訊息清楚明白，粗體標題及細體說明文字則依序編排。灰階和顏色分隔各組訊息。直線線條區隔了各候選人，而加粗的線條劃分各段落區塊。插圖則讓一連串文字說明更易了解。

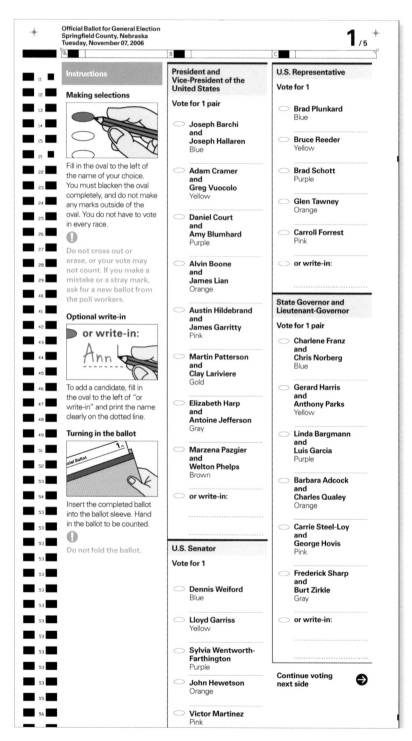

box的外圍線條或邊框，還有箭頭（只出現一次，明顯指向候選人），使視覺上有喘息空間，不致有所混淆。

此設計也適用於其他語言版本，簡潔的原則也同樣適用。

包括兩種語言的選票，文字量就更多，次要語言會比主要語言的字體略小。對於選票的說明文字，插圖可釐清所有令人疑惑之處。

President and Vice-President of the United States

Vote for 1 pair

Joseph Barchi
and
Joseph Hallaren
Blue

Adam Cramer
and
Greg Vuocolo
Yellow

Daniel Court
and
Amy Blumhardt
Purple

Alvin Boone
and
James Lian
Orange

Austin Hildebrand
and
James Garritty
Pink

Martin Patterson
and
Clay Lariviere
Gold

Elizabeth Harp
and
Antoine Jefferson
Gray

Charles Layne
and
Andrew Kowalski
Aqua

Marzena Pazgier
and
Welton Phelps
Brown

or write-in:

U.S. Representative

Vote for 1

Brad Plunkard
Blue

Bruce Reeder
Yellow

Brad Schott
Purple

Glen Tawney
Orange

Carroll Forrest
Pink

or write-in:

State Governor and Lieutenant-Governor

Vote for 1 pair

Charlene Franz
and
Chris Norberg
Blue

Gerard Harris
and
Anthony Parks
Yellow

Linda Bargmann
and
Luis Garcia
Purple

Barbara Adcock
and
Charles Qualey
Orange

or write-in:

(2B)

Continue voting next side ➔

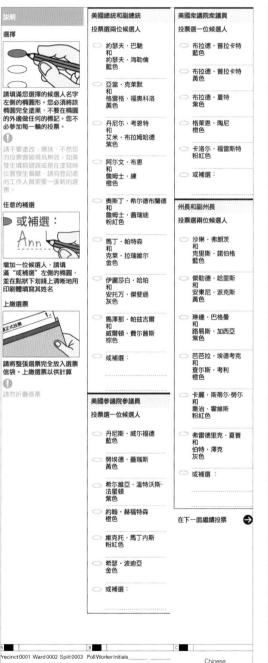

說明

選擇

請填滿您選擇的候選人名字左側的橢圓形。您必須將該橢圓形完全塗黑，不要在橢圓的外邊做任何的標記。您不必參加每一輪的投票。

請不要塗改、擦抹，不然您的投票會被視為無效。如果發生填寫錯誤或是在塗寫時位置發生偏離，請向登記處的工作人員索要一張新的選票。

任意的補選

或補選：

Ann

增加一位候選人，請填滿"或補選"左側的橢圓，並在點狀下劃線上清晰地用印刷體填寫其姓名

上繳選票

請將整張選票完全放入選票信袋。上繳選票以供計算

請勿折疊煙票

美國總統和副總統

投票選兩位候選人

○ 約瑟夫‧巴馳
和
約瑟夫‧海勒倫
藍色

○ 亞當‧克萊默
和
格雷格‧福奧科洛
黃色

○ 丹尼爾‧考恩特
和
艾米‧布拉姆哈德
紫色

○ 阿尔文‧布恩
和
詹姆士‧練
橙色

○ 奧斯丁‧希爾德布蘭德
和
詹姆士‧蓋瑞迪
粉紅色

○ 馬丁‧帕特森
和
克萊‧拉瑞維尔
金色

○ 伊麗莎白‧哈珀
和
安托万‧傑斐遜
灰色

○ 馬澤那‧帕茲吉爾
和
威頓‧費尔普斯
棕色

○ 或補選：

美國參議院參議員

投票選一位候選人

○ 丹尼斯‧威尔福德
藍色

○ 勞埃德‧蓋瑞斯
黃色

○ 希爾維亞‧溫特沃斯‧法星頓
紫色

○ 約翰‧赫福特森
橙色

○ 維克托‧馬丁内斯
粉紅色

○ 希瑟‧波迪亞
金色

○ 或補選：

美國衆議院衆議員

投票選一位候選人

○ 布拉德‧普拉卡特
藍色

○ 布拉德‧普拉卡特
黃色

○ 布拉德‧夏特
紫色

○ 格萊恩‧陶尼
橙色

○ 卡洛爾‧福雷斯特
粉紅色

○ 或補選：

州長和副州長

投票選兩位候選人

○ 沙琳‧弗朗茨
和
克里斯‧諾伯格
藍色

○ 傑勒德‧哈里斯
和
安東尼‧派克斯
黃色

○ 琳達‧巴格曼
和
路易斯‧加西亞
紫色

○ 芭芭拉‧埃德考克
和
查尔斯‧考利
橙色

○ 卡麗‧斯蒂尔‧勞尔
和
喬治‧霍維斯
粉紅色

○ 弗雷德里克‧夏普
和
伯特‧澤克
灰色

○ 或補選：

在下一面繼續投票 ➔

Precinct 0001 Ward 0002 Split 0003 Poll Worker Initials_____ _____ Chinese

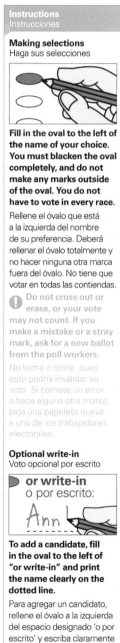

Instructions
Instrucciones

Making selections
Haga sus selecciones

Fill in the oval to the left of the name of your choice. You must blacken the oval completely, and do not make any marks outside of the oval. You do not have to vote in every race.

Rellene el óvalo que está a la izquierda del nombre de su preferencia. Deberá rellenar el óvalo totalmente y no hacer ninguna otra marca fuera del óvalo. No tiene que votar en todas las contiendas.

Do not cross out or erase, or your vote may not count. If you make a mistake or a stray mark, ask for a new ballot from the poll workers.

No tache o borre, pues esto podría invalidar su voto. Si comete un error o hace alguna otra marca, pida una papeleta nueva a uno de los trabajadores electorales.

Optional write-in
Voto opcional por escrito

▶ **or write-in:**
o por escrito:

Ann

To add a candidate, fill in the oval to the left of "or write-in" and print the name clearly on the dotted line.

Para agregar un candidato, rellene el óvalo a la izquierda del espacio designado 'o por escrito' y escriba claramente el nombre de la persona en la línea punteada.

35. 單元未必要方正

單元式格線之美，在於未必一定要正正方方。只要整體單元設計一致，是可以變換形狀、大小及樣式，而且同時又保持規律感和賞心悅目。

限制每頁的顏色變化，讓每頁的色系統一，能展現一種平衡感。

名稱

House Beautiful

客戶

House Beautiful magazine

設計公司

Barbara deWilde

這本雜誌以清新的風格重新設計，結果整體變得煥然一新。

統一又有組織的文字編排，放在每個單元下方，全大寫的灰色無襯線字型則彷彿成了一條條有質感的橫線。

SAN MARGHERITA; $245; RANI ARABELLA: 561-802-9900.

LATTICE, FROM $95; SEACLOTH: 203-422-6150.

CORAL ON WHITE LINEN, $185; HOMENATURE: 631-287-6277.

MARYANN CHATTERTON, $498; D. KRUSE: 949-673-1302.

SEABLOOM, FROM $110; OROMONO: 917-338-7568.

CHRYSANTHEMUM, $55; PINE CONE HILL: 413-496-9700.

TRANSYLVANIAN TULIP, FROM $83; AUTO: 212-229-2292.

SUZANI FLORAL, $212; MICHELE VARIAN: 212-343-0033.

IKAT, $500; D. KRUSE: 949-673-1302.

GREEK REVIVAL EMBROIDERY, $260; DRANSFIELD & ROSS: 212-741-7278.

PLAID, $135; ALPANA BAWA: 212-254-1249.

WEE LOOPY FELTED, $213; THE CONRAN SHOP: 866-755-9079.

VESUVIO, $395; DRANSFIELD & ROSS: 212-741-7278.

NIZAM, $83; JOHN DERIAN DRY GOODS: 212-677-8408.

CYLINER LINEN, $195; GH INTERIORS: 888-226-8844.

LINEN, $70; ALPHA BY MILLI HOME: 212-643-8850.

KAFFE FASSETT HIBISCUS, $68; PINE CONE HILL: 413-496-9700.

DAVID TURNER/STUDIO D.

113

36. 通盤考慮整個表格

名稱

Timetables for
New Jersey Transit

客戶

New Jersey Transit

設計公司

Two Twelve Associates

這些紐澤西大眾運輸系統的時刻表，編排得簡潔又流暢，顯示出設計者無須太擔心有太多表格欄位，也能清楚呈現訊息。像箭頭或圖示的設計，能幫助旅客在大量訊息中找到所需的資訊。箭頭或圖示或許了無新意，但有時用大眾都熟悉的圖像傳達訊息，卻是上上策。

製作圖表、表格以及時刻表時，要處理大量的訊息，算是個有點可怕的艱鉅任務。愛倫·勒普頓（Ellen Lupton）在《以字型思考》（Thinking with Type）一書中，建議設計者不要落入所謂的資料牢籠，加入過多box和線條。遵照她的建議，想想圖表、格線或時間表的整體效果，思考每欄、每列或每個區域要如何扣合整體來設計。

可以用顏色深淺來引導使用者在密集的訊息裡瀏覽。不管是只用黑白兩色，或有預算可用四色來設計，都可運用顏色深淺來變化。深淺不同的橫條區隔數字列，讓使用者能夠找到所需的資訊。至於邊框和線條都是設計編排的工具，不見得要全部捨棄不用。以時間表來說，直線能分隔特定區域，界定特定的內容。針對比較複雜的資料，如火車時刻表，則必須編排出一個完整系統，顏色編選則可區別各線或轉乘線的列車。

格線設計若少了要編排的內容就會變得毫無意義。而對多欄位的設計而言，清楚的文字排版不可或缺。就機場或車站的指示訊息而言，內容編排方式會影響到旅客旅途是否輕鬆順暢，還是頻頻錯過轉乘班次。儘管時刻表必須容納大量的訊息，仍然要確保每行上下留有適度空間。空間能幫助閱讀理解，而可讀性正是編排時刻表的首要原則。

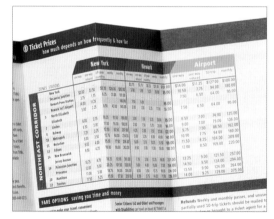

這個時刻表交錯使用不同的有色橫條來區分出各站。表格並未使用很多直線，但使用到時都能清楚顯示各組主要與分項訊息。垂直線區別站名和目的地，橫線則劃分各個主要地區。

適用時刻表的編排方式，也同樣適用於票價表。此處再度使用有色橫條標明火車站名，橫向和縱向直線用來區分標題，把單程票及離峰時段來回票等與站名和票價區分出來。

各段文字項詳述買票須知，以圖示輔助說明各項目的標題。

箭頭表示快車停靠站。

此版面編排清晰又簡單明瞭。設計者讓各欄各列周圍都有足夠空間，減輕閱讀密集訊息的負擔。虛線和曲線用得不多，但都用得效果頗佳。白色箭頭表示方向，深色色條與反白文字則清楚標示每日時刻。

37. 以插畫設計圖表

表格和圖表可以是簡單的數據欄，也可以以插圖呈現，會更便於理解。設計者或插畫者若要將統計數據確切地設計為圖表，可以運用線條、圖形、顏色、材質、重覆圖示等方式，再加上巧思來編排資料。雖然編排的資料不盡相同，但以圖像搭配圖表會比較令人印象深刻。

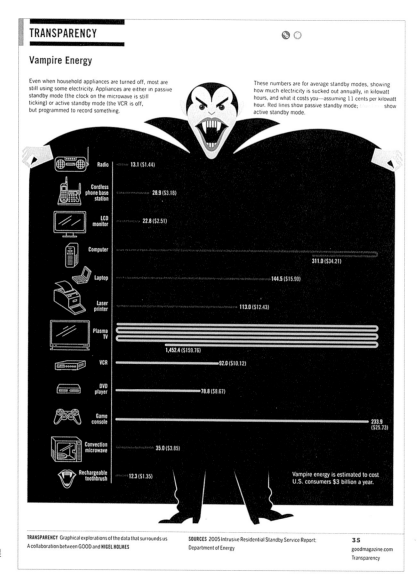

名稱
Good magazine issue 008:
Transparency

客戶
Good Magazine, LLC

設計指導
Scott Stowell

設計公司
Open

圖表
Nigel Holmes

巧思和功力讓這個統計數據很有設計感。

要表達「吸血鬼經濟」如何榨乾荷包的概念，最容易理解的方式就是直接用吸血鬼的圖像來呈現。

用顏色標示出各類議題，能讓人一目了然，解讀大概情況。

巧思立大功。用小圖示來呈現歷史上示威遊行發生的時間點，巧妙地帶領讀者的目光隨之移動前進。

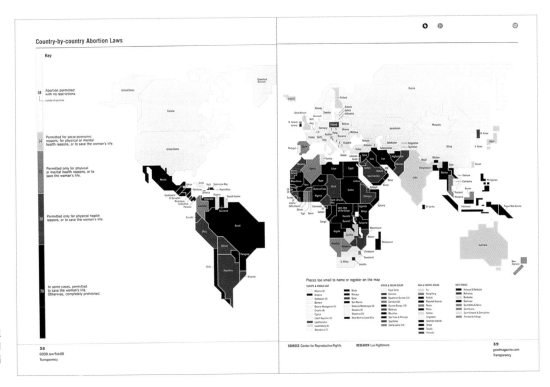

Country-by-country Abortion Laws

Key

Abortion permitted with no restrictions.
number of countries

Permitted for socio-economic reasons, for physical or mental health reasons, or to save the woman's life.

Permitted only for physical or mental health reasons, or to save the woman's life.

Permitted only for physical health reasons, or to save the woman's life.

In some cases, permitted to save the woman's life. Otherwise, completely prohibited.

Places too small to name or register on the map

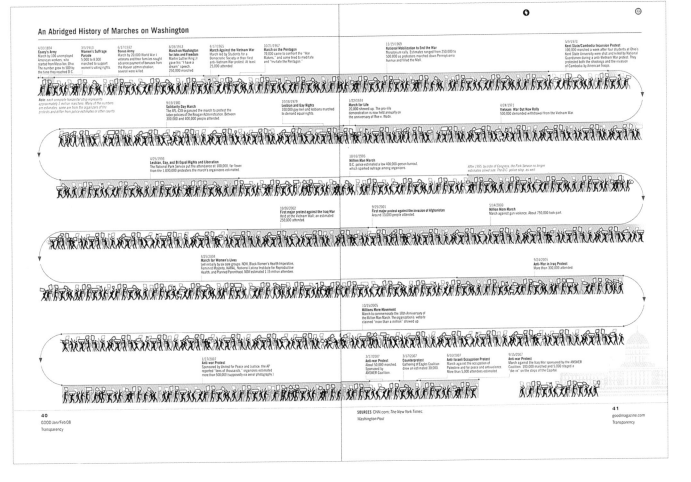

An Abridged History of Marches on Washington

40
GOOD Jan/Feb 08
Transparency

SOURCES CNN.com; The New York Times.
Washington Post

41
goodmagazine.com
Transparency

38. 預期之外的設計

統計資料可用各種層次來呈現，未必只能用數字。除了傳統的列表方式以外，還可選擇利用顏色、圖示，以及其他有創意的方式。這種聰明的做法，並不會造成數據間的重要對比失焦。

重複圖示比光列出數字更能加深印象。

名稱

Good magazine

設計公司

Open

設計指導

Scott Stowell

圖表

Nigel Holmes

就像右圖中這些格外有設計感的統計表，圖表也可以設計得很有趣。

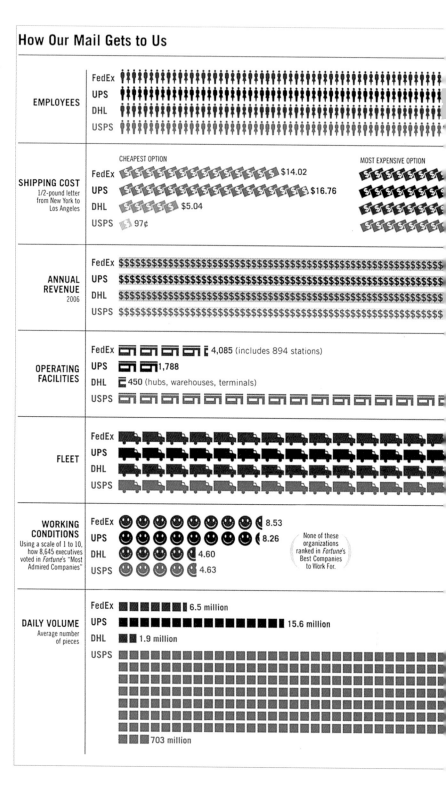

How Our Mail Gets to Us

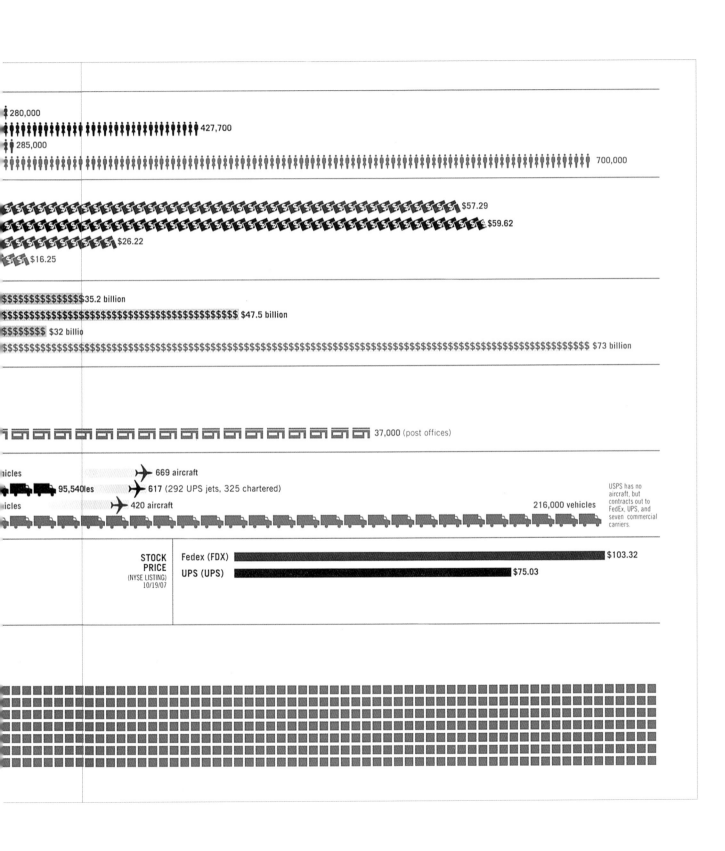

280,000

427,700

285,000

700,000

$57.29

$59.62

$26.22

$16.25

$$$$$$$$$$$$$$$$$35.2 billion

$$$ $47.5 billion

$$$$$$$$ $32 billio

$$ $73 billion

37,000 (post offices)

ehicles →669 aircraft

95,540les →617 (292 UPS jets, 325 chartered)

ehicles →420 aircraft 216,000 vehicles

USPS has no aircraft, but contracts out to FedEx, UPS, and seven commercial carriers.

STOCK
PRICE
(NYSE LISTING)
10/19/07

Fedex (FDX) $103.32

UPS (UPS) $75.03

39. 分開處理box

理想上，表格訊息是可以不用一堆框起來的區塊或box來編排，這樣頁面就不會顯得凌亂不堪。不過，有時內容會涵蓋諸多互不相關的元素，因此最清楚有效的處理方式，就是將每類資訊分隔加框。

雖然在設計訂購單時不一定要用到直線、邊框和邊界，但不同區塊以及有粗有細的直線與邊框，不僅可以增加版面規律感，也能因為規律感而讓人感覺安心可靠。

名稱

Kurashi no techo (Everyday Notebook) magazine

客戶

Kurashi no techo (Everyday Notebook) magazine

設計者

Shuzo Hayashi, Masaaki Kuroyanagi

訂購單不僅美觀，還很實用。

郵 便 は が き

料金受取人払郵便

新宿北局承認

4121

差出有効期間
平成21年11月
23日まで
★切手不要★

1 6 9 − 8 7 9 0
1 3 3

東京都新宿区北新宿1-35-20

暮しの手帖社

4世紀31号アンケート係 行

ご住所 〒 　 −

電話 　 − 　 −

お名前

メールアドレス 　 @

年齢 [　] 歳

性別 女 ／ 男

ご職業 [　]

ご希望のプレゼントに○をつけて下さい。

☐ 「日東紡のふきん」3枚箱入り

☐ 「花森安治の表紙絵ポストカード」5枚セット

いただいた個人情報は、誌面作り、当選プレゼントの発送、小社グループの商品案内等の送付に利用させていただき、厳重に管理、保管いたします。

＊ご回答は、184ページの記事一覧をご参照の上、番号でご記入下さい。

A．表紙の印象はいかがですか [　]
　　ご意見：

B．面白かった記事を3つ、挙げて下さい [　] [　] [　]

C．役に立った記事を3つ、挙げて下さい [　] [　] [　]

D．興味がなかった、あるいは面白くなかった記事を3つ、挙げて下さい
　　　　　　　　　　　　　　　 [　] [　] [　]

E．今号を何でお知りになりましたか [　]
　　その他：

F．小誌と併読している雑誌を教えて下さい

G．小誌を買った書店を教えて下さい [　] 区市町村 [　]

H．小誌へのご要望、ご意見などございましたらご記入下さい

◎ご協力、ありがとうございました。

本頁和下頁：這些訂購單的設計十分注重線條粗細。加粗的線條區隔出某些特定的內容，提醒讀者注意裡面最重要的訊息或標題。不同的粗細線條能讓頁面看起來彼此協調，又能區別重要性，還能同時切分出補充性的資訊。

- 【定期購読】【商品、雑誌・書籍】のお申込みは、こちらの払込取扱票に必要事項を必ず記入の上、最寄りの郵便局に代金を添えてお支払い下さい。
- 169項、183頁の注文方法をご覧下さい。
- 表示金額はすべて税込価格となっております。
- 注文内容を確認させていただく場合がございます。平日の日中に連絡のつく電話番号を、ＦＡＸ番号がございましたら払込取扱票にご記入ください。
- プレゼントの場合はご注文いただいたお客様のご住所、お名前でお送りします。

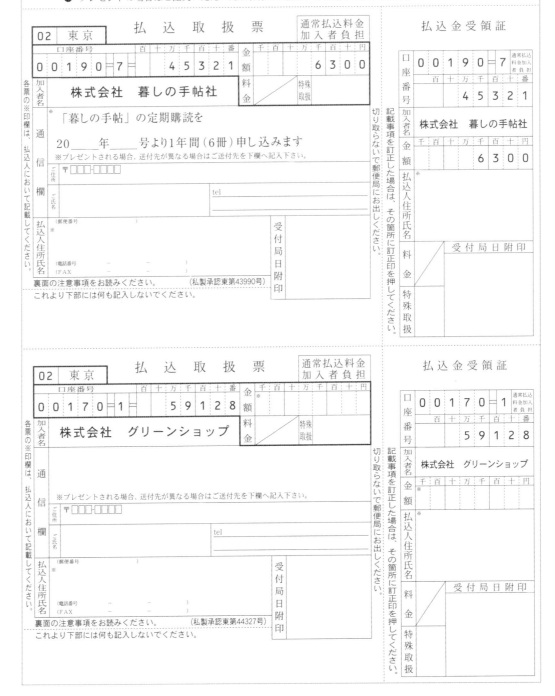

払込取扱票

02 東京

口座番号 00190-7　百十万千百十番 45321

金額　通常払込料金 加入者負担 千百十万千百十円 6300

料金　特殊取扱

加入者名　株式会社　暮しの手帖社

通信欄
「暮しの手帖」の定期購読を
20___年___号より1年間（6冊）申し込みます
※プレゼントされる場合、送付先が異なる場合はご送付先を下欄へ記入下さい。
〒□□□-□□□□　ご住所
ご氏名　tel

払込人住所氏名
（郵便番号　　　）
※
（電話番号　　　-　　　-　　　）
（FAX　　　-　　　-　　　）

受付局日附印

各票の※印欄は、払込人において記載してください。

裏面の注意事項をお読みください。　　（私製承認東第43990号）
これより下部には何も記入しないでください。

払込金受領証

口座番号 00190-7　通常払込料金加入者負担
百十万千百十番 45321

加入者名　株式会社　暮しの手帖社

金額 千百十万千百十円 6300

払込人住所氏名 ※

料金
特殊取扱

受付局日附印

切り取らないで郵便局にお出しください。
記載事項を訂正した場合は、その箇所に訂正印を押してください。

払込取扱票

02 東京

口座番号 00170-1　百十万千百十番 59128

金額　通常払込料金 加入者負担 千百十万千百十円

料金　特殊取扱

加入者名　株式会社　グリーンショップ

通信欄
※プレゼントされる場合、送付先が異なる場合はご送付先を下欄へ記入下さい。
〒□□□-□□□□　ご住所
ご氏名　tel

払込人住所氏名
（郵便番号　　　）
※
（電話番号　　　-　　　-　　　）
（FAX　　　-　　　-　　　）

受付局日附印

各票の※印欄は、払込人において記載してください。

裏面の注意事項をお読みください。　　（私製承認東第44327号）
これより下部には何も記入しないでください。

払込金受領証

口座番号 00170-1　通常払込料金加入者負担
百十万千百十番 59128

加入者名　株式会社　グリーンショップ

金額 千百十万千百十円 ※

払込人住所氏名 ※

料金
特殊取扱

受付局日附印

切り取らないで郵便局にお出しください。
記載事項を訂正した場合は、その箇所に訂正印を押してください。

40. 走出邊界

格 線可處理特殊形狀的版面,將空間分割成幾個均等的區域。圖形可橫向縱向對分、切割成四等分,也可以切成六等分或八等分。

其中一面的圖片滿版出血,使介紹文字和圖片形成對比。文字排版十分簡單,粗黑標題與博物館標誌相互呼應,並吸引讀者注意到標題和網站連結。地鐵車廂的水平直線也和文字部分的排列彼此對應。

名稱
Circle Book education tool, New York Transit Museum

客戶
New York Transit Museum

專案研發
Lynette Morse and Virgil Ta-laid, Education Department

設計公司
Carapellucci Design

設計者
Janice Carapellucci

此圖形版面設計既富有教育功能,也包含了訊息與活動,而且呼應了它的主題,是可以動的!

NAME:

NEW YORK TRANSIT MUSEUM

Think About It...

When New York City's first subway opened on October 27, 1904, there were about 9 miles of track. Today the subway system has expanded to 26 times that size. About how many miles of track are there in today's system?

Most stations on the first subway line had tiles with a symbol, such as a ferry, lighthouse, or beaver. These tiles were nice decoration, but they also served an important purpose. Why do you think these symbols were helpful to subway passengers?

When subway service began in 1904, the fare was five cents per adult passenger. How much is the fare today? Over time, subway fare and the cost of a slice of pizza have been about the same. Is this true today?

Today's subway system uses a fleet of 6,200 passenger cars. The average length of each car is 62 feet. If all of those subway cars were put together as one super-long train, about how many miles long would that train be? (Hint: There are 5,280 feet in a mile.)

Redbird subway cars, which were first built for the 1964 World's Fair, were used in New York City until 2003. Then many of them were tipped into the Atlantic Ocean to create artificial reefs. A reef makes a good habitat for ocean life—and it is a good way to recycle old subway cars! Can you think of other ways that mass transit helps the environment?

To check your answers and learn more about New York City's subway system, visit our website: **www.transitmuseumeducation.org**. You'll also find special activities, fun games, and more!

© New York Transit Museum, 2007
The New York Transit Museum's programs are made possible, in part, with public funds from the New York State Council on the Arts, a state agency.
All photographs are from the New York Transit Museum Collection.

WORLD'S FAIR
SPECIAL
←LOCAL·EXP→

Ⓜ Metropolitan Transportation Authority

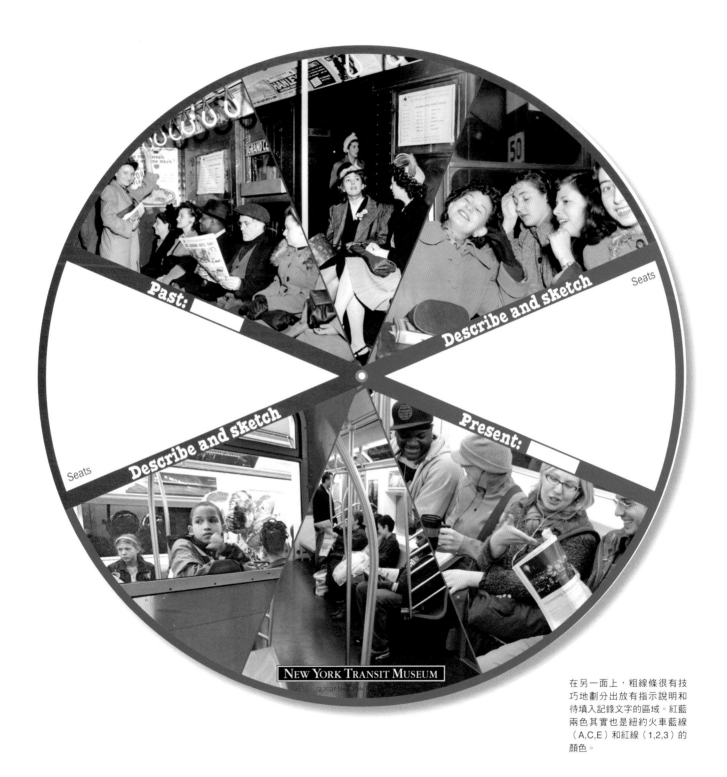

在另一面上，粗線條很有技巧地劃分出放有指示說明和待填入記錄文字的區域。紅藍兩色其實也是紐約火車藍線（A,C,E）和紅線（1,2,3）的顏色。

41. 繽紛色彩, 吸睛利器

色彩鮮艷的頁面能吸引目光, 對擁擠的頁面來說更是如此。彩色的box空間, 最能以一致的方式分隔主副標題。這些區域裡可以放入文字, 也可純粹做為區別空間的色塊。不同大小和粗細的字型能讓頁面有流暢感和動感。此外, 彩色圖片有時也能讓視覺有停頓片刻的效果。

此為四個年度節慶的活動海報, 以鮮艷的彩色格線及一致風格來設計, 但每年會放一張照片, 來呈現不同面貌, 如草地、天空或雲朵。

欄位由上至下:
2005,2006,2007
第二欄:
2008

名稱
Campaign for arts festival
identity, brochure, website,
and banner

客戶
River to River Festival

設計公司
Number 17

創意指導／藝術指導
Emily Oberman, Bonnie
Siegler

彩色box裡也放入文字, 為藝術節的文宣海報增添活力。

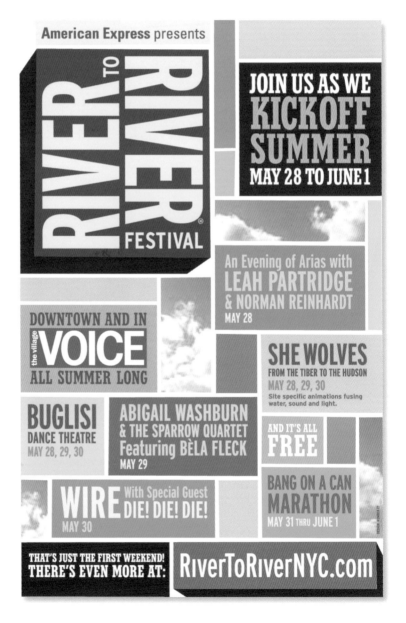

文宣簡介的封面上放了許多訊息，以卡通式的插入文字方式來加強重點部分，讓頁面空間看起來依然開闊。

此文宣之所以設計得成功，一方面在於鮮豔色彩的吸睛效果，一方面來自於大膽字型安排，以及技巧性插入River這個單字。色塊襯托標題，也讓整個頁面有喘息空間。

這個網站充滿巧思的文字編排及色塊，與其他活動內容彼此呼應，不僅可做為banner，也可成為點選查詢的頁籤設計。

42. 確立色系

很多顏色能吸引注意力，但使用過多顏色反而會影響到整體訊息的傳達。明確限制色系可以讓頁面有一致性。若顏色的功用是要醒目吸睛，可選用鮮豔的色彩；如果是較正式的主題，如案例研究或財報，可採用低彩度的顏色來搭配內容。

針對嚴肅主題，可用低彩度、不飽和的色調。

名稱

Website

客戶

Earth Institute at
Columbia University

創意指導

Mark Inglis

設計公司

Sunghee Kim, John Stislow

網站上的各個區塊是透過不同顏色來區別，顏色則是依計畫的不同來做選擇。

以鮮明但柔和的顏色在螢幕上標示出不同的課程。

43. 以顏色為主角

即使版面是像雜誌裡常出現的紮實結構，有時也可以輕鬆一點，單純簡化版面編排，讓顏色成為頁面中心焦點（尤其是令人驚豔的照片），效果便會不同凡響。

本頁和下頁：儘管在全彩的版面上，很難不將顏色用到極致，不過，要讓讀者聚焦在圖片上，就要有限度地使用顏色種類，比方說，可以用黑色來平衡頁面上高飽和度的圖片。太多顏色在視覺上會相互競爭，反而會有反效果。

名稱

House Beautiful

客戶

House Beautiful magazine

設計公司

Barbara deWilde

色彩豐富又具藝術感的圖片，在沒有其他版面元素的干擾下，顯然是大放光彩。

Violet
GENTLE VIOLET (2071-20)
BENJAMIN MOORE COLOR PREVIEW

Peony
SWEET TAFFY (2086-60)
BENJAMIN MOORE COLOR PREVIEW

Magenta Anemone
FORWARD FUCHSIA
(SW 6842) SHERWIN-WILLIAMS

Hydrangea
TROOPER (26-14) PRATT & LAMBERT

Pink Rose
PEACHGLOW (90YR71/144) GLIDDEN

Water Lily
TULIPE VIOLET (30-14) PRATT & LAMBERT

Orchid
VESPER (70RB67/067) GLIDDEN

Hyacinth
ORIENTAL NIGHT (29-14) PRATT & LAMBERT

COOL SHADES A word about finishes:
Light colors look darker in a flat finish.
Dark colors look brighter in a gloss or
semigloss. A flat finish will work well
for the lighter shades here, but the
deep purples and pinks will definitely
look better with a sheen.

Pink Daisy
SMASHING PINK (1303)
BENJAMIN MOORE CLASSIC COLORS

FOR MORE DETAILS, SEE RESOURCES.

44. 結合色彩和文字編排

就全彩的指南性書籍來說，要懂得明智地控制顏色的使用，才不會讓頁面其他元素干擾到內容的閱讀。此外，在特定的色系中慎選色彩，可讓文字編排更加突出。

每章開頭選用色彩鮮艷的整頁大圖。在鮮艷顏色的襯托下，粗體字型十分醒目。

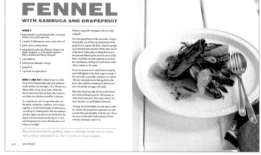

整頁導論文字緊接在出血大圖後出現。不同於開章頁的無襯線字型，此頁導論文字選用一個主色為底，以反白有襯線字型呈現。

名稱

Italian Grill

客戶

HarperCollins

設計公司

Memo Productions, NY

藝術指導

Lisa Eaton,
Douglas Riccardi

這是一本展現獨特個人特色的大廚烹飪書，編排以格線設計為基礎。這本烹飪書選用飽和大膽的顏色，文字排版也同樣高調呈現，毫不掩飾。每章使用一種顏色做為主色系，並再稍加變化，從頭到尾都精彩美觀。

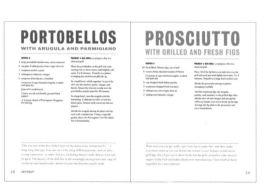

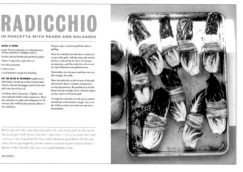

本頁下方三張圖及下頁：各段落的顏色是以同色系稍做變化，襯托隔頁的全彩照片。

FISH AND SHELLFISH

In Italy, cooking fish is all about freshness and simplicity—as I've said before, the philosophy of Italian fish cookery can be summed up in three words: *Leave it alone.* Complicated sauces and techniques are not part of the repertoire, and, in fact, Italians almost never serve any sauce at all with fish, other than an excellent olive oil. Lemon may sometimes appear, but even that is often considered beside the point. The one exception is *salsa verde*, the fragrant green herb sauce, which may sometimes accompany a fish with character enough to stand up to it, such as a whole grilled branzino (see page 126).

Few Italians would consider cooking anything other than local fish, whether from a mountain stream or the ocean, and I urge you to think in the same way: find a good fish market, and remember that what is freshest is best. If the specific fish called for in your recipe is not available—or doesn't look pristine and glistening—the fishmonger can help you choose another option (I include suggestions for substitutions in many of the recipes). If you are able to get fresh king mackerel for Mackerel "in Seapece" with Amalfi Lemon Salad, you will have the best mackerel dish you've ever tasted; if you can't find it, make the recipe with very fresh bluefish, or move on to another one. Most of the other fish recipes in this chapter, such as Monkfish in Prosciutto with Pesto Fregola and Swordfish Involtini Sicilian-Style, call for widely available varieties. But you'll want to be sure to get the best tuna available—sushi-quality, that is—for Tuna Like Fiorentina, and you really should use wild salmon for the Salmon in Cartoccio with Asparagus, Citrus, and Mint.

Cooking shellfish on the grill is easy, and the recipes in this chapter use several different techniques for achieving simple perfection. Clams in Cartoccio are wrapped in a foil package and allowed to steam in their fragrant juices. The shrimp in Shrimp Rosemary Spiedini alla Romagnola are threaded onto rosemary skewers, which impart their herbal fragrance and look sexy besides. I love cooking shellfish (and cephalopods) on a piastra, a flat griddle or stone placed on the hot grill (see page 000 for more on the subject), because it gives them a great sear and char, as in Sea Scallops alla Caprese or Marinated Calamari with Chickpeas, Olive Pesto, and Oranges.

Thinking globally while buying locally is especially important when you are buying fish. Some "trendy" fish have been overharvested to the point of extinction, and we now know that there can be problems with farmed fish as well, like salmon. The Monterey Bay Aquarium, at www.montereybayaquarium.com, maintains an up-to-date list of species that are being overfished in the United States and in the rest of the world. It's an invaluable resource, and I urge you to consult it when writing your shopping list, as I do both at home and at the restaurants.

MARINATED
CALAMARI

WITH CHICKPEAS, OLIVE PESTO, AND ORANGES

SERVES 6

CALAMARI

3 pounds cleaned calamari (tubes and tentacles)

¼ cup extra-virgin olive oil

Grated zest and juice of 1 lemon

4 garlic cloves, thinly sliced

2 tablespoons chopped fresh mint

2 tablespoons hot red pepper flakes

2 tablespoons freshly ground black pepper

CHICKPEAS

Two 15-ounce cans chickpeas, drained and rinsed, or 3½ cups cooked chickpeas

½ cup extra-virgin olive oil

¼ cup red wine vinegar

4 scallions, thinly sliced

4 garlic cloves, thinly sliced

¼ cup mustard seeds

Kosher salt and freshly ground black pepper

OLIVE PESTO

¼ cup extra-virgin olive oil

Grated zest and juice of 1 orange

½ cup black olive paste

4 jalapeños, finely chopped

12 fresh basil leaves, cut into chiffonade (thin slivers)

3 oranges

2 tablespoons chopped fresh mint

CUT THE CALAMARI BODIES crosswise in half if large. Split the groups of tentacles into 2 pieces each.

Combine the olive oil, lemon zest and juice, garlic, mint, red pepper flakes, and black pepper in a large bowl. Toss in the calamari and stir well to coat. Refrigerate for 30 minutes, or until everything else is ready.

Put the chickpeas in a medium bowl, add the oil, vinegar, scallions, garlic, and mustard seeds, and stir to mix well. Season with salt and pepper and set aside.

93

45. 以顏色規範

在此日曆文宣的版面上，大小一致、且位在整體格線裡的色塊單元，排列緊密卻保有彈性，能呈現出圖片和文字的有趣變化。方格與顏色能組成整個版面與結構，也能清楚規範文字。當需要列出大量特定細節時，結合色塊單元的格線便能將日期和訊息從其他文字凸顯出來，如網站連結、號召行動或含有主要標題的banner等。

名稱

Program calendar

客戶

Smithsonian, Cooper-Hewitt, National Design Museum

設計公司

Tsang Seymour Design, Inc.

設計指導

Patrick Seymour

藝術指導

Laura Howell

此季節活動日曆的版面放入統一制式的訊息。這個版面也讓顏色和圖片能有動態的變化。

日曆背面有主要展品的概略介紹和展出日期，就搭配放在不受束縛的大圖旁，引發視覺緊張及壓迫感。

大小不一的圖片、穿插放入的去背圖片，都會放在彩色方格的架構內，但有時也會跳出框架。

首先，先確定整體可運用的空間大小，再分成一樣大小的方格。接著考慮整個外圍邊緣。可把方格看成單格、雙格，甚至三格來運用，橫向或縱向不拘，也可以堆疊合併。留意要放入的訊息，可依照日期、月份、價格、活動主題等來選定方格使用的顏色。而設計比較難處理的訊息時，顏色就必須要達到溝通目的，才能清楚傳遞訊息。

每個方格也能放入插圖和照片。就搭配文字來說，可以把圖片放入一個方格、兩個縱向方格、兩個或四個橫向方格，或是四個堆疊合併的方格。簡單來說，彩色方格能順應諸多變化，卻又能維持規律、呈現整體性。為了增添趣味，偶爾突破格線的邊框，放上去背的圖片，可以為熱鬧的活動提供律動感和視覺空間。

在一整列有井然有序的底色襯托下，訊息可在自己所屬空間內呈現。彩色方格可以用較小的字體、較大的標題及加粗文字來區隔出訊息的重要順序。不同的字型、大小、粗細，以及大小寫，都能讓讀者便於瀏覽日期、活動、時間和概述。多單元方格中的大標題，能增添驚喜和節奏感，穿插在其他類似訊息之間，如行銷文案、客戶或博物館、號召參加及聯絡訊息，也能保有一致性。

雙面或跨頁整版的內容，藉由依循或者跳脫原本清楚劃分的區域，也可以充分利用方格來設計編排。

46. 以顏色在版面上做強調

過多顏色可能會讓頁面顯得繁雜、令人無所適從。然而,適量的顏色能引導讀者依先後順序閱讀內容。利用顏色標出差異,能讓讀者明顯分辨出大小標題。

名稱
Croissant magazine

客戶
Croissant magazine

設計者
Seiko Baba

插圖
Yohimi Obata

顏色巧妙地凸顯了字型,增添雜誌頁面的清晰度和活力。這本雜誌為一種Mook形式,是由《可頌》編輯部發行的特刊。

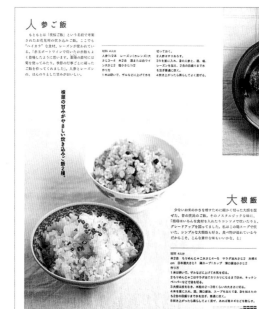

將第一個字放大並標色,能吸引讀者注意到標題。

じゃが芋団子

じゃがいもひとつでできる、定番のおやつ。

「おやつによく作ってくれたお団子。じゃがいもをすりおろして、絞ったおから顆粒を取り出してつなぎにするんです。材料の実験みたいでしょう」ひと手間をかけることで、たった数個のじゃがいもが、もっちりを食べ応えあるお団子になる。「甘いタレで食べるといい。急に友達を連れて帰ったときにも、手早く作ってくれた記憶が」

材料 4人分
じゃがいも（小ぶりのもの）4個　黒練り胡麻大さじ6　醤油大さじ1と1/2　煮切りみりん小さじ1　ハチミツ大さじ1　黒練り大さじ2　白煎り胡麻適量

作り方
1 じゃがいもは皮をむき、おろし金ですりおろす。
2 1をさらしなどで絞り（写真左）、絞り汁はコップなどに入れておく。
3 絞り汁の底に白い澱粉が沈殿してきたら上澄みの汁を捨て、ボウルに入れた身に加えてよく混ぜ、団子に丸める。
4 3を沸騰した湯の中に入れ、浮かんでくるまで茹でる。

薩摩芋もち

冷めてもおいしい、さつまいも入りのおもち。

じゃが芋団子と同じくらいの頻度で登場した甘味。「お餅に芋をつき型ぜて量を増やした、お腹に溜まるおやつでした。お餅だけだとすぐ堅くなってしまいますが、さつまいもが入っていると冷めても柔らかく、おいしく食べられる。甘くしたきな粉をまぶしてもいいですが、塩で食べるとさつまいもの自然な甘みが引き立ちます」

材料 4人分
さつまいも1/2本（約150グラム）切り餅3切れ　きな粉適量　黒砂糖または三温糖適量　塩適量

作り方
1 さつまいもは洗って、皮付きのまま蒸気の上がった蒸し器に入れ、柔らかくなるまで20分ほど蒸す。

茄子の胡麻煮

皮も香ばしく揚げて、トッピングに使う。

ごまの香ばしさうが引き立つ、なすの煮物、とろりとしたなすの食感を出すために、皮はどうしても不要になる。「その度を細く刻んで揚げて、切り昆布のようにトッピングに。材料は仕事も懲式した人で、皮を揚げるとき真っ黒になるまで揚げるのです、でも苦みが強くなるので、からっとしたら引き上げていいと思います」

材料 4人分
なす4本　だし1カップ　日本酒1/3カップ　みりん大さじ3　塩小さじ1　白すり胡麻大さじ1　薄口醤油適量　揚げ油適量

作り方
1 なすは両端を切り落とし、縦に皮をむき全体に切り込みを入れていきます。

煮干しとごぼうの立田揚げ

だしに使う煮干しも、立派なメインに。

「とくに祖母が気に入っていた一品。この料理専用のお皿が決めてあったほどです」使うのは、ごぼうと煮干し、たったそれだけだが、酒と醤油に漬け、片栗粉をまぶしてカリカリに揚げるだけで、メインにも酒の肴にもなってしまう。魔法のようなレシピだ。「煮干しは比較的大きめのものを使うと、おいしく仕上がります」

材料 4人分
煮干し24本（1人前6本計算で）　ごぼう1/3本　醤油大さじ4　酒大さじ4　おろししょうが大さじ1　片栗粉適量　揚げ油適量

作り方
1 煮干しは頭と内臓を取り、醤油大さじ2、酒大さじ2、しょうが大さじ1/2を合わせた漬け汁に漬けてしばらくおく（写真）。
2 ごぼうはたわしなどでこそいでよく洗い、薄く斜め切りにしてさっと水にさらし、水気を切って1と同量の

お付き合い編　**人付き合いを潤滑にする言葉づかい。**

此處，顏色將各項內容加以區分。明確區分各個步驟說明，對教學性內容是尤其實用且重要。在這本烹飪雜誌的版面中，小標題會加上顏色。食譜步驟的編號則標成紅色，以區別文字部分。

問題（Q）部分以不同的字體粗細、大小和顏色，來吸引讀者目光，提升質感。

47. 將內容上色

使用不同顏色來編排月曆，能有效區分頁面上特定元素，如一週的各天。訊息因此不僅能從整個版面凸顯出來，與頁面整體效果也很搭配。此外，月曆所用的顏色也能呼應照片中的色調。

如果想要強調日期，使其看起來清楚明白，這時就要慎選擇彩度，才不會搶了內容的風采。若文字要印在有顏色的頁面上，選用非飽和色彩（灰階色彩）的效果最佳。

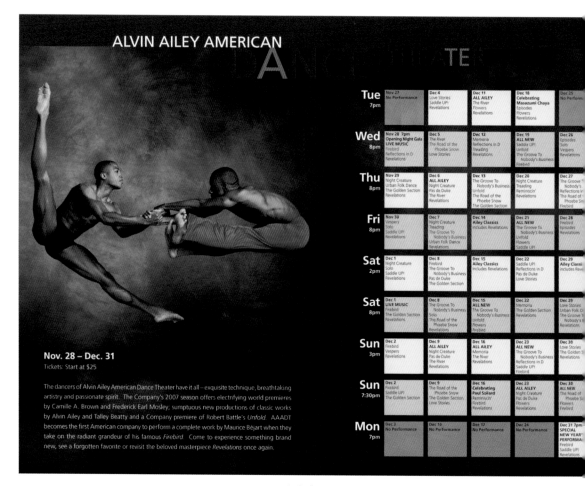

名稱

Calendar of events

客戶

New York City Center

設計公司

Andrew Jerabek

照片和色調決定了月曆方格的用色。

色彩濃深的背景與圖片的驚人動感，搭配以互補色編排的月曆，可說是相得益彰。

彩色方格選用細緻又獨特的顏色，與美麗動人又富藝術感的照片呈現互補，而非相互較勁。

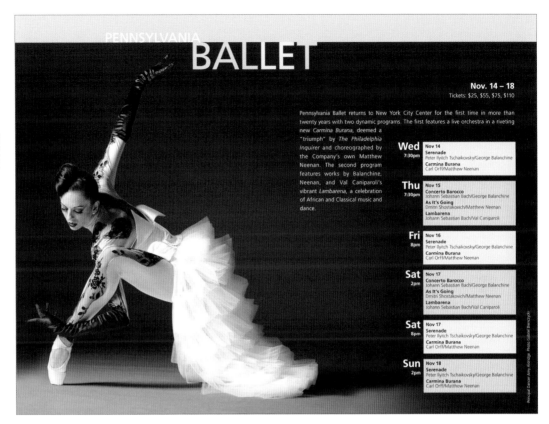

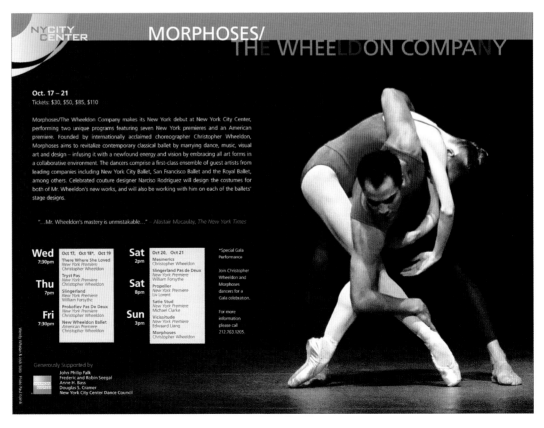

秋天色系呼應頁面上以橙黃色為主的動感照片。

48. 以顏色編排

以顏色編排內容，能有助於觀看者快速找到所需訊息。仔細選定一個色調，再搭配圖示，比起單純使用文字或顏色，能快速傳達更多訊息。要選用鮮明還是深沉的顏色，得看客戶或內容來決定。飽和色彩，即沒有灰階的顏色，能快速吸引目光。

經過設計，各領域有若干研究中心及相關學位課程，而且也有各自的代表顏色。

名稱
Identity program

客戶
Earth Institute at
Columbia University

設計公司
Mark Inglis

創意指導
Mark Inglis

哥倫比亞大學地球科學中心的整套六個自然科學領域，以顏色區分。

LEGEND ○ Centers ● EI Associated Degree Programs

HEALTH SCIENCES
- Center for Global Health and Sustainable Development
- Center for National Health and Development in Ethiopia

SOCIAL SCIENCES
- Center on Globalization and Sustainable Development
- Laboratory of Populations
- Center for Capitalism and Society
- Center for Economy, Environment and Society
- Center for the Study of Science and Religion
- Center for Sustainable Urban Development
- Program on Science and Technology and Global Development

BIOLOGICAL SCIENCES
- Columbia University/UNESCO Joint Program on Biosphere and Society
- Center for Environmental Research and Conservation
- Black Rock Forest

CROSS DISCIPLINARY SCIENCES
- Center for Hazards & Risk Research
- Center for International Earth Science Information Network
- International Research Institute for Climate & Society
- Tropical Agriculture Program

ENGINEERING SCIENCES
- Earth Engineering Center
- Lenfest Center for Sustainable Energy

EARTH SCIENCES
- Lamont-Doherty Earth Observatory
- Center for Rivers and Estuaries
- Goddard Institute for Space Studies at Columbia University
- Center for Nonlinear Earth Systems
- Center for Climate Systems Research

圖示也可以和色系結合在一起。

		WATER
		ENERGY
		URBANIZATION
		HAZARDS
		HEALTH
		POVERTY
		FOOD ECOLOGY & NUTRITION
		ECOSYSTEMS
		CLIMATE & SOCIETY

色彩和圖示、色塊或字型是一起搭配
的。

| Water | Energy | Urbanization | Hazards | Health | Poverty | Food, Ecology & Nutrition | Ecosystems | Climate & Society |

Cross-Disciplinary Sciences	Earth Sciences	Health Sciences	Engineering Sciences	Social Sciences	Biological Sciences
IRI The International Research Institute for Climate and Society	**LDEO** Lamont-Doherty Earth Observatory	**CGHED** Center for Global Health and Economic Development	**LCSE** Lenfest Center for Sustainable Energy	**CGSD** Center on Globalization and Sustainable Development	**CERC** Center for Environmental Research and Conservation (work in progress)
CHRR Center for Hazards and Risk Research	**TAP** Tropical Agriculture Program	**CNHDE** Center for National Health Development in Ethiopia		**CSSR** The Center for Science and Religion	
CIESIN Center for International Earth Science Information Network	**CICAR** Cooperative Institute for Climate Applications and Research			**CPII** The Columbia Program on International Investment	
MCI The Millennium Cities Initiative	**CRE** Center for Rivers and Estuaries				

A.

CENTER ON GLOBALIZATION AND SUSTAINABLE DEVELOPMENT
THE EARTH INSTITUTE AT COLUMBIA UNIVERSITY

The Optima Font is used for all the 'Center Names'

Helvetica Nueu 'Roman' is always used for the subline The Earth Institute at Columbia University on all EI trademarks

B.

All EI Trademark
• Are circular
• Are solid forms, no halftones
• Are reversable
• Reduces to less than .5 inch

C.

Trademarks as Symbols
All trademarks are designed to be abstract, and to engage the viewer to interpret what it means. That said all of the trademarks were created to symbolize a concept associated with the Center. For example the trademark above is rooted in the mission of LDEO, that being the study of the Earth's core, surface and outer atmosphere.

D.

Adding Typography to the Trademark
All EI trademarks are formatted to the left of the locked up text. All text is flush left, with the subline always matching the longest line of the title of the Center.

49. 顏色區分內容

有時只需用顏色就可區分內容段落。除了顏色的選擇之外,突然出現的粗體大字能在長篇文字之後讓視覺休息片刻,產生預期之外卻又讓人欣然接受的效果,抑或是營造出期待後續內容的興奮感。

不管字體是有顏色或反白(也就是有背景底色而字體本身反白),兩種效果都能讓章節段落開頭醒目吸睛。白字搭配有顏色的背景都會極為成功,如國際通用的「stop」標誌。

本頁與下頁:顏色吸引目光,襯托出粗體標題。

名稱

No Reservations

客戶

Bloomsbury USA

設計公司

Elizabeth van Itallie

此書各段落是以顏色來區分,就像此書作者安東尼·波登(Anthony Bourdain)一樣作風大膽。

AFRICA

98 99

BEIRUT

114 115

50. 用顏色深淺來達到彩色效果

有時候，預算會不夠以全彩印製。雖然大部分文宣和廣告設計可以一稿多用，如登在書報、網站及電視，但還是會有預算只夠以黑白印刷的情況。這種顏色上選用的限制常發生在書籍、報刊和傳單中。

　　儘管只有黑白色，還是可用不同灰階來增加色度和質感。頁面上可以白底黑字、黑底白字或在不同深淺的灰階顏色上印字來豐富質感。也可以用圖片和平面設計增添變化。

灰階效果

一般百分之七十的灰階是可以顯現得出色彩，且印在上面的字體還是清晰可見，百分之十的灰階能讓字型清楚明顯，但還是要看紙張材質。灰階照片明暗兼具，能提升頁面質感，提供深淺濃淡的變化。底色愈深，反白文字就愈明顯好讀，淺色的底色則能讓文字直接印在上面。

　　雖然在黑底用反白方式排很小的字是不必太擔心印刷會不清楚，但是最好還是留意一下過小的字體。

下頁：深色系灰階呈現出不同顏色和質感，由於底色夠深，所以反白字夠清楚，標題和文字都清晰好讀。深色方格內的標題是用反白字體，使清晰度、色彩變化與質感都大為提升。

名稱

Movie ad for *Before the Devil Knows You're Dead*

客戶

ThinkFilm

這則廣告跨越顏色限制，呈現大膽風格。

PHILIP SEYMOUR HOFFMAN ETHAN HAWKE MARISA TOMEI ALBERT & FINNEY

"SUPERB! GO OUT AND SEE IT AS SOON AS YOU CAN! ONE OF LUMET'S GREATEST ACHIEVEMENTS!"
-ROGER EBERT, *CHICAGO SUN-TIMES*

"BRILLIANT!"
-DAVID EDELSTEIN,
NEW YORK MAGAZINE

"DYNAMITE! RANKS WITH THE YEAR'S BEST!"
-PETER TRAVERS, *ROLLING STONE*

★★★★
-ROGER EBERT,
CHICAGO SUN-TIMES

★★★★
-LEAH ROZEN,
PEOPLE

★★★★
-LOU LUMENICK,
NEW YORK POST

★★★★
-MARSHALL FINE,
STAR MAGAZINE

★★★★
-STEVEN REA,
PHILADELPHIA INQUIRER

★★★★
-MICK LASALLE,
SAN FRANCISCO CHRONICLE

"GRADE A! RIVETING!"
-OWEN GLEIBERMAN,
ENTERTAINMENT WEEKLY

"THE SEASON'S FIRST MUST-SEE!"
-LOU LUMENICK,
NEW YORK POST

"DON'T MISS IT!"
-LEAH ROZEN, *PEOPLE*

BEFORE THE DEVIL KNOWS YOU'RE DEAD

"FURIOUS AND ENTERTAINING! FEVERISHLY ACTED."
-DAVID DENBY, *THE NEW YORKER*

"CAPTIVATING! HOFFMAN AND HAWKE ARE EXCELLENT!"
-CLAUDIA PUIG, *USA TODAY*

"ONE HELL OF A MELODRAMA!"
-J. HOBERMAN, *VILLAGE VOICE*

"A TERRIFIC SUCCESS!"
-A.O. SCOTT, *THE NEW YORK TIMES*

51. 把指標資訊分層

設計指標資訊是一種挑戰，需要有邏輯性、組織性和一致性。平面設計所使用的格線系統極適用於指標設計，能顧及以下情況，尤其適合擺放在出口周圍的指標設計：

・需要依序查找的分層訊息，如選項1、選項2等。

・依然有其重要性的次要訊息選項，如使用者語言。

・回答基本問題與需求的更次要訊息，包括機場登機門、洗手間位置，以及飲食場所。

・遵照指標指示的過程中，會出現的許多複雜選項，比方說，使用者得知自己必須回到上個步驟。

不管使用者是在走路還是開車，在看到指標時，都要能容易讀懂並理解訊息。所以字型必須清楚，且有明確的層次關係，選用的顏色也要很醒目。

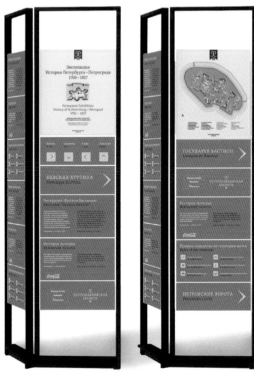

放在指標柱上的主要指標及圖示，被編排成許多橫條狀資訊欄。

名稱

Identity and Signage

客戶

The Peter and Paul Fortress,
St. Petersburg, Russia

藝術指導

Anton Ginzburg

設計公司

Studio RADIA

這是關於俄國聖彼得堡「彼得保羅要塞」的介紹，遊客能選擇以英文或俄文閱覽，找到想抵達的方式。

從版面上的細節可以看出，設計者必須很明確編排各種資訊。

指標柱上的指標說明文字編排得清楚又典雅，呼應城市的悠久歷史。

藍色的海報為暫時性的長掛軸，採數位印刷，掛在指標柱上公告各活動時間。從左邊海報的文宣則可看出這些活動文宣的版面設計。

52. 物以類聚

要清楚地分隔訊息可使用橫向的階層設計。在網站上，條狀的訊息可成為操作點選系統的一部分。訊息也可編排成條狀。

為使每個類別都以橫向線性呈現，可將訊息設計為展開的選項列表，只要點選就能開啟新的頁面，如此便可展開另一橫向階層的訊息。

操作欄位是以橫條組成，位於另一水平橫條上方。

點選藍色操作欄位即可展開下拉選單，選單是以橫向排版。

首頁可點選的選單，展開後可顯示更多訊息。

名稱

artgallery.yale.edu

客戶

Yale University Art Gallery

網站設計與規劃

The Yale Center for Media Initiatives

耶魯大學藝廊網站，以分隔清楚的橫向區塊來設計，看起來清晰又雅致。

點選主要操作條，可展開另一個橫向排列的主選單。

副選單使用兩欄編排，左側放置圖片。每條內容都以水平直線分隔。

即便以兩欄呈現，頁面還是遵守整齊規劃的橫向階層設計。

53. 以空間界定範圍

頁面上的文字若適度留白，能讓版面看起來和諧又有規律。藉著保留大量空白，可以區別介紹性文字與解釋性內文。前者包括標題與說明文字，後者涵蓋如圖說或步驟等。將兩者分離有助於讀者閱讀頁面上訊息。

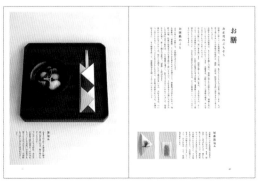

名稱

Kurashi no techo (Everyday Notebook) magazine

客戶

Kurashi no techo (Everyday Notebook) magazine

設計者

Shuzo Hayashi, Masaaki Kuroyanagi

針對有大量圖片和文字的頁面或整頁版面，橫向階層設計能有效區分標題及後續分層步驟，令人感覺沉穩有規律，讓內容更清晰易懂。

空白的部份能明顯區分圖片與文字，界定出內容所在位置。

実際に和紙を折ってみましょう 4種類の作り方です

折形と日本のしきたり

折形は、室町時代に始まった、武家に伝わる礼法と伝えられます。折形をはじめとする日本のしきたりの数々は、本来の意味や由来は忘れられながらも、暮らしの中に生き続けています。「......」と折形デザイン研究所の山田悦子さんはおっしゃいます。

お正月にお雑煮をいただき、結婚のお祝いには水引のかけられたご祝儀袋を贈る。こうした私たちの心に根付いた後の心持ちのすがすがしさを考えてみればよい。民俗学者の折口信夫は「生活の古典」と呼びました。

「......私ども生活は、功利の目的のついで贈り、いわばかりばかりと思われる様式の由来不明なる「為来り」によって、純粋にせられることが多い。その多くは、家庭生活を優雅にし、しなやかな力を与え、門松を樹てた後の心持ちのすがすがしさを考えてみればよい。......」《古代生活の研究、中公クラシックスより》

松飾り

 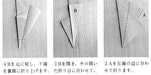

④檀紙を半紙の大きさに切って、左下の角を対角線で折ります。

③Aを左端の辺に合わせて折ります。

②Bを開き、その開いた折り目に合わせて、左端の辺を折ります。

①いったん開いて、同寸の赤い紙を重ねて折り直し、下端を裏側に折り上げます。赤い紙を最初から重ねて折ってもいいでしょう。

年玉包み

⑤出来上がりです。

④上の角の2枚の紙の間から三つ折りのお札や硬貨を入れ、上の角を、下の角の2枚の紙の間に差し込みます。

③上の角を上に引き上げて、下辺を中央に合わせて折ります。

②右端の角を左に折ります。

①13cm四方の縁紅紙を対角線で折り、左辺を三等分して、上の角、下の角の順に折ります。

屠蘇散包み

⑤赤い紙を、下の三角の上端から少し出る大きさに切って、差し込みます。

④上端の4枚の紙を2枚ずつに開いて屠蘇散を入れ、右上の角を、下の角に合わせて差し込みます。

③右辺を左辺に合わせて折り、左辺を右に折り返します。

②右下の角を上辺に合わせて折り、左辺を右辺に合わせて折り上げます。

①半紙を横半分に切った手紙を横に置き、下辺を上辺に合わせて折り上げます。

箸包み

⑤いったん開いて、同寸の赤い紙を重ねて折り直します。赤い紙を最初から重ねて折ってもいいでしょう。

④下端を裏側に折り上げます。

③左にある2つの角を裏側に折ります。

②上に、右と同じ正方形ができるように、右にある2つの角を左に折ります。

①半紙を横半分に切った手紙を縦に置き、左にある2つの角が右上に接するように折ります。

お正月は、しきたりが特に身近になる時期。まずは小さな折形から、日本の豊かな心を感じてみてはいかがでしょう。

贈り物を包むことは紙を選ぶことから始まっています。

折形には、和紙で出来た手紙を使います。和文具店などで手に入りますが、やはり一味違うもの、手漉きの和紙を使うと、グッと良いものに入ります。今回は、折形デザイン研究所の美濃和紙「折形手紙1-2」を使いました。ここでは折形手紙の243×343を目安にしています。今回の折形は全て折形デザイン研究所のオリジナルです。包み方は同じでも、贈り物や相手に合わせて紙を変えれば、格が異なってきます。松飾りと年玉包みの祝儀袋に使用した檀紙は、顏という凸凹のある格の高い和紙。年玉包みに使用した縁紅紙、緑に赤い線が入った正方形の和紙で、彩りのアクセントに使われた赤。屠蘇散包みに赤い和紙でも、少しかせた赤い、他の赤い和紙とは「におい」としています。今回は民芸紙を使いますが、67頁の古の紙閒近にいます。片端に赤い線が入った折形半紙を使っています。松の実で端に線を描いてもいいでしょう。

------ は手前に折る折り目、...... は裏に折り返す折り目、——— は辺を示します。

62　63

經仔細規劃過的橫向編排，能將介紹性文字分成不同區塊。圖片和說明文字橫跨整個版面，產生一種橫向流動感，使每組圖片與搭配的文字說明，成為清楚又好讀的步驟解說。

54. 繪製時間年表

能把時間年表編排成不只是功能性的訊息，實在是極具功力。時間年表是呈現個人生平或者某個時代的大事記，因此設計要能反映內容。

名稱

Influence map

客戶

Marian Bantjes

設計者與插畫

Marian Bantjes

在瑪莉安·本傑思（Marian Bantjes）關於藝術流派及藝術語彙的插畫中，技巧和細節是最為重要的部分。她自這些流派所學到的，如動態、流動和裝飾等，在此展露無遺。本傑思擔任書籍設計者長達十年，讓她具備了絕佳的文字編排長才。

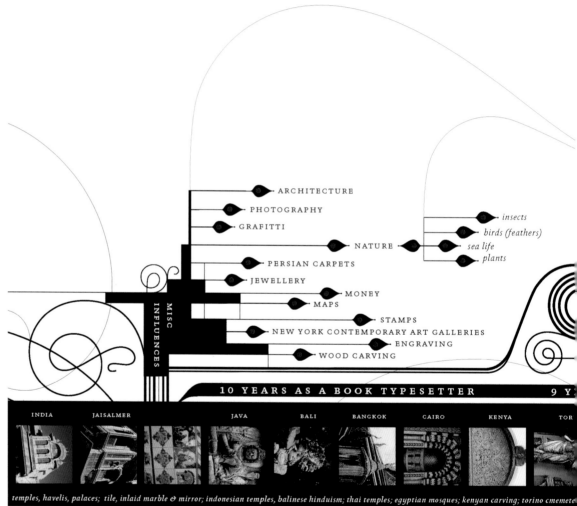

抒情味不僅來自於插圖的曲線，也出自線條粗細。大寫小字的字母間距增添了質感和明快感。「&」的符號十分美麗，儘管整體設計的動感令人印象深刻，但經仔細安排的直線線條，與曲線所形成的對比更是特色所在。

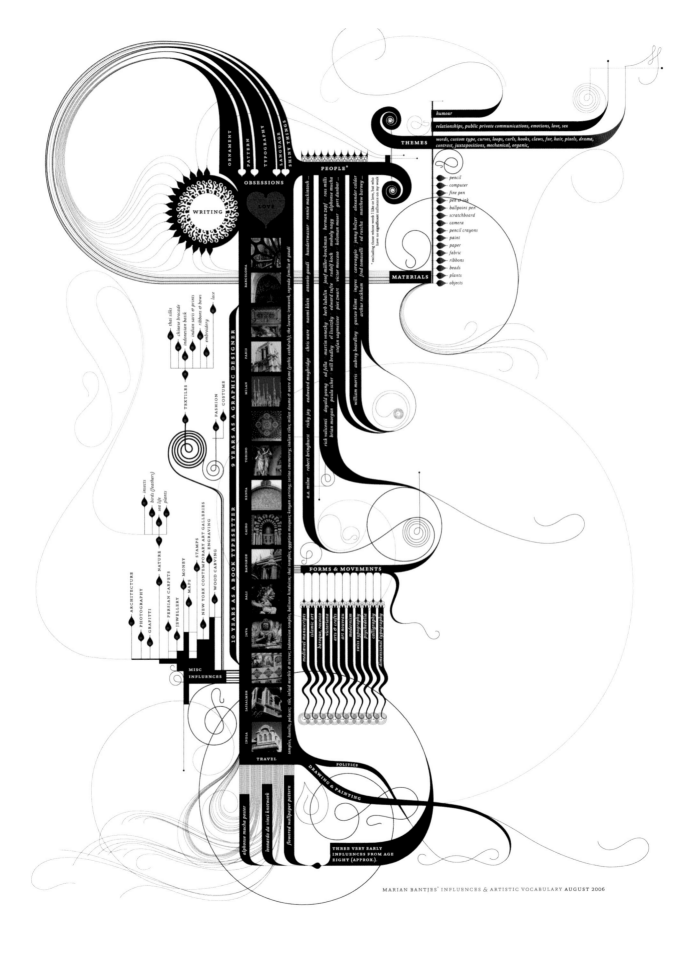

MARIAN BANTJES' INFLUENCES & ARTISTIC VOCABULARY AUGUST 2006

55. 運用（捲軸）收起的上下區域

要區隔頁面上的各個項目，最有效的方式便是分割現有空間。顯而易見的橫條可做為標示，吸引讀者注意要聞或訊息。此外，在橫條上方加一條底色，可以藉此將訊息與標題隔開，使頁面呈現一種迷人的緊張感，如正面與負面、明亮與晦暗、主要與次要的相互對立。

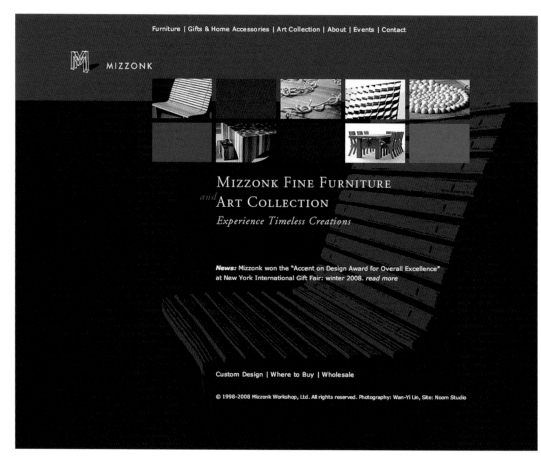

在橫向的編排中，首頁可從上到下快速閱讀。

名稱

www.mizzonk.com

客戶

Mizzonk Workshop

設計公司

Punyapol "Noom" Kit-tayarak

此為溫哥華訂製家具的業者網站，出現在頁面下方的細小字句為其設計特點。

在次頁面中，操作用的橫條仍是極為有用的橫向指引。

並非所有元素都大小一致或深度相同。將文字放在圖片下方，可創造一種順暢的流動感。

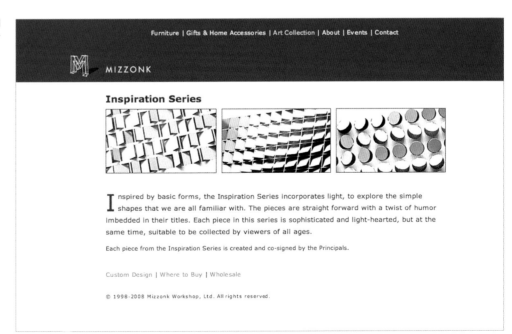

56. 熱鬧一點

有時文字不需全然清楚明白。不同的大小、走向、旋轉、寬窄與粗細變化，能讓文字效果倍增。在這種清況下，觀者不需仔細閱讀，就能融入其中。

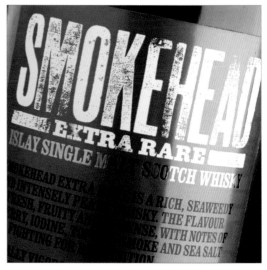

名稱
Identity and packaging

客戶
Smokehead

設計公司
Navy Blue

設計者指導
Marc Jenks

設計者
Ross Shaw

此包裝讓人聯想到木刻字，這樣的字型與陽剛、煙灰色的酒瓶外盒是絕佳的搭配。

前頁兩張圖：不管是做為海報
或包裝，此文字編排以有趣又
喧鬧的方式呈現出格線的設
計。除了顏色之外，字型所塑
造出的凸出與凹下的空間，使
得有些字模糊不清，有些則抓
住目光焦點。

瓶身的字型選用充滿巧思，品
牌標記故意設計得有些摩擦。
錫製外包裝上的文字排法，呼
應鑄字排版的3D立體感。

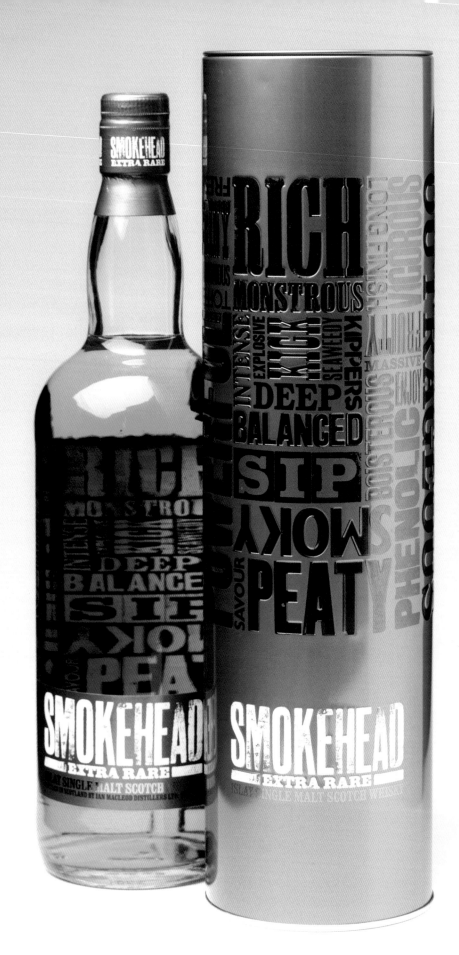

57. 轉個方向

名稱

Theater ad for *Cyrano de Bergerac*

客戶

Susan Bristow, Lead Producer

設計公司

SpotCo

創意指導

Gail Anderson

設計者

Frank Gargiulo

插畫者

Edel Rodriguez

這個《大鼻子情聖》的電影海報設計將重點放在要讓人印象深刻的片名部分,省去容易被忽視的文字,而將其中一個名字放到最大,其姓氏則以較小字型呈現。

字型可同時橫向與縱向放置。可以將大型字體視為一種特定空間,容納其他訊息。巧妙使用字距、不同的字型大小、寬窄和粗細,就能靈活調整各個人名的寬度。

本頁和下頁:安排簡潔與使用特定色調,未必一定會讓版面了無生氣。醒目的粗體形成版面中心的訊息欄。設計者以出色的人物輪廓插畫,結合精采生動的文字排版,強打片中的主角。

10 WEEKS ONLY

CYRANO

KEVIN KLINE

JENNIFER GARNER

DANIEL SUNJATA

DE BERGERAC

BY EDMOND ROSTAND

TRANSLATED AND ADAPTED BY
ANTHONY BURGESS

DIRECTED BY DAVID LEVEAUX

58. 擠進所有訊息

不管是海報、購物袋或火柴盒（或者是像文宣的對摺式紙火柴），在版面上放進大量文字，反而能有助於形成格線設計。使用大量線條明快又帶點鄉村風味的字型來編排商標和文字，可以突顯一些重要資訊，例如商家名稱和地址。

字型大小不一，能賦予版面動感和戲劇效果。調整字母間距和字型來將行句排列整齊，能產生一種閱讀訊息的優先順序。版面顏色深淺交替、有襯線字型與無襯線字型對比，以及大膽與低調相互呼應，這些反差形成一個個特定區域，可以擺放圖、物影和聯絡訊息。

名稱
Restaurant identity

客戶
Carnevino, Las Vegas

設計公司
Memo Productions, NY

設計者
Douglas Riccardi,
Franz Heuber

嚴整對齊的線條與格線劃分的區域，讓拉斯維加斯一家牛排館的文宣設計別具特色。有人想來些牛排嗎？

這家牛排館的火柴盒尺寸比大部分餐廳的還大，或者也可以說裡面的料更多。

CARNEVINO ITALIAN STEAKHOUSE
AT THE PALAZZO° HOTEL
3325 LAS VEGAS BLVD. SOUTH
702·789·4141
WWW.CARNEVINO.COM

59. 大玩格線

就跟爵士樂一樣，文字編排也是可以被切分的。即便格線編排緊密、考慮周全，排版時還是可能因字型大小、粗細和所在位置，造成版面擁擠。這樣的話，可以試試將所有元素稍加轉向，看看效果如何。

由於小的無襯線字型與大的字句相互成對比，所產生的動態讓版面有了強烈的律動感。放在版面側邊及去背圖片上的字型，其實也彷彿在搖擺。

名稱
Ads and promos

客戶
Jazz at Lincoln Center

設計公司
JALC Design Department

設計者
Bobby C. Martin Jr.

林肯中心的爵士樂文宣看起來鮮明又內斂，且充滿活力。整體設計俐落、有瑞士風，儘管有部分被裁切，但是非常酷。

反白字放在大小和寬度不同的
色塊裡，與裁切巧妙的圖片形
成強烈又有節奏感的對比。

60. 邀觀者參與

有時候格線設計要走出框架。字型大小、形狀及粗細都能傳達一種文化氣息，不論是在地性或是全球化的，都可激起讀者興趣，進而身體力行。

名稱

Alliance for Climate Protection advertisement

客戶

WeCanDoSolveIt.org

設計公司

The Martin Agency; Collins

設計者

The Martin Agency: Mike Hughes, Sean Riley, Raymond McKinney, Ty Harper; Collins: Brian Collins, John Moon, Michael Pangilinan

此環保推廣活動的廣告是利用粗體字來強調訴求。

字句的選用及字型大小可能是（也可能不是）經過精密計算的。大的字型能抓住目光，而較小或細的字則能留住目光。對於呼籲環保的廣告來說，亮綠色是顯眼又完美的顏色選擇。

61. 規律讓小邊緣發揮效果

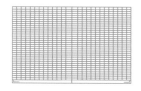

格線設計只要經過仔細規劃，邊緣部分還是可以留很小。若圖片都依明確的格線工整地編排，空間和排版又經仔細規範，外圍窄小的邊緣就可以是別出心裁概念的表現。勻稱的頁面所呈現出的專業度和規律，能烘托較窄的邊緣，讓中規中矩的版面有搶眼之處。

因此，剛開始要先預留空間，萬一出錯才不會無法挽救。邊緣對初學者和資深老手來說都一樣不太容易掌握。若要在格線設計加一點或很多變化，需要懂得平衡版面、具備熟練技巧，以及在錯誤中反覆嘗試。大部分傳統印刷業者和出版商，看到邊緣太小都會退避三舍。的確外圍邊緣若設定太小，印刷時是會受到影響。因此，出版品的設計者通常都會先確保外圍邊緣留得夠大。

名稱

étapes: magazine

客戶

Pyramyd/*étapes:* magazine

設計公司

Anna Tunick

在這本法國設計雜誌的版面上，整齊的格線成功地表現出規律感，而窄小的邊緣也是整體設計的一部分，以便盡可能容納最大量的文字。

頁面看起來很均衡又條理分明，顯示出格線設計有極大的彈性空間。所有元素都相互對齊，而大型字體則賦予律動感。整個版面內的空間，與外圍狹窄的邊緣成功地形成對比。文字排版也相當協調一致，各式粗細、大小、字體及顏色全都和諧並存。

此版面上的所有元素皆一致對齊，狹小的邊緣也與圖片之間所留的空間一致。

整個跨頁版面為12欄格線，有些欄位維持空白，可以平衡窄小的邊緣部份，為內容豐富的整個版面提供呼吸空間。

j'ai vu le moment où l'on allait inaugurer le bâtiment sans mon travail. POURQUOI? PARCE que l'on ne parvenait pas à s'accorder sur sa dénomination exacte: "sculpture typographique" ou "enseigne"?

62. 呈現重點

有些主題的內容比較深奧複雜，詳細說明很多。若要在有限空間，放入大量訊息，不妨利用設計技巧凸顯重點。這些技巧包括：保留空間形成刊頭與次要內容的色塊（用顏色編排）、列點陳述、可吸引讀者視線注意特定刊頭的小圖示，以及在重要標題與內容加顏色標示。

完整的圖示系統呈現在各頁的刊頭。相關議題的圖示均被特別強調，而且被用來成為每段文字的引導。

名稱

Materials and Displays
for a Public Event

客戶

Earth Institute at
Columbia University

創意指導

Mark Inglis

設計公司

Sunghee Kim

此複雜詳盡的教育網頁，採用圖示和顏色的整合系統，標示出各章節或段落的討論議題。各式各樣的圖像設計，包括圖示、標題、頁首文字、內容文字、圖片及圖表，一方面區別各章節，讓內容更易理解；一方面則符合各種理想的準則，包括空間、質感、顏色、組織、黑白對比空間，以及易讀的字型。雖然可以運用的教學方法有很多種，但工整清楚的頁面是有助於達到教導啟迪的功能，而不會讓學習者喪失興趣。

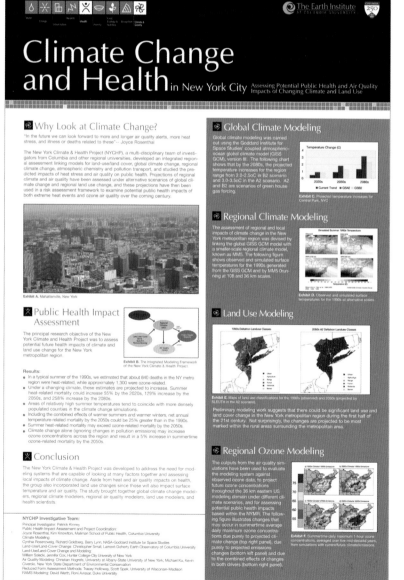

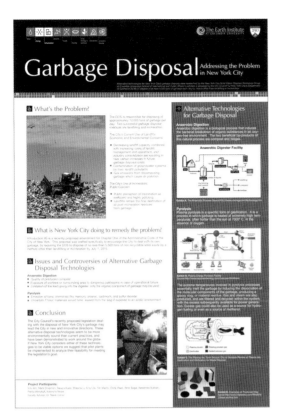

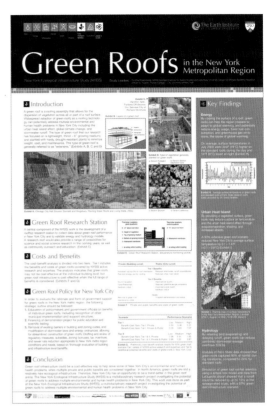

整體版面經過仔細整合規劃，使用一致的黑色橫條，在各頁面中做為刊頭。黑色橫條內承載且管理訊息，如圖示系統、哥倫比亞大學標誌、大學內研究所、主題題和副標題。

在黑色橫條下方，各項內容不只包含圖示，還包括標題。各標題在不同版面中以不同顏色及字體做為區隔。

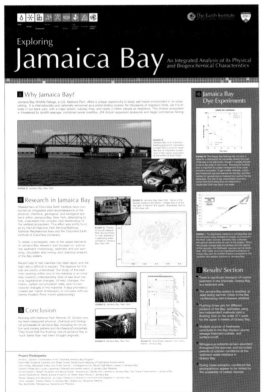

版面編排清晰，以項目符號來分隔內容。各個科學的主題結論，都是用該主題所代表的顏色呈現。

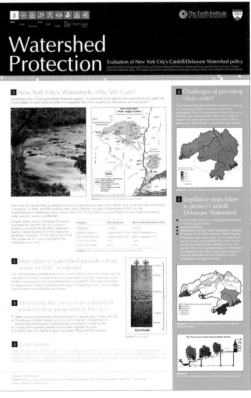

右側的邊欄也使用各類別的代表顏色為底，而且區分出內容的類別，如實驗與研究。

63. 避免擁擠

有時編排的重點是要放入所有的內容，而且還要清楚易讀。在處理指南、詞彙表或索引時，最好先找出合適的排版方式。

將標目文字放在色塊上，文字則放入欄位中。頁面的平衡是用頁尾的橫條來穩定。

名稱
Guide

客戶
Venice Bienniale

The Artists

為避免讓整個版面看起來黑壓壓一大片，可以放大主標題，若效果過於突兀，則可以用灰階顏色呈現。

Aballi Ignasi, Arsenale
Abd El–Baky Haiam, Egypt National Pavilion
Abdessemed Adel, Arsenale
Abidin Adel, Northern Europe National Pavilion
AES+F (Arzamasova Tatiana, Evzovich Lev, Svyatsky Evgeny + Fridkes Vladimir), Russia National Pavilion
Aghabeyova Tora, Azerbaijan National Pavilion
Ahmed Faig, Azerbaijan National Pavilion
Alakbarov Rashad, Azerbaijan National Pavilion
Alexiou Nikos, Greece National Pavilion
Alÿs Francis, Arsenale
Alptekin Hüseyin, Turkey National Pavilion
Alterazioni Video (Paololuca Barbieri Marchi, Andrea Masu, Alberto Caffarelli, Giacomo Porfiri, Matteo Erenbourg), Padiglione Italia in Giardini
Altmejd David, Canada National Pavilion
Alvarado Narda, Latin America National Pavilion
Amer Ghada, Arsenale
Anatsui El, Arsenale
Anselmo Giovanni, Padiglione Italia in Giardini
Aslanov Orkhan, Azerbaijan National Pavilion
Babayev Chingiz, Azerbaijan National Pavilion
Bajić Mrdjan, Serbia National Pavilion
Balassanian Sonia, Armenia National Pavilion
Bamgboyé Oladélé, Arsenale
Barcelò Miquel, Arsenale
Barrada Yto, Arsenale
Bartenev Andrey, Russia National Pavilion
Basilico Gabriele, Arsenale
Basquiat Jean Michel, Arsenale
Bengoa Mónica, Latin America National Pavilion
Benjamin Mario, Arsenale
Bidjocka Bili, Arsenale
Bouabdellah Zoulikha, Arsenale
Bourgeois Louise, Padiglione Italia in Giardini
Brandi Herbert, Austria National Pavilion
Bratkov Serhiy, Ukraine National Pavilion
Braun Jan Christiaan, Arsenale
Briceño Antonio, Venezuela National Pavilion
Bueno Patricia, Latin America National Pavilion
Buren Daniel, Padiglione Italia in Giardini
Buvoli Luca, Arsenale
Byrne Gerard, Ireland National Pavilion
Caldas Waltercio, Padiglione Italia in Giardini
Calle Sophie, France National Pavilion and Padiglione Italia in Giardini
Canevari Paolo, Arsenale
Capurro Christian, Arsenale
Cardoso Pablo, Latin America National Pavilion

Castellanos Maria Dolores, Latin America National Pavilion
Cherinet Loulou, Arsenale
Chkadua Eteri, Georgia National Pavilion
Chusuwan Amrit, Thailand National Pavilion
Cybil Vladimir, Latin America National Pavilion
Dahdouh Bassem, Syria National Pavilion
Dahlgren Jacob, Northern Europe National Pavilion
Damasceno José, Brazil National Pavilion
De Boer Manon, Arsenale
De Keyser Raoul, Padiglione Italia in Giardini
Dergham Sahar, Egypt National Pavilion
Detanico Angela & Lain Rafael, Brazil National Pavilion
Do Espirito Santo Iran, Padiglione Italia in Giardini
Drake James, Arsenale
Dumas Marlène, Arsenale
Duyckaerts Eric, Belgium National Pavilion
Dyu Natalya, Central Asia National Pavilion
Dzine, Ukraine National Pavilion
Effendi Rena, Azerbaijan National Pavilion
Eielson Jorge, Latin America National Pavilion
El-Komy Tarek, Egypt National Pavilion
El-Semary Aiman, Egypt National Pavilion
El-Solh Mounira, Lebanon National Pavilion
Elkoury Fouad, Lebanon National Pavilion
Emin Tracey, Great Britain National Pavilion
Epaminonda Haris, Cyprus National Pavilion
Export Valie, Arsenale
Eyfjörd Steingrimur, Iceland National Pavilion
Fatmi Mounir, Arsenale
Fei Cao, China National Pavilion
Ferrari León, Arsenale
Ferrera Ângela, Portugal National Pavilion
Fikry George, Egypt National Pavilion
Filomeno Angelo, Arsenale
Fischer Urs, Switzerland National Pavilion
Fogarasi Andreas, Hungary National Pavilion
Fudong Yang, Arsenale
Francisco René, Latin America National Pavilion
Fujimoto Yukio, Arsenale
Gabráns Gints, Latvia National Pavilion
Gaines Charles, Arsenale
Garcia Torres Mario, Padiglione Italia in Giardini
Geers Kendell, Arsenale
Genzken Isa, Germany National Pavilion
Gjergji Helidon, Albania National Pavilion
Gjokola Gent, Albania National Pavilion

Gladwell Shaun, Padiglione Italia in Giardini
Goksoyr Toril, Northern Europe National Pavilion
Gonzalez – Torres Felix, United States of America National Pavilion and Padiglione Italia in Giardini
Ganahl Rainer, Arsenale
Ganihar Tomer, Arsenale
Gmelin Felix, Arsenale
Guerin José Luis, Spain National Pavilion
Gugulashvili Zura, Georgia National Pavilion
Gutov Dmitry, Arsenale
Hajdinaj Alban, Albania National Pavilion
Hamon Neil, Arsenale
Harker Jonathan, Latin America National Pavilion
Harri Lyle Ashton, Arsenale
Hasanov Ali, Azerbaijan National Pavilion
Hill Christine, Arsenale
Hnlitsky Alexandre/Zaiats Lesia, Ukraine National Pavilion
Holzer Jenny, Arsenale
Hugonnier Marine, Arsenale
Hulusi Mustafa, Cyprus National Pavilion
Huseynov Orkhan, Azerbaijan National Pavilion
Huyghe Pierre, Padiglione Italia in Giardini
Ibrahimov Elshan, Azerbaijan National Pavilion
Ibrahimova Tamilla, Azerbaijan National Pavilion
Ihosvanny, Arsenale
Ivanov Pravdoliub, Bulgaria National Pavilion
Jaar Alfredo, Arsenale
Jacir Emily, Padiglione Italia in Giardini
Jones Kim, Padiglione Italia in Giardini
Joreige Lamia, Lebanon National Pavilion
Juste Andre, Latin America National Pavilion
Jůzová Irena, Czech and Slovak National Pavilion
Kabakov Ilya and Emilia, Arsenale
Kami Y.Z., Arsenale
Kapela Paulo, Arsenale
Kato Izumi, Padiglione Italia in Giardini
Kelly Ellsworth, Padiglione Italia in Giardini
Kenawy Amal, Arsenale
Khalilov Rauf, Azerbaijan National Pavilion
Kholikov Jamshed, Central Asia National Pavilion
Kia Henda Kiluanji, Arsenale
Kippenberger Martin, Padiglione Italia in Giardini
Kiyekbayeva Gaukhar, Central Asia National Pavilion
Komu Riyas, Arsenale
Kuitca Guillermo, Arsenale
Kvesitadze Tamara, Georgia National Pavilion
Labirint Art Group, Azerbaijan National Pavilion
Laing Rosemary, Arsenale
Lamata Rafael, Spain National Pavilion

Lee Hyungkoo, Korea National Pavilion
León María Verónica, Latin America National Pavilion
Leonilson, Padiglione Italia in Giardini
Leow Vincent, Singapore National Pavilion
LeWitt Sol, Padiglione Italia in Giardini
Lopez Rosario, Arsenale
Lim Jason, Singapore National Pavilion
Lozano-Hemmer Rafael, Mexico National Pavilion
Lulaj Armando, Albania National Pavilion
Mäetamm Marko, Estonia National Pavilion
Malani Nalini, Padiglione Italia in Giardini
Maljkovic David, Croatia National Pavilion
Man Victor, Romania National Pavilion
Manevski Blagoja, FYROM National Pavilion
Martens Camilla, Northern Europe National Pavilion
Maskalev Roman, Central Asia National Pavilion
McQueen Steve, Padiglione Italia in Giardini
Mejia Xenia, Latin America National Pavilion
Mercedes Jill, Luxembourg National Pavilion
Mescheryakov Arseny, Russia National Pavilion
Mik Aernout, The Netherlands National Pavilion
Mikhailov Boris, Ukraine National Pavilion
Miller Paul D. aka DJ Spooky, Arsenale
Milner Julia, Russia National Pavilion
Mofokeng Santu, Arsenale
Monastyrsky Andrei, Arsenale
Morán Ronald, Latin America National Pavilion
Mori Hiroharu, Arsenale
Morrinfno Group, Padiglione Italia in Giardini
Morton Callum, Australia National Pavilion
Mosley Joshua, Padiglione Italia in Giardini
Mosquito Nástio, Arsenale
Moudov Ivan, Bulgaria National Pavilion
Muñoz Oscar, Arsenale
Murray Elizabeth, Padiglione Italia in Giardini
Murtezaoglu Aydan, Turkey National Pavilion
Mutima Ndilo, Arsenale
Mwangi Ingrid, Arsenale
Naassan Agha Nasser, Syria National Pavilion
Namazi Sirous, Northern Europe National Pavilion
Naskovski Zoran, Arsenale
Nauman Bruce, Padiglione Italia in Giardini
Nazmy Hadil, Egypt National Pavilion
Netzhammer Yves, Switzerland National Pavilion

Ngangué Eyoum and Titi Faustin, Arsenale
Nikolaev Alexander, Central Asia National Pavilion
Nikolaev Stefan, Bulgaria National Pavilion
Norie Susan, Australia National Pavilion
Nozkowski Thomas, Padiglione Italia in Giardini
Odita Odili Donald, Padiglione Italia in Giardini
Ofili Chris, Arsenale
Oguibe Olu, Arsenale
Ohanian Melik, Arsenale
Okabe Masao, Japan National Pavilion
Opazo Mario, Latin America National Pavilion
Oraniwesna Nipan, Thailand National Pavilion
Ostapovici Svetlana, Moldovia National Pavilion
Paats William, Latin America National Pavilion
Parcerisa Paola, Latin America National Pavilion
Parreno Philippe, Arsenale
Pema Heldi, Albania National Pavilion
Penone Giuseppe, Italy National Pavilion in the Arsenale
Perjovschi Dan, Arsenale
Pettibon Raymond, Padiglione Italia in Giardini
Pineta Jorge, Latin America National Pavilion
Pogacean Cristi, Romania National Pavilion
Polke Sigmar, Padiglione Italia in Giardini
Ponomarev Alexander, Russia National Pavilion
Prieto Wilfredo, Latin America National Pavilion
Prince Emily, Arsenale
Putrih Tobias, Slovenia National Pavilion
Ramberg Lars, Northern Europe National Pavilion
Ramos Balsa Rubén, Spain National Pavilion
Restrepo José Alejandro, Arsenale
Rhoades Jason, Arsenale
Ribadeneira Manuela, Latin America National Pavilion
Richter Gerhard, Padiglione Italia in Giardini
Riff David, Arsenale
Rondinone Ugo, Switzerland National Pavilion
Rose Tracey, Arsenale
Rothenberg Susan, Padiglione Italia in Giardini
Rumyantsev Aleksei, Central Asia National Pavilion
Ryman Robert, Padiglione Italia in Giardini
Sacks Ruth, Arsenale
Sadek Walid, Lebanon National Pavilion
Salmerón Ernesto, Latin America National Pavilion and Arsenale
Salmon Margaret, Arsenale
Samba Cheri, Padiglione Italia in Giardini
Sanala Paata, Georgia National Pavilion
Sandback Fred, Padiglione Italia in Giardini

Sasportas Yehudit, Israel National Pavilion
Shonibare Yinka, Arsenale
Solakov Nedko, Arsenale
Sosnowska Monika, Poland National Pavilion
Soto Cinthya, Latin America National Pavilion
Spero Nancy, Padiglione Italia in Giardini
Streuli Christine, Switzerland National Pavilion
Tabaimo, Padiglione Italia in Giardini
Tabatadze Sophia, Georgia National Pavilion
Tang Dawu, Singapore National Pavilion
Taylor-Wood Sam, Ukraine National Pavilion
Tedesco Elaine, Arsenale
Teller Juergen, Arsenale
Thomas Philippe, Padiglione Italia in Giardini
Titchner Mark, Ukraine National Pavilion
Trope Paula, Arsenale
Trouvé Tatiana, Arsenale
Ugay Alexander, Central Asia National Pavilion
Urbonas Nomeda & Gediminas, Lithuania National Pavilion
Useinov Vyacheslav (Yura), Central Asia National Pavilion
Vallaure Jaime, Spain National Pavilion
Vari Minette, Arsenale
Vatamanu Mona & Tudor Florin, Romania National Pavilion
Vezzoli Francesco, Italy National Pavilion in the Arsenale
Vila Ernesto, Uruguay National Pavilion
Vilariño Manuel, Spain National Pavilion
Vincent + Feria, Venezuela National Pavilion
Viteix, Arsenale
Von Sturmer Daniel, Australia National Pavilion
Walker Kara, Padiglione Italia in Giardini
Warhol Andy, Arsenale
Weiner Lawrence, Padiglione Italia in Giardini
West Franz, Arsenale
Whetnall Sophie, Arsenale
Wirkkala Maaria, Northern Europe National Pavilion
Wolberg Pavel, Arsenale
Wörsel Troels, Denmark National Pavilion
Xiuzhen Yin, China National Pavilion
Xuan Kan, China National Pavilion
Yaker Moico, Latin America National Pavilion
Yonamine, Arsenale
Yoneda Tomoko, Arsenale
Yuan Shen, China National Pavilion
Zaatari Akram, Lebanon National Pavilion
Zhen Chen, Padiglione Italia in Giardini
Zhenzhong Yang, Arsenale
Zulkifle Mahmod, Singapore National Pavilion

64. 善用空間

編排複雜的訊息需要規範嚴明的格線設計。各單元的大小比例要依內容規劃，才能使觀者清楚易懂。由於海報版面夠大，是傳達密集訊息的絕佳平台。標題的設計最好能讓看的人在幾英尺遠也可以清晰可見。

名稱
Voting by Design poster

客戶
Design Institute,
University of Minnesota

編輯／企畫
Janet Abrams

藝術指導／設計公司
Sylvia Harris

這張海報極有規律地將重要的步驟過程切分開來，充分利用了每吋空間，並使用格線來引導讀者的視線。

下頁：即使海報上涵蓋了大量訊息，但在編排上將過程分成了幾個步驟，因此非常容易理解

VOTING BY DESIGN

The century began with an electoral bang that opened everyone's eyes to the fragility of the American voting system. But, after two years of legislation, studies and equipment upgrades, major problems still exist. Why?

Voting is not just an event. It's a complex communications process that goes well beyond the casting of a vote. For example, in the 2000 presidential election, 1.5 million votes were missed because of faulty equipment, but a whopping 22 million voters didn't vote at all because of time limitations or registration errors. These and many other voting problems can be traced not just to poor equipment, but also to poor communications.

Communicating with the public is what many designers do for a living. So, seen from a communications perspective, many voting problems are really design problems. That's where you come in.

Take a look at the voting experience map below, and find all the ways you can put design to work for democracy.

A COMMUNICATIONS MAP OF THE AMERICAN VOTER'S EXPERIENCE

EDUCATION	REGISTRATION	PREPARATION	NAVIGATION	VOTING	FEEDBACK
LEARNING ABOUT VOTING RIGHTS AND DEMOCRACY	SIGNING UP TO BECOME A REGISTERED VOTER	BECOMING INFORMED AND PREPARED TO VOTE	FINDING THE WAY TO THE VOTING BOOTH	INDICATING A CHOICE IN AN ELECTION	GIVING FEEDBACK ABOUT THE VOTING EXPERIENCE
WORD-OF-MOUTH	PAPER REGISTRATION FORMS	SAVE-THE-DATE CARD	EXTERIOR STREET SIGNS	HAND-COUNTED PAPER BALLOT	CENSUS SURVEYS
HIGH SCHOOL CIVICS CLASSES	ONLINE REGISTRATION FORMS	VOTER REGISTRATION CARD	PRECINCT SIGNAGE	MACHINE-COUNTED PAPER BALLOT	EXIT POLLS
CITIZENSHIP CLASSES	MOTOR VOTER APPLICATIONS	PUBLIC SERVICE ANNOUNCEMENTS	LINE AND BOOTH IDENTITY	MECHANICAL LEVER	
	VOTER ROLLS	PRE-ELECTION INFO PROGRAMS	PRECINCT WORKERS	PUNCHCARD	VOTING EXPERIENCE SURVEYS
		CAMPAIGN LITERATURE	CAMPAIGN WORKERS	DIRECT RECORD ELECTRONIC	
		SAMPLE BALLOTS		VOTING INSTRUCTIONS	

| DISAPPEARING CIVICS CLASSES | FORMS THAT ARE BARRIERS TO PARTICIPATION | TOO MUCH OR TOO LITTLE INFORMATION | GETTING TO THE BOOTH ON TIME | USER-UNFRIENDLY VOTING MACHINES | FUTURE IMPROVEMENTS LACK VOTER INPUT |

DESIGN TO THE RESCUE

ALL KINDS OF DESIGNERS CAN PARTICIPATE IN VOTER REFORM. HERE'S WHO SHOULD BE ON ANY VOTING DESIGN DREAM TEAM:

GRAPHIC DESIGNERS can help by designing voter information and educational materials that are clearly different from everyday, political material.

ENVIRONMENTAL GRAPHIC DESIGNERS can help voters get to the right place at the right time through effective signage and wayfinding.

INFORMATION DESIGNERS can make everything from registration forms to voting machine instructions easier to understand, by anticipating people's everyday navigation needs and understanding.

ARCHITECTS can work with election commissions to create precinct design guidelines that would enable any public space to be turned into an efficient voting precinct.

INDUSTRIAL DESIGNERS have the know-how to distill the most complex voting machines into easy-to-use, at-a-glance effort.

EXPERIENCE DESIGNERS can analyze the entire pattern of the voting process for election officials and help in creating a far better-designed voting system.

HOW YOU CAN GET INVOLVED

THERE IS WORK TO BE DONE TO IMPROVE VOTING BY DESIGN, STARTING WITH YOUR OWN COMMUNITY. HERE ARE FIVE THINGS THAT ANY DESIGNER CAN DO, TO MAKE A DIFFERENCE BEFORE THE 2004 ELECTIONS:

1. BECOME A POLLWORKER in your own precinct. By volunteering and spending time in your local polling place you can learn where small improvements in the design of communications or the physical space can be made, based about voting systems or other ways.

2. FORM A VOTING DESIGN COALITION in your own community. Gather together a group of design professionals and offer your services to your local election commission. If you are willing to volunteer, they will usually take advantage of what you have to offer. These coalitions can get involved in all aspects of voting design from precinct design to ballot typography.

3. WORK WITH THE POLITICAL PARTY OF YOUR CHOICE to improve design in the precincts and districts that are targeted for major get-out-the-vote campaigns. Many election officials win ways of change, but political parties can use well designed educational materials to help encourage voter participation. Political parties often have volunteer ever bureau based issues and can use as ideas from professionals like you.

4. CALL YOUR CONGRESSPERSON ABOUT HR 3295, the new federal election reform bill passed by Congress. Soon, $3.2 billion will be granted to the states to improve voting systems and administration. Ask your congressperson to donate some of those funds to design-related research projects. Follow the money and make sure designers at your state are involved in any reform efforts.

5. FORM A VOTING DESIGN ADVISORY TEAM within your professional organization. Under HR 3295, a new Election Assistance Commission will be given limited voting reform powers and funding. Your professional organization can and should send its best design professionals to Washington to work with the commission and to help create design guidelines for voting systems. Master sets of these guidelines can be you.

IDEAS AND SOURCES

VOTE PROJECT RESEARCH • DESIGN

DESIGN INSTITUTE KNOWLEDGE MAPS

DESIGN INSTITUTE

65. 設計出一個平衡的觀點

有些版面要求達到平衡的效果。文字的長度常是編排刊物的首要考量，尤其對非營利組織來說更是如此。在有限的版面（通常是四或八頁）中必須容納所有訊息，這是一種限制，但也有助決定架構。

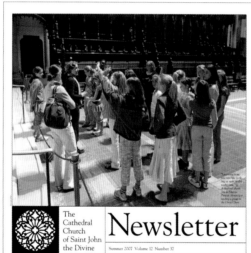

名稱

Newsletter

客戶

Cathedral Church of
St. John the Divine

設計指導

Pentagram

設計公司

Carapellucci Design

這份非營利組織的會刊充分展現五欄格線的多種運用方式。

此頁中，外圍欄位是放一些實用的資訊，列出資料出處、服務項目、聯絡方式及版面索引。外圍欄位以縱線分隔，剩下欄位便放入文章。插圖和引述的文字則是低調地插入這篇令人沉思的文章。

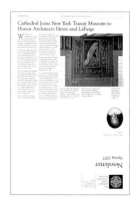

背面那頁的格線與正面的結構一致，還可做為郵寄單。

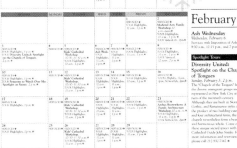

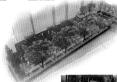

活動的年曆乃是利用格線來設計，分成一週各天寬度不同的欄位，而寬窄取決於文字多寡。線條為分隔線，粗線內可容納文字，灰階色塊則可放入次要訊息，而大型標題能讓頁面增添變化和質感。

文章和標題可占滿單欄、雙欄或三欄。圖片占滿整個欄位寬度，中間那張圖片的邊緣還以柔階處理，使得極有規律的版面，有視覺休息的空隙。

66. 引導讀者

不管版面多麼受人矚目,引導讀者閱讀的設計也必定功不可沒。線條、放大的首字、加粗的標題,以及規律但粗細和顏色同時有所變化(但要有限度)的字型,都能避免多頁連續走文看起來黑壓壓的一片,而且也有助於讀者在閱讀過程中找到各式各樣引起興趣的點,以及喘息空間。明智地慎選圖片大小和位置,也能進一步提升閱讀經驗。

名稱

Upfront

客戶

The New York Times and Scholastic

設計指導

Judith Christ-Lafond

藝術指導

Anna Tunick

這本雜誌期望能吸引青少年讀者關注國際新聞,並且看待這類新聞「就像看待自己的事一樣。」清新的設計風格有助於達成其宗旨。

首字放大、副標加粗,以及醒目的引述句子,都為頁面增添色彩、質感,以及趣味。而壓在照片上的插畫,也增添了質感和深度。這些頁面雖然充滿資訊,空間卻看起來仍然廣闊。

黑色橫條內放有反白字,強化了如標語(近似文案訴求)與引述等句子的部分。圖說放在黑色色塊上,引領讀者將目光移至醒目的圖片。

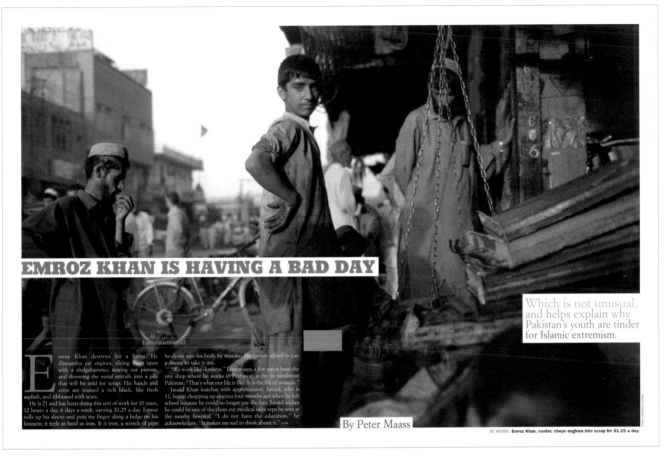

EMROZ KHAN IS HAVING A BAD DAY

Which is not unusual, and helps explain why Pakistan's youth are tinder for Islamic extremism.

Emroz Khan destroys for a living. He dismantles car engines, slicing them open with a sledgehammer, tearing out pistons, and throwing the metal entrails into a pile that will be sold for scrap. His hands and arms are stained a rich black, like fresh asphalt, and ribboned with scars.

He is 21 and has been doing this sort of work for 10 years, 12 hours a day, 6 days a week, earning $1.25 a day. Emroz rolls up his sleeve and puts his finger along a bulge on his forearm; it feels as hard as iron. It *is* iron, a stretch of pipe

he drove into his body by mistake. He cannot afford to pay a doctor to take it out.

"We work like donkeys," Emroz says, a few paces from the tiny shop where he works in Peshawar, a city in northwest Pakistan. "That's what our life is like. It is the life of animals."

Javaid Khan watches with apprehension. Javaid, who is 17, began chopping up engines four months ago when he left school because he could no longer pay the fees. Javaid wishes he could be one of the clean-cut medical sales reps he sees at the nearby hospital. "I do not have the education," he acknowledges. "It makes me sad to think about it." →

By Peter Maass

AT WORK: **Emroz Khan, center, chops engines into scrap for $1.25 a day.**

If you want to understand why young Muslim men line up to be suicide bombers, you would do well to stroll down Cinema Road, where Emroz and Javaid work. You would hear the chanting call to prayer, the shouts of peddlers selling bruised bananas, the groan of buses so overloaded that passengers ride on the roofs, and the cries of mutilated beggars pleading for a few cents. And all around, you would notice young men for whom life is abuse. The population of Peshawar (pronounced puh-SHAH-wuhr) reflects the population of Pakistan as a whole—63 percent are under the age of 25.

Most of these young men are not burning effigies of President George W. Bush or fighting Pakistani riot police. Their anger is only loosely expressed, often because they are struggling to survive and cannot afford the luxury of taking an afternoon off to join a demonstration.

They believe, or can be led to believe, that America is to blame for their misery. Many are adrift, cut off from their social foundations. Perhaps they moved to the city from dying villages, or were driven there by war or famine. There is no going back for them, yet in the city there is not much going forward; the movement tends to be downward. As they fall, they grab hold of whatever they can, and sometimes it is the violent ideas of religious extremists.

AN ANCIENT CITY PLAGUED BY WAR

Peshawar, once conquered by Alexander the Great and Genghis Khan, is one of the oldest cities in Asia. The city has long been the gateway to Afghanistan—a designation that became a curse 22 years ago when Afghanistan entered an era of warfare that has yet to end. Nearly half of Peshawar's 2 million inhabitants are Afghan refugees, most of them living in squalid camps. The local economy revolves around the smuggling of guns and ammunition, of VCRs and TVs, of heroin and hashish.

Aziz ul Rahman is a product of Peshawar. He is 18 and works in the mornings at a tire shop. In the afternoons he studies the Koran at a madrassa, or religious school. The

WORK OR PLAY **Children scoop up ash at a Peshawar brick kiln.**

one he attends is of the extreme variety, as most are these days. I meet him at a protest organized by a pro-Taliban religious party.

"The American leaders are very cruel to Muslims, so that is why I am taking part in the demonstration today," he says politely. What he means is that America supports Israel, which is seen in the Muslim world as oppressing Palestinians, and supports certain Arab regimes, such as the one in Saudi Arabia, which are regarded as corrupt and oppressive.

In the background, a speaker is railing against Pakistan's military government, which supports the U.S. anti-terror campaign. "The generals are stupid," the speaker shouts. Then, like a rock star inviting crowd participation, he calls out, "Generals!" and the crowd roars back. "Stupid!" They are quick learners.

Aziz did not fall into religious extremism by choice; his preferred path, of becoming an engineer, was closed off by poverty. This is common in Pakistan. Poor families do their best to send a son to school, but in the end they cannot manage. The son will get a backbreaking job or maybe keep the donkey's life at bay by enrolling at a madrassa, most of which offer free tuition, room, and board. That's where they learn to think it's honorable to blow yourself up amid a crowd of non-Muslims and that the greatest glory in life is to die in a holy war.

1,000 BRICKS A DAY, SIX DAYS A WEEK

On the outskirts of Peshawar is Dabaray Ghara, an expanse of pits in which several thousand men, mostly Afghan refugees, make bricks. This labor, literally backbreaking, pays next to nothing and takes place outdoors, no matter how hot or cold.

Bakhtiar Khan began working in the pits when he was 10. He is now 25 or 26. He is not sure, because nobody keeps close track. He works from 5 in the morning until 5 in the afternoon, making 1,000 bricks a day, six days a week, earning a few dollars a week. He is thin, wears no shirt or shoes, and he cannot believe a foreigner is asking about his life.

"Life is cruel," Bakhtiar says. "You can see for yourself. You wear nice clothes and are healthy. But look at us. We have no clothes to wear, and we are not healthy. Your question is amazing."

The youths at Dabaray Ghara are illiterate, and the world of politics is beyond their grasp. They can be led to rally behind any person or idea that promises to improve their lot. "I blame the world community," Bakhtiar says. "All humans should be equal, but we are not. . . . We arrived from Afghanistan 15 years ago. Since then I blame America.

CHILD LABOR: **This 7-year-old works at a brick factory outside Peshawar. About 3.3 million Pakistanis under 14 work full-time.**

The youths at Dabaray Ghara are illiterate, and the world of politics is beyond their grasp. They can be led to rally behind any person or idea that promises to improve their lot.

because it used to support us, but now it leaves us in a place like this. So if someone is fighting a jihad against America, I would support them. But if America is willing to help us, we support that, too."

VIDEO GAMES & A FARAWAY FATHER

Ihsan u-Din is enrolled at a civil engineering college in Peshawar. Ihsan, 18, speaks good English, and he has the ultimate luxury in Pakistan—pocket money, which is why I can stop him at a video parlor. Compared with Emroz and the brick makers and most youths here, Ihsan has it good. But there's a catch. Pakistan is one of the poorest countries in the world. Even with a degree, it's very hard to get an

engineering job. You need connections and money. Ihsan's family doesn't have enough of either.

"It is a game of money," he explains. "Even if you are a good engineer, you will not get a positive response when you apply, unless you pay. This has been the truth for 20 years."

The second catch is this: Ihsan's father is staying in the United Arab Emirates, where he works as a taxi driver earning infinitely more than he could in Pakistan. He sends money back to his family so that his children can eat well and go to school, but he doesn't earn enough to buy a plane ticket home.

"I have not seen my father for eight years," Ihsan says. "Is that right? He sends pictures and calls. But we don't want

此頁的版型結構嚴謹，而精心挑選的照片與插入圖片的白色方格，使頁面別有生氣。

顏色、大寫、橫線和box等手法，吸引讀者從文字開頭讀起。文字編排的各項元素相互作用，效果頗為成功，並引導讀者觀看令人動容的照片。

67. 設定自己的節奏

版型即是述說故事的方式，尤其是有跨頁插圖的版面。這些跨頁或螢幕頁面需要設計版型，尤其是書籍章節頁或雜誌專題文章。

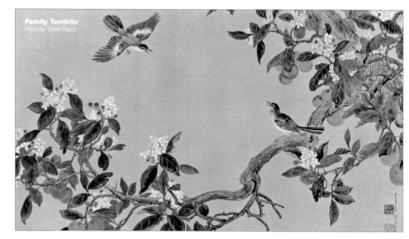

開頭的跨頁可以做成整版出血的版面。這個非常動人的跨頁為後面的頁面定調，就像電影的標題左右內容調性一樣。

名稱

Portrait of an Eden

客戶

Feirabend

設計公司

Rebecca Rose

這本詳述一個地區發展和歷史的書，使用不同的跨頁版面編排，來引領讀者閱讀各個時代的演變。

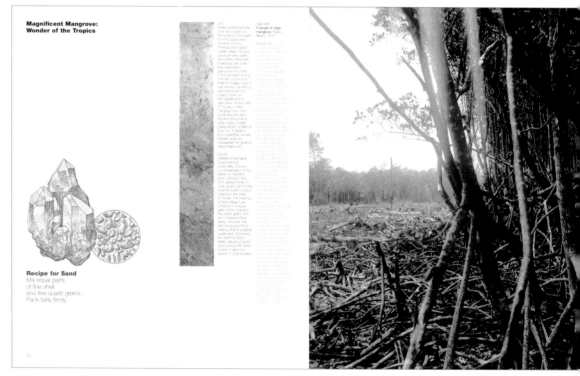

從單頁或整版跨頁到下一個頁面，各個頁面或跨頁上的字型大小、形體、欄位、圖片和顏色等的變化，引導了整個故事進行，提供一種戲劇效果。

Gertrude leaning against a coconut palm in Lummus Park wearing a playsuit, 1938. A range of Miami's architecture, a sliver of the beach, and in the background, stretching the length of Ocean Drive from 6th Street to 14th Place, Lummus Park was donated to the City in 1912 by the Lummus brothers' Ocean Beach Realty Company.

A few years later, Ave was mesmerized, perhaps with the motor fuel to aggrandize rich soften when a nurse brought under ground mineral. To host the sandy aqua pearl sculpted patterns were planted as well as a palisade closing arcade just a few feet off the. Finally, a fire road wide sidewalk with a 10,000 from 5th to the 14th the Lummus Brothers silent $40,000 to create and maintain Lummus Park for the people of Miami Beach.

Barbara June Oka poses by the Shower of Gold - known for its silky bark, red light and the smooth paled and spiked mass relevant along path, the yellow and pink its simple structure.

Healing Plant

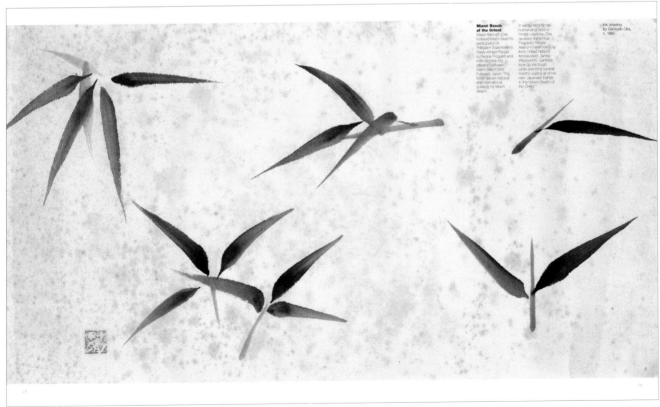

Miami Beach of the Orient

Mayor Kenneth Oka fostered Miami Beach's participation in President Eisenhower's newly minted People to People Program and intended the city affiliation between Miami Beach and Nagasaki, Japan. This bond created national and international publicity for Miami Beach.

In recognition for his outstanding work in foreign relations, Oka received the annual Peoplento People Award in New York City from United Nations Ambassador James Wadsworth. Gertrude took up the brush while spending several months visiting all of her new Japanese friends in the Miami Beach of the Orient.

Ink drawing by Gertrude Oka, c. 1960.

廣闊卻又不失重點 ■ 135

68. 創造綠洲

如果想呈現權威感並且聚焦，少即是多。空間讓讀者知道重點是在哪裡。

The driving principle of Cuadro Interiors is to ensure the building process works professionally and efficiently. Projects are executed on an individual basis, utilizing a skilled team of long-term employees and tradespeople. Our commitment is to produce the highest quality project in a reasonable and honest manner.

Founded by Raphael Ben-Yehuda and Mark Snyder, Cuadro's approach reflects its partners' backgrounds in fine arts. Their combined forty plus years of building experience includes projects ranging from wood boat building to faux finishing.

Today we are a company with extensive experience in a broad range of project types, from historically accurate prewar homes to modern offices to contemporary residences in a range of materials.

以單元主題介紹作品。

名稱

Cuadro Interiors
capabilities book

客戶

Cuadro Interiors

設計公司

Jacqueline Thaw Design

設計者

Jacqueline Thaw

攝影者

Elizabeth Felicella,
Andrew Zuckerman

這是為一家室內設計公司製作
的公司簡介，以單元式格線為
基礎，並刪減不必要的內容，
僅著重介紹他們設計過的有特
色的住家和辦公室。

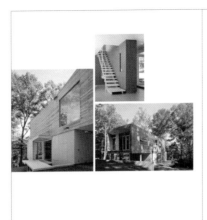

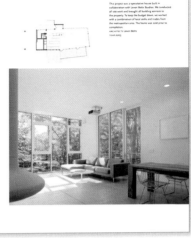

Hudson Valley House

This project was a speculation house built in collaboration with Leven Betts Studios. We conducted all site work and brought all building services to the property. To keep the budget down, we worked with a combination of local skills and trades from the metropolitan area. The home was sold prior to completion.
ARCHITECTS: Leven Betts
YEAR 2003

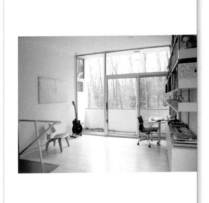

賞心悅目的留白空間，能讓讀
者有機會來回觀賞每張圖片和
內容部分。

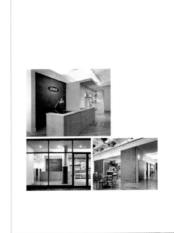

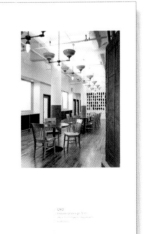

69. 讓圖片自己說話

留白的頁面能讓人很快就能注意到要凸顯的照片或插圖。讀者能一眼就看到主要焦點，不會分神。

製造空間

內容往往會左右設計者分配文字或圖片的空間。若文字是要和特定照片、圖片或圖表搭配，那麼圖片的位置接近相關的文字，對讀者而言最為清楚。若還要來回翻找比對，則會有反效果。

照片的尺寸大小也會有影響。將藝術品的圖片放大、聚焦在其中細節，能為跨頁版面帶來朝氣。就吸引注意力而言，以圖片四周為白色空間，與圖片周圍放了許多其他元素相比，前者對觀者較具吸引力

名稱

*Mazaar Bazaar: Design and
Visual Culture in Pakistan*

客戶

Oxford University Press,
Karachi, with Prince Claus
Funds Library, the Hague

設計公司

Saima Zaidi

這本關於巴基斯坦設計史的書，使用了嚴密的格線來編排珍貴的巴基斯坦工藝品，作品周圍則留下大量留白空間。

這篇名為〈石製記事板〉的文章，內容討論的是一件手握蓮花的工藝品。版面留有大量空白，而以下頁的圖說、文章及註釋來加以平衡。

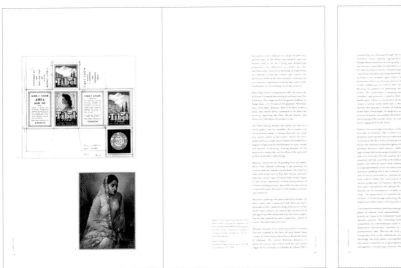
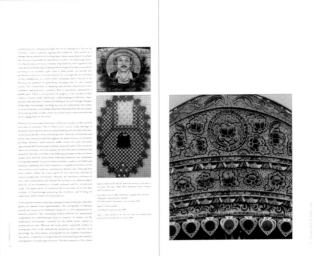

一系列的髮油包裝圖與人物肖像放在同一頁面上，搭配大量的空間供讀者來回瀏覽。

這些繪畫和花紋樣式，讓版面配置看起來多采多姿，其中一張圖是出自一個小東西的背面。

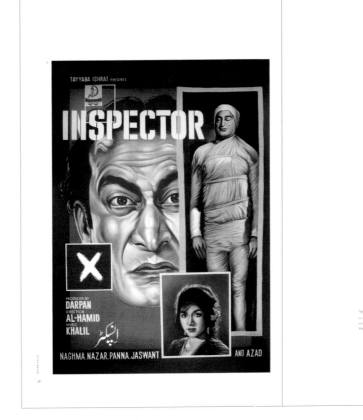

以風格強烈的圖片做為文章段落起頭。

70. 以手繪圖規劃版面

手繪草稿能讓概念成形，並有助於編排平面出版品或網頁頁面的版面。初稿可能看起來像隨意塗鴉，而非看得懂的各個元素，但卻能提供整體規劃或概念雛形。若要在一個大概的版面構想中放入一張或多張圖片，可以先畫出圖樣和格線，以便構思如何將不同元素搭配在一起。

粗略畫出概念及圖樣能省去不少功夫，因為沒有人有時間可以一再重複各個步驟。不管版面編排是否包括字型、圖片，或手繪文字、圖片，構思都極為重要。

此草稿所顯示的，不僅是思考和草擬過程，也是組織整個藝術品中多元圖片的方法。

上圖與下圖：畫好主圖且安排妥當後，就可以設計其他部分。

名稱

McSweeney's 23

客戶

McSweeney's

設計公司

Andrea Dezsö

總編輯

Eli Horowitz

在這本《麥絲維尼23》（Mc-Sweeney's23）的書封上，藝術家Andrea Dezso將其手繪、鏡像及重複的圖形，運用各種不同媒材呈現，並組合在一起。鉛筆素描、手縫刺繡、3D立體手工皮影照片、蛋彩畫，以一種嚴密的架構編排起來。Dezso用到電腦的部分只有掃描和編排。

此書封設計主要著重於花紋和規劃，以及爭奇鬥艷的封面繪圖。在這張大封面上，其實放了許多不同書籍封面。

框裡的框放了十個封面和封底，每一個封面都是《麥絲維尼23》裡的一個故事。十個封面又組合在一個對摺的雙面書衣中，展開後就變成一張適合展示的全開海報。手繪框在視覺上極為吸睛，成功地將各部分統合起來，使原來各自獨立的藝術插畫結合成更完美的整體。

71. 隱含階層關係

即便版面是搭配圖片以拼貼方式設計，或將版面元素隨興組合在一起，都隱含了階層關係，尤其是關於上帝的主題最為常見。譏諷階層關係有時會讓設計更有趣，當然也就更成功。

上帝和統治者出現在以線條劃分的欄位上方。所有文字遊戲皆故意為之。

名稱

Xanadu, the Book! Seriously!

客戶

KD Productions

編輯指導

Karen Davidov

藝術指導與設計

Mark Melnick

專案顧問

Chip Kidd

此書像是奇妙古怪的讚頌歌一樣包羅萬象，在沒有特定版型的規範下，書中融合劇場史、藝術史以及小說史的內容。

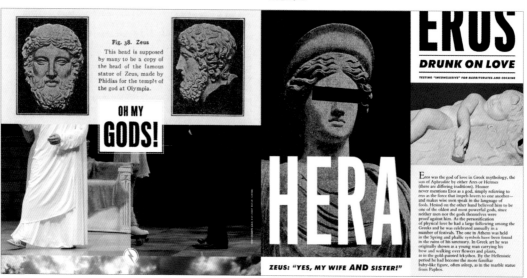

大小！粗細！裁切！

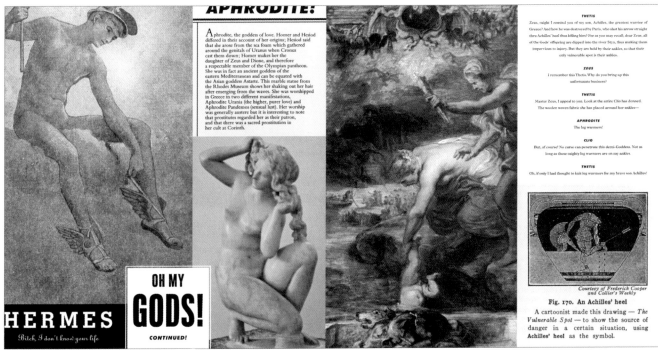

這個有趣又瘋狂的版面實在妙不可言。一切都經過安排,因此圖片是相互關聯,不只在內容上,配置上也息息相關。

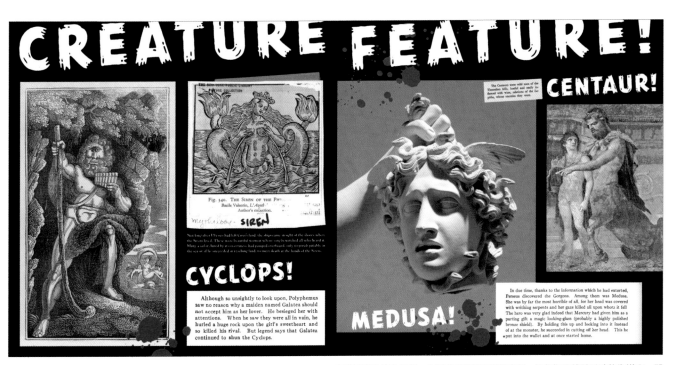

有時最出色的設計者,會刻意選擇最通俗的字型。這個版面設計以功能為導向,即使版面是採拼貼方式,字型來自恐怖電影也是如此。

看起來不存在的格線 ■ 143

72. 結構組織原則

即便一開始並沒有以基本的格線原則來設計版面，但還是會派上用場。格線通常都是用來編排重複或連續內容，不過也適用於想要表現動態感的版面。此外，版面的設計概念還可以是一張如格線般的圖片。

名稱

A Monstrous Regiment of Women
and *The Beekeeper's Apprentice*

客戶

Picador Publishers

藝術指導／設計者

Henry Sene Yee

插畫者

Adam Auerbach

從這兩本系列書的書封，可以看出設計者有技巧地使用結構安排，巧妙運用了負空間來設計。

《養蜂人的學徒》以蜂窩造型，框出行銷文案、作者、書名和引述。

A NOVEL of
SUSPENSE FEATURING
MARY RUSSELL and
SHERLOCK HOLMES

LAURIE R. KING

THE *NEW YORK TIMES* BESTSELLING AUTHOR

The
BEEKEEPER'S
APPRENTICE

PICADOR

"*The Beekeeper's Apprentice*
has the power to charm the most
grizzled Baker Street Irregular."
—*Daily News* (New York)

73. 流動性

結構完整的設計，往往具有穩固的基礎，雖然框架部分不會馬上就被注意到。

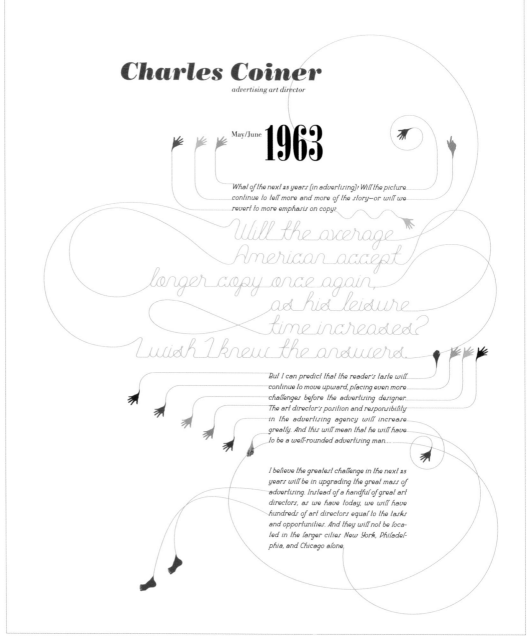

名稱

Magazine illustration

客戶

Print magazine

設計公司

Marian Bantjes

這本設計雜誌的頁面，展現了細膩的文字編排功力。

瑪莉安・本傑思（Marian Bantjes）論技巧

「我會在視覺上對齊所有元素。在這方面我是挺偏執的，而且堅持版面一定要有結構。我會把頁面元素與部分圖像，或是標題的垂直線相互對齊。我會多方嘗試並極為講究，以確保效果。我也對邏輯結構、內容階層關係和一致性等原則很堅持。我認為設計與文字編排就像身訂作的西裝：一般人可能不會特別注意到手縫鈕扣（字距）、合身的縫摺（對齊完美），或是高級布料（字型大小零缺點）……他們只是憑直覺認為這套西裝看起來好像價值百萬。」

此頁與左頁：瑪莉安・本傑思十分注重文字編排的細節，例如段落要首尾對齊，並搭配間距一致的字型，而這些自某個年代選取的字型，從她敏銳的眼光看來仍是十分清新。不過，真正讓頁面鮮活的是她充滿巧思、如插畫一般的書寫字體。

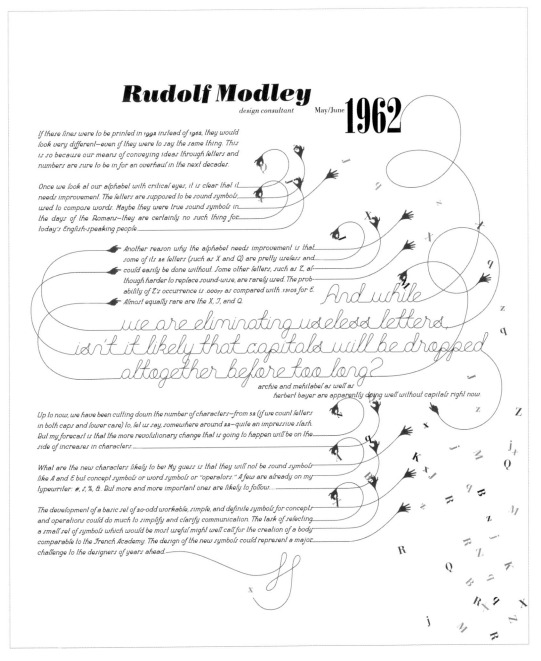

74. 規劃「插入」

規劃是設計的首要原則之一。版型即規劃，格線也是一種規劃。插入原有編排也是規劃的一環。藉著決定哪些名字或者特點要放大或加粗，哪些需要加上顏色，以及是否放大文首字母是否有幫助或有必要，設計者要決定哪些是可以做為插入編排的部分。

變化各式圖片的大小也可做為一種編排上的插入，為版面添加生命力和樂趣。

sylvia tournerie revisite les formes des **avant-gardes.**

POUR l'art et la musique : **constructions et collages** par vanina vinter ■ ■ ■

工整的格線襯托出色彩鮮豔的大張圖片。

名稱

étapes: magazine

客戶

Pyramyd /*étapes:* magazine

設計公司

Anna Tunick

這是法國雜誌《étapes》的跨頁頁面，設計者以大張圖片、去背的圖像或大量留白空間，來避免整體版面流於制式。

4. pochette du maxi-vinyle
"novo screen" pour
le groupe bosco, 2002.
2. pochette cp pour panti
will, album "w.i.l.l", 2003.
3. pochette de "eastback"
maxi-vinyle pour sodex,
(pour le label client zoooo1),
utilisation d'une typo
originale, la copland.
5. pochette cp pour
experience, album
"hémisphère gauche", 2004.

ses "gimmicks"

À l'incontournable – et douloureuse – question sur l'auto-définition de son style, Sylvia Tournerie évoque deux éléments signifiants. L'école s'étant équipée d'ordinateurs à la fin de ses études et le recours à la photocopieuse étant également plus facile, cela a entraîné un style repérable, économique, un jeu de découpes. *Mon travail est marqué par des grosses masses noires avec des couleurs primaires.* Difficile de ne pas faire allusion à l'empreinte de Cieslewicz. Sylvia Tournerie a étudié à l'ESAG-Penninghen au temps où Roman Cieslewicz y enseignait? Il fut son maître de thèse. De lui, elle se souvient d'un rire qu'il eut, durant un stage, alors qu'il manipulait des formes et concevait un hors-série pour *Le Monde.* Cette excitation, cette légèreté, qui ne s'essouffle pas malgré les années, cette ouverture d'esprit face aux étudiants, n'excluant pas la sévérité, sont les "outils" qu'il lui légua. L'attitude de Cieslewicz, entre détachement et jouissance personnelle d'une affirmation, semble être une aspiration, comme un moteur pour la graphiste. Son style se forgea aussi en raison des contraintes financières qu'elle subit. Les labels n'ayant pas de budgets pour une production photo, jugeant que ses propres photos ne peuvent se suffire à elles-mêmes, elle transforme celles qu'elle reçoit ou qu'elle prend en paysages. Ainsi, ses photos sont-elles plus à l'aise avec l'esprit décalé provoqué par les collages. Dans ces conditions naît la mémorable et si furtive identité de *Point éphémère,* où elle transforme en une toile de Jouy, les acteurs de la musique.

émergence

Sylvia Tournerie ne compose que sur ordinateur, et parle de la légèreté de l'outil, puisque, au propre comme au figuré, les données ne pèsent rien. Sur son Mac, un dossier vrac regroupe ses premières sessions de travail peu organisées, *une étape de vidage, suite à ma rencontre avec le commanditaire.* Dans un état presque hypnotique, où l'important est de se laisser aller, elle façonne une matière formelle abstraite. Elle la pétrit jusqu'au moment où se manifeste la première émotion, cette émotion, qu'elle peut perdre en cours de route, mais qu'elle n'a de cesse de faire vivre, de conserver jusqu'au bout du projet. Tout est dans le doigté et dans ces ressentis impalpables. Sylvia Tournerie parle avec sensibilité, avec intelligence de cette étape de travail, capitale, qui l'interroge douloureusement aussi. Elle évoque son incapacité à décrypter ses convictions. Cette étape est de l'ordre de l'émotion. *J'ai rarement une idée avant de faire les choses.* Ainsi, l'objet graphique émerge-t-il de son façonnage. *Je justifie les formes une fois qu'elles sont là.* Pendant longtemps, il lui fut difficile d'assumer cette prétendue gratuité, aujourd'hui, Sylvia Tournerie se dit plus sereine face à sa façon de composer? Ses formes ne sont pas le fruit du

hasard, avec l'expérience, toutes relèvent d'un choix. Sylvia Tournerie agit dans la traduction – le graphisme avec ses composants parle à l'âme directement de la même manière que la musique parle avec ses notes et ses gammes –, elle n'est pas sur le territoire des intentions. Ses identités visuelles ne sont pas des chartes, mais des pulsations, des vibrations, concentrées ou fragmentées.

Peu d'affiches, pas de théâtre, ni d'identité institutionnelle (excepté sa participation avec Gilles Poplin à l'identité du CNAP *cf. 126*), pas de gros chantiers, ni de régularité (cette situation qu'on retrouve chez d'autres de ses contemporains devrait inciter les commanditaires à défier ces graphistes sur ces terrains balisés). Pourtant, les gammes de Tournerie marquent leur empreinte dans le

poster pour la styliste
andrea crew (avec la
participation de leslie
david, 2006). au recto, les
mannequins présentaient
la collection de la saison et
des motifs géométriques
auréolaient chaque modèle
et accentuaient leurs
postures irrévérencieuses.
au recto, le processus
de travail d'andrea crews
se révèle dans un vaste
désordre recollé: la styliste
élabore ses pièces uniques
à partir d'habits récupérés
et recyclés.

www.andreacrews.com

去背的圖像和精挑細選的照片，為井然有序的頁面整版帶來生氣。

75. 考慮戲劇效果

裁切能創造戲劇效果。直接使用原來拍攝的圖片能夠敘述故事，不過若經過裁切，便能形塑特定重點、傳達觀點，以及引發讀者恐懼或興奮的情緒。此外，裁切也能改變照片傳達的訊息，引導視線到照片的焦點，略過多餘部分。

注意裁切限制
要注意某些圖片裁切時的限制。許多博物館會嚴格規定藝術品的圖片要如何使用。有些圖片，特別是關於著名畫作或雕塑的圖片，都不得隨便刪改。此外，有許多步驟類的圖片必須完整呈現，才能確保教學性的內容是清楚明瞭。

名稱

Paparazzi

客戶

Artisan

設計公司

Vivian Ghazarian

攝影者

Rose Hartman/
Globe Photographers

圖片的某個部分就是唯一要呈現的內容，傳達出本書擅闖入侵的主題特質。

下頁：聳動吸睛的八卦小報，以斗大的文字對應大膽的裁切圖片。

PAPARAZZI

PETER HOWE

76. 使用去背圖增添動感

去背圖能避免讓頁面顯得過於死板或沉悶。為了符合排版需求，去背圖片是指消除背景的圖片。去背圖可以是各種形體，例如葉片，或是較固定的形狀，如圓形。去背圖的形狀愈有動態感，就愈能增添版面的動態感。

名稱
Croissant magazine

藝術指導
Seiko Baba

設計者
Yuko Takanashi

此日本手作雜誌的頁面，顯示出去背圖是如何有助於凸顯編排的規律和組織。

橫線和縱線明顯地界定出標題、每篇介紹文字和主文的區域。各頁面的步驟指示極為清楚，且因去背圖的植物形狀顯得更為生動。

線條為原本雜誌的格線設計增加了額外的格線。各個元素都編排得工整和清楚。圖像的形狀互異，為規律又有階層的頁面增添動感。

首藤さんは多めに炊いて袋に入れて保存している。

自然形狀 ■ 153

自然形狀

77. 直覺為上

就和大自然一樣，結構和變化也是設計的重要元素。若版面編排上必須使用清楚劃分的欄位格線，那麼加入去背圖或看來隨興的圖像，會大有幫助。

統一元素對清楚傳達訊息極為重要，但設計若可以表現出不做作與異想天開的特點，能讓內容難忘、悅目又平易近人。當然如果可以寓教於樂是最好。

名稱
Poster

客戶
Philadelphia University

設計公司
The Heads of State

版面設計
Jason Kernevich,
Dustin Summers, and
Christina Wilton

攝影
Christina Wilton

費城大學設計與多媒體學院的系列演講海報，設計者巧妙地將媒體結合進來。

連續走文編排的版面直接又適中，並且以內含標題的白色方塊圖形做為版面的一些停頓。古典的工筆畫（鳥）則額外增添自然風味。

下頁：長方形的大型圖片位於嚴謹的三欄式格線上方，此為遵守格線規律的部分。圖片的文字部分為手工繪製，長方形的背景是以種子整齊鋪滿，字母形狀則為其反白部分。

2008 SPRING LECTURE SERIES

**PHILADELPHIA
UNIVERSITY
SCHOOL OF DESIGN
AND MEDIA**

Graphic Design

CHRISTOPH NIEMANN

Thursday, April 10th, 7:00 p.m.

Tuttleman Center Auditorium

Co-sponsored by AIGA Philadelphia

Industrial Design

PAUL HAIGH

Light : Space : Material

Friday, April 11th, 6:00 p.m.

Gutman Library Media Room

78. 設定系統

多用途的系統，能將不同大小、圖形和內容以多種方式排列組合。

先驅者

愛倫‧勒普頓認為，瑞士格線首倡者Josef Müller Brockmann和Karl Gerstner定義了設計的「程式」，建構出一套解決視覺設計問題的規則。勒普頓點出了瑞士設計的重要關鍵點：「這些設計者在重複結構的範圍內，創造出驚喜和變化。這個編排系統能在版面上同時呈現緊密和寬鬆的頁面。」

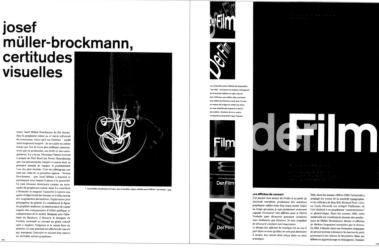

這種系列格線，可以使版面得以分成兩塊、三塊及四塊，分割方式也可採水平劃分。

嚴密的格線限制了圖片的大小，但也還是有變化可言。

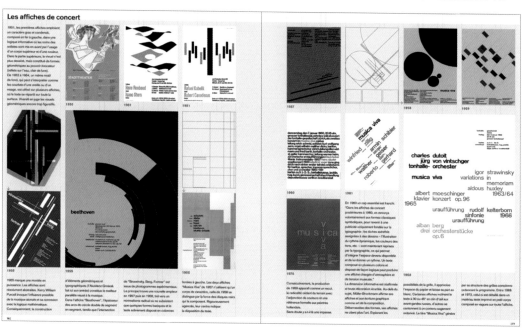

名稱

étapes: magazine

客戶

Pyramyd/*étapes:* magazine

設計公司

Anna Tunick

這篇雜誌文章採用有彈性的格線系統編排，內容則是探討格線大師Josef Müller Brockmann的設計作品。

嚴謹的格線未必能激發觀者的興致。但吸引力十足的圖片，以及有節奏感的編排，能創造出變化和新奇。

此跨頁版面顯示出格線能便於容納補充資料，而且在頁面有大量空白時，如何編排內容部分。

Überholen…?
Im Zweifel nie!

protegez l'enfant !

> *En une fraction de seconde, l'affiche doit agir sur la pensée des passants, les contraignant à recevoir le message, à se laisser fasciner avant que la raison n'intervienne ne réagise. Somme toute, une agression discrète, mais soigneusement préparée.*

est capable de remises en cause profondes. Malgré le succès de son style illustratif, il sait que les graphistes dans cette voie sont déterminées par des talents artistiques dont il se sent dépourvu. Le dessin, le plaisir de créer, le goût de la trouvaille surprise et la joie de la communication spontanée, satisfactions personnelles du graphiste, ne sont pas le langage formel le plus apte à répondre aux aspirations de l'époque, à qui les lois du design et d'un graphisme objectif seraient plus adaptées. La raison essentielle du renoncement à l'illustration réside dans le fait qu'aucune illustration ne résout totalement les problèmes que présente un travail. La conception illustrative à elle seule ne rend pas l'indispensable caractère documentaire de la publicité et confère au dessin une note personnelle qui ne s'harmonise pas avec le style publicitaire moderne.

En 1950, la commande de la salle de concerts (Tonhalle-Gesellschaft) de Zurich contribue à ce virage déterminant. Samuel Hirschi, secrétaire du lieu, y programme des compositeurs modernes et cherche à actualiser le lieu. Les deux hommes nouent une amitié solide et durant près de vingt-cinq ans, saison après saison, le graphiste va s'expérimenter les possibilités de l'abstraction et de l'art de la construction typographique. La relation du graphiste à la musique, qu'il estime l'art le plus abstrait, y constitue une part de responsabilité. Mélomane, époux d'une violoniste, il pousse ses élèves à s'y intéresser et invite dans ses cours des compositeurs comme John Cage. Autre domaine d'élection, l'art concret, dont l'influence est sensible dans les affiches pour le festival June Festwochen ou la programmation Musica Viva, organisés chaque année au Tonhalle et dans les lieux de la ville. *Les plus grandes œuvres d'art nous impressionnent par leur équilibre, leur harmonie et leurs proportions, tout ce qui peut être mesuré.* En 1960, il cesse de citer les formes de l'art moderne et met en place sa propre écriture: la composition d'affiches exclusivement typographiques. Expressions artistiques, ces travaux sont pourtant vécus comme un cas à part par leur auteur, soucieux de moderniser la communication visuelle, le design graphique et la publicité, pour accroître leur efficacité et inscrire leurs formes dans le temps présent. Dans cette perspective, ils sont aussi un territoire d'exploration formelle et d'expérimentation sur la fonction informative de l'affiche et les possibilités de la grille. Autant de découvertes, qui transformées en principes, constitueront la matière de ses livres et de son discours.

rationalité, objectivité et efficacité
Les progrès du travail restent déterminés par des créateurs susceptibles de pressentir, au travers des tensions latentes, les possibilités nouvelles et de les transformer en certitudes visibles. La parution des écrits de Müller-Brockmann coïncide avec leur rencontre de son parcours professionnel. En 1956, il entreprend un voyage en Amérique, donne des conférences aux États-

Philosophie de la grille et du design

L'usage de la grille comme système d'organisation est l'expression d'une certaine attitude en ce sens qu'il démontre que le graphiste conçoit son travail dans des termes constructifs et orientés vers l'avenir.

C'est là l'expression d'une éthique professionnelle, le travail du designer doit avoir l'évidente, objective et esthétique qualité du raisonnement mathématique.

Son travail doit être une contribution à la culture générale dont il constitue lui-même une partie.

Le design constructiviste qui est capable d'analyse et de reproduction peut influencer et rehausser le goût d'une société et la façon dont elle conçoit les formes et les couleurs.

Un design qui est objectif, engagé pour le bien-être collectif, bien composé et raffiné constitue la base d'un comportement démocratique. Un design constructif signifie la conversion des lois du design en solutions pratiques. Un travail accompli de façon systématique, en accord avec de stricts principes

formels, permet ces exigences de droiture d'intelligibilité et l'intégration de tous les facteurs aux aussi vitaux pour la vie sociopolitique. Travailler avec un système de grille implique la soumission à des lois valides universellement.

L'usage du système de grille implique
la volonté de systématiser, de clarifier;
la volonté de pénétrer à l'essentiel;
la volonté de concentrer;
la volonté de cultiver l'objectivité au lieu de la subjectivité;
la volonté de rationaliser les modes de production créatifs et techniques;
la volonté d'intégrer des éléments de couleur, de forme et de matière;
la volonté d'accomplir la domination de l'architecture sur l'espace et la surface;
la volonté d'adopter une attitude positive et visionnaire;
la reconnaissance de l'importance de l'éducation et les effets du travail conçu dans un esprit constructif et créatif.

Tout travail de création visuelle est une manifestation de la personnalité du designer. Il est marqué de son savoir, de son habileté et de sa mentalité. *– Josef Müller-Brockmann*

the
architectonic
in
graphic
the design
concert
poster
series
of
josef
müller-
brockmann

Unis, visite le Mexique et prend des contacts à New York, où il songeait à s'établir, devant la difficulté pour la Suisse à reconnaître et à laisser s'épanouir ses talents, du fait de son esprit de villageois et de paysans. Il retourne finalement à Zurich, où il prend la suite de son professeur à l'école des arts et métiers, Ernst Keller, et met en place la revue qu'il songeait à monter depuis 1955: *Une publication pour un graphisme rationnel et construit pour contrer les excès d'une publicité irrationnelle et pseudo-artistique que je voyais autour de moi.* Animée et éditée avec Richard Paul Lohse, Carlo Vivarelli et Hans Neuberg, la revue *Neue Grafik* ("Graphisme actuel"), éditée en allemand, anglais et français approximatif, comptera dix-huit numéros publiés jusqu'en 1965. D'abord approchées, des personnalités comme Armin Hoffman ou Emil Ruder sont écartées, leurs productions étant jugées trop diversifiées par le quartetron des puristes. Une idéologie formelle et fonctionnelle se met en place. Les trois mots-clefs en sont rationalité, objectivité et efficacité: *J'en suis venu à apprécier l'Akzidenz Grotesk davantage que ses successeurs Helvetica et Univers. Il est plus expressif et ses

bases formelles sont plus universelles. La fin du "e", par exemple, est une diagonale qui produit des angles droits. Dans le cas de l'Helvetica et de l'Univers, les terminaisons sont droites, produisant des angles aigus ou obtus, des angles subjectifs.* Après la Seconde Guerre mondiale et le désordre nazi, graphisme espère un retour à l'harmonie et ambitionne un rôle constructeur. La subjectivité et du dessin est écartée au profit de l'objectivité de la photo et de la construction. Les règles de la nouvelle typographie constituent avec le fer à gauche une dynamique vers le progrès technique et social: *La symétrie et l'axe central sont ce qui caractérise l'architecture fasciste. Le modernisme et la démocratie rejettent l'axe. Le savoir-faire du designer se précise et quitte la théorie pour passer à l'épreuve du réel au service des entreprises: Un design constructif signifie la conversion des lois du design en solutions pratiques.* C'est dans ce sens que s'oriente son premier *Problèmes d'un artiste graphique*, dont la publication en 1961 correspond à son départ de l'école des arts et métiers de Zurich, où il n'est pas parvenu à installer son enseignement. Dix ans plus tard, il publie une *Histoire de la communi-

cation visuelle* (avec sa seconde épouse) une *Histoire de l'affiche*, qu'il organise de nouveau avec l'affiche constructiviste en ligne de mire et l'efficacité en lieu et place de l'expressivité: *En une fraction de seconde, l'affiche doit agir sur la pensée des passants, les contraignant à recevoir le message, à se laisser fasciner avant que la raison n'intervienne ne réagise. Somme toute, une agression discrète mais soigneusement préparée.* Quatre ans plus tôt, Müller-Brockmann a fondé avec trois associés l'agence Müller-Brockmann & Co, qui intègre la publicité dans son activité régulière, aux côtés de l'identité visuelle, la signalétique et la communication culturelle. Au terme de dix années supplémentaires, en 1981, il publie son ouvrage de référence: *Raster systeme für die

visuelle Gestaltung.* Ses expérimentations dans les affiches du Tonhalle ainsi que son récent travail pour les chemins de fer suisses lui ont permis de forger une théorie mais aussi une éthique de la grille. Derrière son apparence de manuel technique, l'ouvrage est un manifeste. Le livre est introduit par un texte sur la philosophie de la grille et du design (voir encadré). Müller-Brockmann conclut par un renvoi à l'individualité du créateur: *Tout travail de création visuelle est une manifestation de la personnalité du designer. Il est marqué de son savoir, de son habileté et de sa mentalité.* Las, les départs qu'il contient et propose ne seront pas perçus comme les choix déterminés d'un graphiste ou comme des règles parfois comprises proposées à la profession, mais plus souvent

Stellwerk Bern Wylerfeld

CFF Cargo

SBB CFF FFS

Gleis 1

79. 粗細和測量

以瑞士設計為基礎的版面格線，讓大量篇幅的文字閱讀起來也能十分愉悅。這種版面設計由於在視覺上可成功地傳達訊息，因此閱讀起來格外清楚有力。多欄式格線可涵蓋大量內容，且能容納圖片及有色方格的分類訊息。此外，這種版型也能順應不同變化，捨棄部分內容反而可強調頁面上所涵蓋內容。

7 GREAT SERIES. 7 GREAT EXPERIENCES!

2 JJ SERIES

Jazz Jam
4 Concerts
Rose Theater, 8pm

WYNTON AND THE HOT FIVES
SEPTEMBER 28, 29 & 30, 2006
Hearts beat faster. It's that moment of pure joy when a single, powerful voice rises up from sweet polyphony. Louis Armstrong's Hot Five masterpieces—"West End Blues," "Cornet Chop Suey," and others—quicken the pulse with irresistibly modern sounds. **Wynton Marsalis, Victor Goines, Don Vappie, Wycliffe Gordon**, and others re-imagine the recordings that defined jazz, and then bring that pure joy to the debut of equally timeless new music inspired by the original.

RED HOT HOLIDAY STOMP
DECEMBER 14, 15 & 16, 2006
Tradition gets fresher. When Santa and the Mrs. get to dancin' the "New Orleans Bump," you know you're walking in a *Wynton Wonderland*—a place where joyous music meets comic storytelling. **Wynton Marsalis, Herlin Riley, Dan Nimmer, Wycliffe Gordon, Don Vappie**, and others rattle the rafters with holiday classics swung with Crescent City style. *Bells, baby. Bells.*

THE LEGENDS OF BLUE NOTE
APRIL 26, 27 & 28, 2007
Bop gets harder. The music is some of the best ever made—Lee Morgan's *Cornbread*, Horace Silver's *Song for My Father*, Herbie Hancock's *Maiden Voyage*—all wrapped up in album cover art as bold and legendary as the music inside. The **LCJO** with **Wynton Marsalis** debuts exciting and long-overdue big band arrangements of the best of Blue Note, complete with trademark cracklin' trumpets, insistent drums, and all manner of blues.

IN THIS HOUSE, ON THIS MORNING
MAY 24, 25 & 26, 2007
Tambourines testify. It's that sweet embrace of life—sometimes celebratory, sometimes solemn—rising from so many houses on so many Sundays. We mark the 15th anniversary of Wynton's first in-house commission, a sacred convergence of gospel and jazz that

3 MM SERIES

Music of the Masters
4 Concerts
Rose Theater, 8pm

FUSION REVOLUTION: JOE ZAWINUL
OCTOBER 27 & 28, 2006
Grooves ask for mercy, mercy, mercy. Schooled in the subtleties of swing by Dinah Washington, keyboardist **Joe Zawinul** brought the fundamentals of funk to Cannonball Adderley, the essentials of the electric to Miles Davis, and carried soul jazz into the electric age with his band Weather Report. Now the **Zawinul Syndicate** takes us on a hybrid adventure of sophisticated harmonies, world music rhythms, and deeply funky grooves. *Mercy.*

BEBOP LIVES!
JANUARY 26 & 27, 2007
Feet tangle and neurons dance. Fakers recoil, goatees sprout, and virtuosos take up their horns. Charlie Parker and Dizzy Gillespie set the bebop revolution in motion, their twisting, syncopated lines igniting the rhythms of jazz. Latter day fakers beware as the legendary James Moody and Charles McPherson, the alto sax voice of Charlie Parker in Clint Eastwood's *Bird*, raise battle axes and *swing*.

CECIL TAYLOR & JOHN ZORN
MARCH 9 & 10, 2007
Souls get freer. Embark on a sonic voyage as the peerless **Cecil Taylor** navigates us through dense forests of sound—percussive and poetic. He is, as Nat Hentoff proclaimed, "a genuine creator." The voyage banks toward the avant-garde as **John Zorn's** Masada with **Dave Douglas** explores sacred and secular Jewish music and the "anguish and ecstasy of klezmer." Musical wanderlust *will* be satisfied.

THE MANY MOODS OF MILES DAVIS
MAY 11 (Kisor/Blanchard) &
MAY 12 (Payton/Miller), 2007
Change gets urgent. "I have to change," Miles said, "It's like a curse." And so his trumpet voice—tender, yet that *edge*—was bound up in five major movements in jazz. The LCJO's **Ryan Kisor** opens with bebop and the birth of the cool. GRAMMY®-winner **Terence Blanchard** interprets hard bop and

1 LCJO SERIES

Lincoln Center Jazz Orchestra with Wynton Marsalis
4 Concerts
Rose Theater, 8pm

COLTRANE
SEPTEMBER 14, 15 & 16, 2006
Blue tranes run deeper. Ecstatic and somber, secular and sacred, John Coltrane's musical sermons transform Rose Theater into a place of healing and celebration with orchestrations of his small group masterpieces "My Favorite Things," "Giant Steps," "Naima," and more. Join us as the **LCJO** with **Wynton Marsalis** marks the 80th year since the birth of one of

名稱
Subscription brochure

客戶
Jazz at Lincoln Center

設計公司
Bobby C. Martin Jr.

文字編排凸顯了豐富的節目內容，而且好讀易懂。

細部（上圖）與下頁：此節目簡介呈現出有限度的變化，包括粗細、行距、記號、標題與印刷。階層關係清楚又完整。彩色方格裡標示出七項不同節目。每個彩色方格內的文字編排皆清楚勻稱，字型大小粗細則明確呈現不同分項訊息。

就這個簡介的整體編排來說，彩色方格十分成功地切割了版面。每個彩色方格內都是使用雅致的字型並對齊，看起來就像小banner。

From Satchmo's first exuberant solo shouts to Coltrane's transcendent ascent, we celebrate the emotional sweep of the music we love by tracing the course of its major innovations. Expression unfolds in a parade of joyous New Orleans syncopators, buoyant big band swingers, seriously fun beboppers, cool cats romantic and lyrical, blues-mongering hard boppers, and free and fusion adventurers. From all the bird flights, milestones, and shapes of jazz that came, year three in the House of Swing is a journey as varied as the human song itself, and the perfect season to find your jazz voice.

7 GREAT SERIES. 7 GREAT EXPERIENCES!

1 — LCJO SERIES
Lincoln Center Jazz Orchestra with Wynton Marsalis
4 Concerts
Rose Theater, 8pm

COLTRANE

GERSHWIN

JAZZ AND ART

THE SONGS WE LOVE

2 — JJ SERIES
Jazz Jam
4 Concerts
Rose Theater, 8pm

WYNTON AND THE HOT FIVES

RED HOT HOLIDAY STOMP

THE LEGENDS OF BLUE NOTE

IN THIS HOUSE, ON THIS MORNING

3 — HH SERIES
Music of the Masters
4 Concerts
Rose Theater, 8pm

FUSION REVOLUTION: JOE ZAWINUL

BEBOP LIVES!

CECIL TAYLOR & JOHN ZORN

THE MANY MOODS OF MILES DAVIS

4 — ALJO SERIES
Afro-Latin Jazz Orchestra with Arturo O'Farrill
3 Concerts
Rose Theater, 8pm

BEBO VALDES

STEPHANIE JORDAN & THE WESS ANDERSON QUARTET

WILLIE NELSON SINGS THE BLUES

CUBANA BE CUBANA BOP

TODO TANGO

5 — SH SERIES
Singers Over Manhattan
4 Concerts
The Allen Room
7:30pm & 9:30pm

DIANNE REEVES

DARIN ATWATER GOSPEL

6 — SS SERIES
Singin' & Swingin'
3 Concerts
The Allen Room
7:30pm & 9:30pm

COLTRANE/HARTMAN

PAQUITO D'RIVERA

THE BIRTH OF COOL

7 — JOYP SERIES
Jazz for Young People™
3 Concerts
Rose Theater, 12pm & 2pm

WHAT IS AN ARRANGER?

WHAT IS LATIN JAZZ?

HOW DO WE CREATE JAZZ MOODS?

ROSE THEATER

THE ALLEN ROOM

SUBSCRIBE HERE

CONTACT INFORMATION

PAYMENT INFORMATION

80. 運用瑞士赫維提卡體

赫維提卡體（Helvetica）在2007年適逢五十週年紀念，讓這個古典又工整的無襯線字型又開始流行。為何赫維提卡體明顯與瑞士格線有關呢？一方面「赫維提卡體」這個名稱是赫爾維希亞（Helvetia）的變體，也就是瑞士的拉丁文拼法。此外，這個字型裡的功能性線條原稱為Neue Haas Grotesk，在1950年代，它與有規律、工整的格線共同定義了什麼是現代主義。

赫維提卡體的眾多字母展示

客戶

· Designcards.nu by Veenman Drukkers

· Kunstvlaai/Katja van Stiphout

照片來源

Beth Tondreau

赫維提卡體有各種粗細大小可選用。中型粗體通常呈現一種嚴謹莊重感；細瘦字型則傳達簡單、大方，以及沉靜感。在為版面設計選字型時，記得要把字型大小、粗細以及想表達的旨意都考量在內。

細瘦、雅致的赫維提卡體，看起來沉靜又老練。

K_nst
VI__. | A.P.I.

Art Pie
International

Een boek navertellen
op video in precies
één minuut of kom

Win 1000 euro

naar de Kunstvlaai A.P.I.
bij de stand van The One Minutes en
maak hier jouw boek in één minuut.
Van 10–18 mei 2008

Westergasfabriek
Haarlemmerweg 6-8
Amsterdam
www.kunstvlaai.nl

不同的粗細大小傳達了既鮮明又實際的感覺。

工整的字母讓赫維提卡體看來平凡，但卻讓每個人都注意到是否對齊和間距！

赫維提卡體的特色在於嚴謹，在文字編排上，其重要程度就像空氣和水一樣。

81. 善用線條

線條具備眾多功能。線條可做為：

· 導覽列
· 容納標題空間
· 圖片底線
· 分隔工具
· 刊頭

名稱
www.vignelli.com

客戶
Vignelli Associates

設計公司
Dani Piderman

設計指導
Massimo Vignelli

格線和線條大師馬西莫・維那利（Massimo Vignelli），在網站設計上展現其功力。

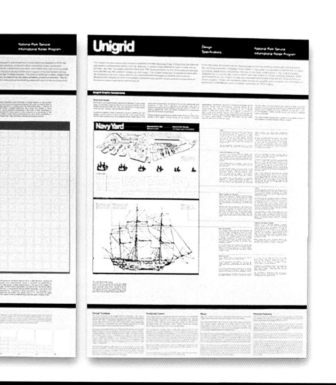

左頁上圖：維那利公司的風格總是一致，其簡潔有序的作品風格也表現在其網站設計上。

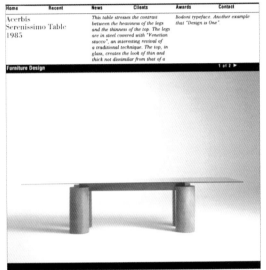

Acerbis
Serenissimo Table
1985

This table stresses the contrast between the heaviness of the legs and the thinness of the top. The legs are in steel covered with "Venetian stucco", an interesting revival of a traditional technique. The top, in glass, creates the look of thin and thick not dissimilar from that of a

Bodoni typeface. Another example that "Design is One".

Furniture Design　　　　　　1 of 2 ▶

Malma Pasta
Packaging

Made with the best wheat in the world and processed in their own mills, this is one of the very best quality of pasta, made in Poland with Italian equipment.

We designed a new logo and all the packages, which are red for the large market , and clear for the gourmet line, with the identification on a hanging booklet describing the product.

Packaging Design　　　　　▶ more

粗細不同的線條兼具分隔和容納訊息的功能。

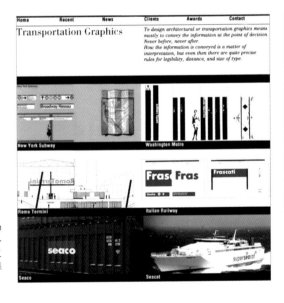

Transportation Graphics

To design architectural or transportation graphics means mostly to convey the information at the point of decision. Never before, never after.
How the information is conveyed is a matter of interpretation, but even then there are quite precise rules for legibility, distance, and size of type.

New York Subway　　Washington Metro
Rome Termini　　Italian Railway
Seaco　　Seacat

Furniture Design

We design furniture either because we can not find in the market what we need for a specific use, or because we are asked by a furniture manufacturer to design something for them. In the first case, we select the materials; in the second, we articulate the manufacturer's

resources. The manufacturer establishes certain parameters related to his market position and we work within or beyond them, to solve the problem at hand.

Casigliani　　Acerbis　　Bernini
Knoll　　Poltrona Frau　　Poltronova
Poltrona frau Teatro　　Poltrona Frau CEO　　Casigliani

左頁下圖：標題採用Franklin Gothic粗體，一方面與Bodoni斜體呈現對比，一方面又互補，為瑞士風的設計加添義大利調性。

82. 運用橫向與縱向的階層排列

將 版面分割成數個輪廓清楚的區域，可以用來編排信紙、表格與發票收據，既實用又美觀。橫向和縱向格線能夠和諧並存，以一種不同於一般所預期的方式組織各組訊息，同時卻又涵蓋了所有必要元素。

名稱

Stationery receipt

客戶

INDUSTRIES Stationery

設計公司

Drew Souza

此發票的設計特點在於採用已故平面設計師Herbert　Bayer處理版面的技巧，他將版面變成可分割平面。

IS
INDUSTRIES stationery

91 Crosby Street
New York, NY 10012
212.334.4447
www.industriesstationery.com

ITEM NUMBER	DESCRIPTION	QUANTITY	PRICE	EXTENSION
11.150.3	Small Spiral Pads with Black cover/Colorfest pages-set of 3	1	16.50	16.50
71.120.2	SpirilSquare Notebook PopPrints Khaki	1	6.50	6.50
71.120.1	SpirilSquare Notebook PopPrints Blue	1	6.50	6.50

SALES RECEIPT

DATE
4/8/2008

REFERENCE NUMBER
80901

SALESPERSON
CE

SOLD TO

SHIP TO

RETURN POLICY
Merchandise may be returned for exchange or store credit within 14 days of purchase with the store receipt. Sale merchandise is non-returnable. All returns must be in saleable condition.

STORE HOURS
Monday-Saturday 11:00-7:00
Sunday Noon-6:00

MERCHANDISE TOTAL	SHIPPING	OTHER CHARGES	DISCOUNT	TAXABLE SUBTOTAL	SALES TAX	NON TAX SALES	TOTAL	AMOUNT PAID	BALANCE DUE
29.50				29.50	2.47		**31.97**	31.97	

左頁與本頁：在版面上採用橫向和縱向的階層編排，可讓信
紙和收據的版面被明顯劃分成涵蓋多組訊息的區塊。由於此
收據還未印上銷售數額，因此有種抽象的美感。加上具體細
節後，收據便具備了功能性。

IS
INDUSTRIES stationery

91 Crosby Street
New York, NY 10012
212.334.4447

www.industriesstationery.com

SALES RECEIPT

DATE

REFERENCE NUMBER

SALESPERSON

SOLD TO

SHIP TO

RETURN POLICY
Merchandise may be returned for
exchange or store credit within
14 days of purchase with the store
receipt. Sale merchandise is
non-returnable. All returns must
be in saleable condition.

STORE HOURS
Monday-Saturday 11:00-7:00
Sunday Noon-6:00

ITEM NUMBER

DESCRIPTION

QUANTITY

PRICE

EXTENSION

SALES DRAFT

DATE

REFERENCE NUMBER

SALESPERSON

SOLD TO

DISCOUNT

MERCHANDISE TOTAL

SHIPPING

OTHER CHARGES

TAXABLE SUBTOTAL

SALES TAX

NON TAX SALES

TOTAL

AMOUNT PAID

BALANCE DUE

PAID BY

PAID BY

MERCHANDISE TOTAL

SHIPPING

OTHER CHARGES

DISCOUNT

TAXABLE SUBTOTAL

SALES TAX

NON TAX SALES

TOTAL

AMOUNT PAID

BALANCE DUE

83. 加入驚喜

整齊且接近瑞士風格的設計，可以為讀者完美又清晰地分隔訊息。版面乾淨清楚很好，但若能更上一層樓就太棒了。規劃完善的格線，搭配縱欄和易讀的編排，然後只要再變換字型大小就會更好。在結構清楚的跨頁版面，大大小小的重點字能讓版面有深度，以及意想不到的朝氣。

若要編排大量資訊，可使用格線增添變化、清晰和權威性。完善規劃的格線，能讓設計者的版面更為多元，並維持一貫的結構。三欄式格線涵蓋的訊息量可多可少，少則僅出現標題，多則包含主標題和副標題的列表。

從封面開始，三欄式的縱向格線便在整個目錄中不斷出現，風格一致卻不著痕跡。

名稱

Masters of Graphic Design Catalog Covers of UCLA Extension 2

客戶

University of California, Los Angeles

設計公司

AdamsMorioka, Inc.

創意指導

Sean Adams

設計者

Sean Adams, Monica Schlaug

嚴謹的格線設計與各種的編排變化，在這個目錄中相輔相成。此目錄主焦點即為封面。

三欄式結構在整個版面的標題部分視顯而易見，在視覺上襯出大型靈活的字型，打破瑞士風格字型的沉著穩重。字型有大有小且強調差異，為有規律的欄位帶來出乎意料的反差，呈現出清新活潑的效果。

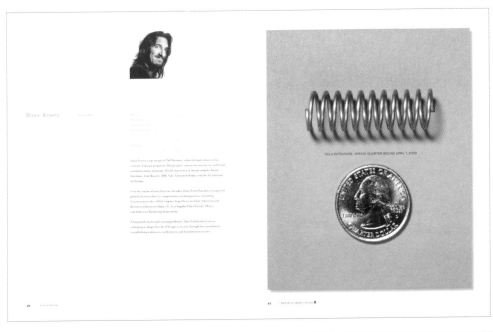

這個版面展現目錄的核心特點。左頁中,三欄式版面清楚涵蓋設計大師的名字、生卒時間、照片和生平介紹,右頁則僅放設計者所設計的目錄封面。

嚴謹的編排可以組織版面。此設計大師一覽表,縱欄成為橫條的標題項目。各橫條包括設計大師的名字、其作品小圖以及有出現的作品名稱。

84. 變換大小

決定了整體格線的設計後，就可以大大發揮比例、空間、大小和文字編排的部分。圖片和字體大小主要與整體內容的訴求和重要性有關，可以充滿動態感，也可以很平凡，端看會需要占到多少空間而定。

這個封面上的圖像本身即清楚又直接傳達了訴求，使得文字減縮至最小部分。

As if it wasn't challenging enough to choose between one color and another, now there's green, which comes loaded with its friends: sustainable, eco-friendly, cradle-to-cradle, recycled, recyclable, small footprint, low-VOC, Greenguard, LEED and FSC-certified. Being a design company, we're encouraged by the increasing number of smart solutions to improve the planet. But we know that not all items fit into every category of ecological perfection. At DWR, we believe in honestly presenting our assortment so you can choose what's best for you. We also believe in selling products that last. We're all doing our part, and we welcome your response when we ask, "What is green?"

第一頁便以文字排版開場，而且是以一整篇表達立場，填滿整個版面。

名稱

What Is Green?

客戶

Design within Reach

設計公司

Design within Reach Design

創意指導

Jennifer Morla

藝術指導

Michael Sainato

設計者

Jennifer Morla, Tim Yuan

文案

Gwendolyn Horton

綠化和永續發展是熱門主題，許多企業像DWR，以環保為訴求，多年來都極具生態意識。這本書的頭13頁，便以一個相關議題和多變化的版型，為整篇報導加添了流暢感。

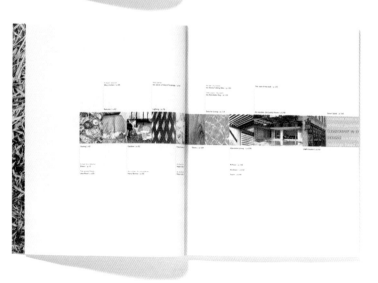

目錄頁的編排則有劇烈轉變，採橫向排列，讓讀者容易閱讀。版面上的指引線引導目光注意各項內容。小圖則是快速提示目錄內容的指標。

Emeco is up-cycling cans into a chair that lasts 150 years.

The hand-brushing department at Emeco, U.S.A.
At Emeco, all aluminum waste is recycled, even the aluminum dust that's filtered out of the air.

這幾頁版面上的文字編排長度並不一致。請注意有一頁的文字走文極寬,通常在文字排版上,會避開這種情形。但是此處,風格與傳達的訴求打破了一般設計原則。若有人想要了解可回收再利用的鋁製環保椅,自然會去讀。這樣的好處是,描述椅子的文字便格外簡練。

The upside of up-cycling aluminum: chairs for a lifetime or two.
When Emeco started making its aluminum chairs in 1944, you can be darn sure there wasn't a marketing brief that said, "Make it attractive to the eco-conscious community." Emeco had other things on its mind, namely how to make a chair withstand a torpedo blast. The irony is that Emeco chairs have become an outstanding example of what's commonly referred to as "green." To create the 1006 Navy Chair (1944), Emeco invented a 77-step process to satisfy the military's need for lightweight, corrosion-resistant chairs for destroyers and submarines. In the process, the company invented a method to make aluminum three times stronger than steel, and a chair so durable that it has an estimated lifespan of 150 years. Legend has it that Wilton Dinges, who founded Emeco in 1944, actually tossed a 1006 Navy Chair out the window of a six-story building. The people on the sidewalk below were a bit surprised, but the chair was fine, with the exception of a few scratches. Today, everything Emeco makes is still manufactured by hand using the same 77-step patented process. Emeco chairs and tables all begin with 80% recycled aluminum, which requires only 5% of the energy needed to produce virgin aluminum, and they're all made in Pennsylvania, U.S.A. Emeco's all-aluminum chairs and stools are built to last, and generations from now, when your great-great-grandchildren finally manage to wear out a chair that's tested to withstand 1,700 pounds of weight (big kids), the aluminum can be 100% recycled and made into something else. In recent years, Emeco has partnered with Philippe Starck, Norman Foster and others to create classic designs for a new century, and these collections are made in the same facility, using the same processes and by the same people who make everything else at Emeco. Perhaps Philippe Starck said it best when he explained that "working with Emeco has allowed me to use a recycled material and transform it into something that never needs to be discarded – a timeless and unbreakable chair to enjoy for a lifetime. It is a chair you never own, you just use it for a while until it is the next person's turn." On the next page you'll find Emeco chairs and stools, all of which contribute to LEED™ credit #4.2 Recycled Content (and credit #5.) J shipped within 500 miles of Hanover, Pennsylvania). For the entire **Emeco Collection**, visit dwr.com.

85. 讓照片自己發聲

如果照片效果極佳,就不要隨便破壞。有時最好的方式,就是盡可能放大照片,就算要修,也是小修就好,或者乾脆什麼都不動,而且也不要在照片上壓字或耍花招。換句話說,讓照片與格線相互搭配,不然就是讓照片自己傳達訊息。

名稱
Magazine

客戶
Bidoun

創意指導
Ketuta-Alexi Meskhishvili

設計者
Cindy Heller

攝影者
Gilbert Hage (portraits) and
Celia Peterson (laborers)

本頁和下頁:這些照片不須額外處理,不需要做任何設計,本身就可以說明內容。

Cautious Radicals

Art and the
invisible majority

By Antonia Carver

At the 2005 Sharjah Biennial, artist Peter Stoffel attempted to get himself banned. Taking inspiration from the notices placed by employers in local newspapers, featuring the names, nationalities, passport numbers and mug shots of ex-employees, Stoffel requested that the biennial's organizing body fire him and announce his occupational demise in the same way. Other potential employers— presumably those organizing another biennial in the UAE—would be luring him "at their own risk and responsibility." At the same time, the biennial would write Stoffel a recommendation letter "acknowledging his reliable services as an artist," which would be freely available to visitors to the biennial.

The artist's concept turned out to be more potent than the proposed work itself. In keeping with the generally taboo nature of discussion surrounding the rights of the Gulf's underclass of foreign maids and laborers, the biennial organizers declined to go along with Stoffel's ruse. During the exhibition, he showed two panels of text—one a narrative explaining his concept and the outcome, the other a page from a local newspaper with advertisements placed by "sponsors" of Sri Lankans and Pakistanis who had "absconded from duty" and were therefore now outside the employer's responsibility.

For Gulf-based biennial visitors, Stoffel's project was audacious in its attempt to query the region's strict racial and financial hierarchy of workers' rights. (Since the biennial, new legislation has begun to address both the rights of the employee in the transferral of sponsorship and the prerogative of sponsors to impose the customary six-month ban—from the country, and/or from working for a competitor company—on some employees.)

As he describes it, Stoffel attempted to establish a connection between the smallest minority in the UAE, that of the immigrant artist, and the largest, the immigrant laborer. (About two-thirds of the UAE's work force comes from abroad, and about a quarter of all expats work as unskilled laborers for construction companies.) Stoffel concluded that the "two parallel lines of the biennial artist and the Pakistani worker never cross, and that is the paradox of the paradox: that even at an imaginary point, within an artwork, it's impossible to establish a connection."

Despite being the largest segment within the UAE population, the foreign working class remains by and large a faceless majority, known only in the worldly minority through increasingly bulky local media stories. Every week, the usually self-censoring UAE newspapers detail grey tales of trafficking, suicide, and rape; of false promises made by dubious foreign employment agencies and mounting debts; of dehydration while working in extreme summertime heat and humidity; of industrial accidents and loan sharks; of depressed, desolate labor camps. The Indian Embassy's official list of its functions includes such grisly tasks as "processing applications received for providing free air tickets by Air India Indian Airlines for transportation of dead bodies of destitute/stranded/absconded Indian nationals."

In many ways, the situation faced by the Gulf's legions of residential laborers is mirrored worldwide, from Chinese cockle-pickers in the UK to Mexican meatpackers in US abattoirs. But the particular state of affairs in Dubai, with its rapid growth and surface prodigacy, takes a microscope to what's vaguely termed globalization.

Photos of laborers in Dubai by Celia Peterson, 2005, courtesy of Celia Peterson and arabianEye

86. 以補充欄切分版面

補充欄就是放次要訊息的邊欄，為主文內容的延伸補充。補充欄內容與主文內容彼此相關，但需要互相區分開來，這種方式在劃分內容上相當常見。各邊欄可放在格線內，做為補充資料，而非打斷頁面編排。

名稱

Nikkei Architecture

客戶

Nikkei Architecture magazine

設計公司

ar

這本建築公會雜誌裡，邊欄和圖表內是放專業技術的訊息。

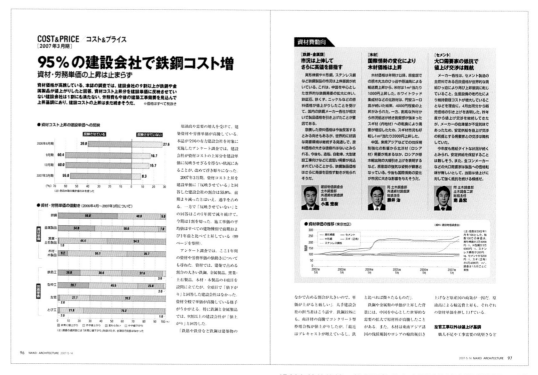

規劃完善的格線一般是可放入大小不同的補充欄或邊欄，以多欄、雙欄或單欄方式編排皆可。

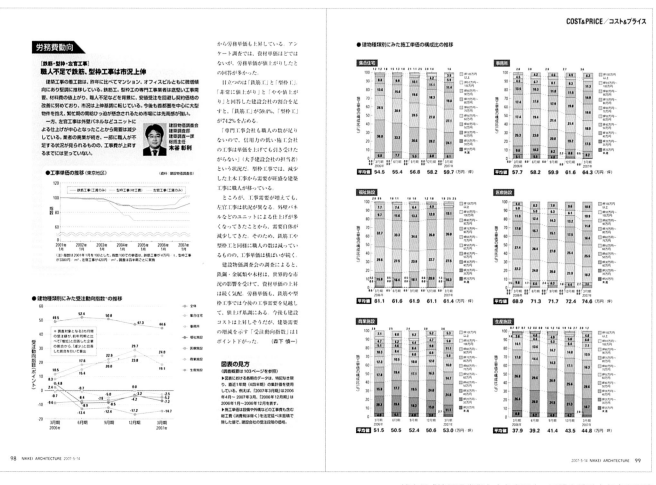

補充欄或邊欄通常與主文各自獨立，不過在設計上仍會有所連結，例如使用共同顏色、字型或線條。

插入格線 ■ 173

87. 向大師看齊

仔細多研究設計大師的作品，可以讓你編排的作品近似大師之作，同時卻又有個人對於格線設計的創新詮釋。藉由透徹了解編排概念、掌握基本原則，而非一味模仿特定元素，即使是師法那些瑞士大師們的獨創性設計，也還是可以有令人耳目一新的感覺。

名稱

étapes: magazine

客戶

Pyramyd/*étapes:* magazine

設計公司

Anna Tunick

此雜誌頁面是一篇關於設計師 Josef Müller Brockmann的文章，內容涵蓋了格線設計的基本原則，還包括設計大師的生平、設計過的書封和廣為流傳的圖片，十分珍貴。

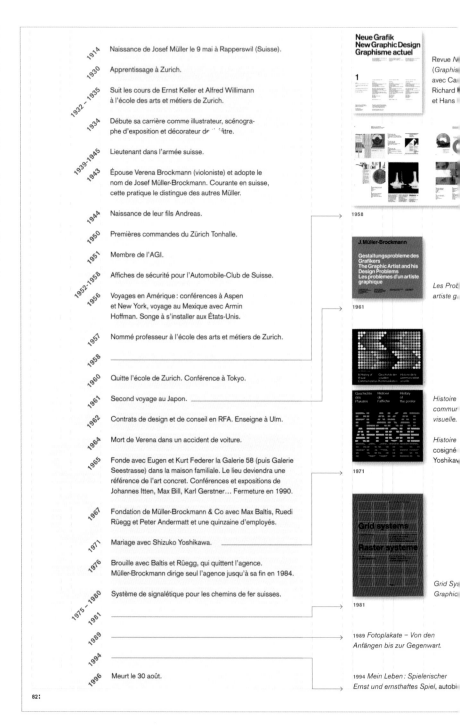

> *Plus la composition des éléments visuels est stricte et rigoureuse, sur la surface dont on dispose, plus l'idée du thème peut se manifester avec effi-cacité. Plus les éléments visuels sont anonymes et objectifs, mieux ils affirment leur authenticité et ont dès lors pour fonction de servir uniquement la réalisation graphique. Cette tendance est conforme à la méthode géométrique. Texte, photo, désignation des objets, sigles, emblèmes et couleurs en sont les instruments accessoires qui se subordonnent d'eux-mêmes au système des éléments, remplissent, dans la surface, elle-même créa-trice d'espace, d'image et d'efficacité, leur mission informative. On entend souvent dire, mais c'est là une opinion erronée, que cette méthode empêche l'individualité et la perso-nnalité du créateur de s'exprimer.*

"kleines küchenlexikon", livre de cuisine. 1956.

"zürcher konkrete kunst", affiche pour une exposition d'art concret, référence implicite à l'affiche "Allianz" par max bill. 1979.

comme des recettes appliquées par défaut. Phéno-mène encore appuyé par la structure des logiciels de PAO, qui recourent au gabarit comme point de départ à l'édition de tout document. L'effica-cité radicale de l'abstraction sera quant à elle escamotée au profit d'effets plus spectaculaires et moins préoccupés.

ceci dit, au boulot

Depuis ses débuts de scénographe, Müller-Brockmann a réalisé un grand nombre de travaux, seul ou à la tête de son agence (1965-1984): scéno-graphies d'expositions didactiques ou commer-ciales, identité, communication et édition (bro-chures, publicités et stands) d'entreprises pour des fabricants de carton (L + C: lithographie et cartonnage, 1954 et 1955), de machines-outils (Elmag, 1954), de machines à écrire (Addo AG, 1960) pour des fournisseurs de savon (CWS, 1958) de produits alimentaires (Nestlé, de 1956 à 1960) ou pour la chaîne de magasins néerlandais Bijenkorf (1960). En 1962, il décroche d'importants contrats auprès d'entreprises allemandes: Max Weishaupt (systèmes de chauffage) et Rosenthal

:83

88. 挑戰視覺

格線可讓版面氣勢驚人，具壓倒性力量，也可以默默襯托，就像有位作者說的：「格線典雅有邏輯，而且從不突兀。」

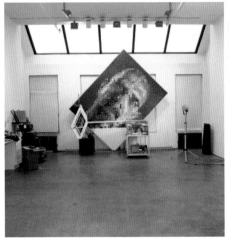

此封面的力道在於其簡潔有力，並著重藝術家與其作品。把書衣包上已裝訂好的書籍前，要注意書衣的整體版面。

名稱

Chuck Close | Work

客戶

Prestel Publishing

設計公司

Mark Melnick

不突兀的設計，雅致地呈現大型人物繪畫。

印在扉頁上的圖片，是藝術家的側影，對應封面上正在創作中的藝術家。

左上圖：就開章頁的版面來說，放大眼睛的局部可捕捉藝術家的精神，而標題則是和書封一樣簡單大方。

右上圖：此處最明顯的格線編排就是主文和標題。

中間兩張圖片：主文的格線編排同樣是版面重點。

89. 改變分界

補充性的內容可以排得和主文一樣美觀，而且還可改變與主文的分界。書末，也就是一本書或目錄的末尾，則是可以編排得十分複雜，例如附錄、時間表、註解、書目和索引。細部會決定整體設計是否成功，所以連較容易被人忽略的頁面，也要編排得清楚美觀。

名稱

Exhibition Catalog
Show Me Thai

客戶

Office of Contemporary
Art and Culture, Ministry
of Culture, Thailand

設計公司

Practical Studio/Thailand

設計指導

Santi Lawrachawee

視覺設計

Ekaluck Peanpanawate
Montchai Suntives

這本展覽目錄用到許多實用格線，其中參展者的一覽表編排得尤其特別。

左頁上圖：單張照片卻有大量留白，與依格線編排的頁面形成對比。

左頁下圖：以左頁來說，文字或版面走文設定的寬度，與兩張並列的圖片同寬。一般不太鼓勵走文過寬，但此處編排版算是成功。

三欄格線與圖表巧妙呈現規律感。

此跨頁版面上的表格編排得清楚、美觀又有趣，裝飾性圖形則賦予了質感。

90. 複雜化

看來近乎不可能達成的版面設計，只要分成幾個步驟，也能辦得到。顏色能創造出不同的造形和空間。基本上淺色是負空間，主色是前景的一部分。好好構思如何讓變化多端的重疊元素，在版面上塑造出另一空間。不妨讓自己放手嘗試一下多種層次和形狀。

至於要怎麼從迷宮走出來，就要靠自己了。

格線設計的極致境界就是迷宮。瑪莉安·本傑思以巧手賦予了版面空間的深度。她喜歡「用自己熟知的線條，創造出讓自己不安的作品，但效果卻不錯。」

名稱

Cover for the Puzzle
Special of *The Guardian's G2*

客戶

The Guardian Media Group

設計公司

Marian Bantjes

這個G2拼圖主題的封面使用了分層線條和方塊。

91. 構思出多個空間

儘管大部分格線排版都是平面，但無論是印刷紙面或電腦螢幕，都需要掌握內容本身的多元空間。DM簡介的版型設計可以不同於書本、小書或平面頁面。先構思3D立體頁面，再設計為平面，這樣能讓M形摺或包摺的DM簡介格外有立體感。

名稱

Exhibit Catalog for Stuck, an art exhibit featuring collages

客戶

Molloy College

藝廊總監

Dr. Yolande Trincere

策展人

Suzanne Dell'Orto

設計者

Suzanne Dell'Orto

這份巧妙構思的摺疊式DM是為拼貼畫展覽製作的，令人聯想起藝廊展示的搞怪藝術。

Persistent Provocation: The Enduring Discourse of Collage

Borne out of avant-garde artistic practices beginning shortly before the first World War, the history of collage as an art form is rooted in the twentieth century. Pablo Picasso and Georges Braque's *papier-colle* (literally, "stuck paper") works, in which they combined materials like bits of newspaper, tablecloth, rope, and other detritus of everyday life, were arguably the first attempt to create a new art form—one in dialogue with painting, but with a different relationship to time, representation, and the value of the art object itself. Soon afterward, collage was also taken up by Italian Futurists like Umberto Boccioni and Carlo Carra, who used print typography clipped from newspapers in their paintings to convey propagandistic messages on the virtues of war, speed, and industrialization. Constructivists in Russia created "painting reliefs," by attaching defiantly unpainterly sheets of metal and wire mesh to their canvases; at the same time, they used paper collage techniques to create completely original posters and street decorations. Borrowing and modifying Cubist ideas of space, they put those ideas to work in the service of new meanings and ideals.

The artists of the Dada movement, which began in Zurich during World War I and spread throughout Europe and to New York, defined the particular (and now iconic) collage form of photomontage, in which the work consists almost exclusively of juxtaposed photographic elements. In Berlin, Max Ernst, John Heartfield, and Hannah Höch sliced up magazines and advertisements, pasting images of lightbulbs onto ladies' heads, and the head of Hitler onto an ape's body. The combination of images of fashion, politics, and industry to create fragmented, absurd, and fantastic images became an iconoclastic, boldly political means of attacking the European political establishment, and of reflecting a society in extreme flux. A decade later, the Surrealists often employed collage to create their enigmatic works, juxtaposing unrelated and discordant objects or images to produce visual and psychological dissonance. Even when such juxtapositions were achieved with paint alone, they were theorized by Max Ernst as part of a "collage idea" in which memories, dreams, materials, and events collide and are transformed.[1]

Collage persisted through the twentieth century, even after World War II disrupted the Surrealist movement. Abstract Expressionists like Robert Motherwell used collage to evoke a lyrical and transcendent sensibility, rooted in gesture and ideas of the spiritual. Robert Rauschenberg would later directly challenge those ideas, creating "combines" that included materials like silkscreened sheets and taxidermied animals—an extreme attempt to bridge the gap between art and life. In the Sixties, the arrangement and assemblage of various elements, both natural and industrial appeared in Minimalist and Earth art, while in the Seventies,

the kaleidoscopic montages of Romare Bearden evoked experiences of the rural South, and of Harlem in the Jazz Age. And more contemporary examples of art that appropriates, recombines, and juxtaposes abound, from Barbara Kruger's raw, blown-up images paired with aphorisms, to the conceptual photographic environments of Doug and Mike Starn, to seamless, illusionistic photomontage works by Jeff Wall and Andreas Gursky. But while the political or aesthetic agendas of artists that use collage techniques has always been in flux, certain formal and conceptual themes persist. Among them are temporal issues, the commodification of the art object, organicism, and formalism, which the artists in *Stuck* take up in various ways.

ABOVE: **Curt Ikens, *Art through the Ages*, 2005.
Book (*Gardner's Art through the Ages*) and hair, 30" x 72" x 15".**

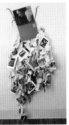

傳統格線為此展覽中特異多變的拼貼作品提供了編排骨幹。工整的字型，以及縝密規劃的版面空間，兩者結合起來為生動的藝術提供了框架。上圖為DM簡介最前與最末頁，下圖則為內頁。雙面印刷及摺頁的設計，讓DM呈現出3D立體感。

左頁：此為4頁簡介DM的一面內頁，介紹的是一本解構藝術史的書，圖片皆工整地擺放在其中一欄。版面結合嚴肅正統的Gill Sans和滑稽有趣的P．T．Barnum字型，令人想起拼貼藝術中將各種元素拼湊起來的手法。

92. 考慮總體

格線架構能有助於呈現多種疊壓的元素。

千萬牢記：

· 文字編排要清晰可讀。

· 寬鬆的空間是版面編排成功的關鍵。

· 未必要把圖片或文字塞滿整個版面。

　　基本上，版面上的層次能夠引起讀者興趣。而且更進一步來看，也能藉著層次讓讀者仔細思量畫面各元素的結合。

名稱

Branding posters

客戶

Earth Institute at
Columbia University

創意指導

Mark Inglis

設計者

John Stislow

插畫者

Mark Inglis

這個版面以分層的照片、線圖與圖標，來增加頁面的空間立體感，並傳達不同層次的意涵及引人之處。

本頁兩張圖：此簡介封面與展開的內頁上，圖片的層次增添了立體感，但仍讓訊息清楚易讀。

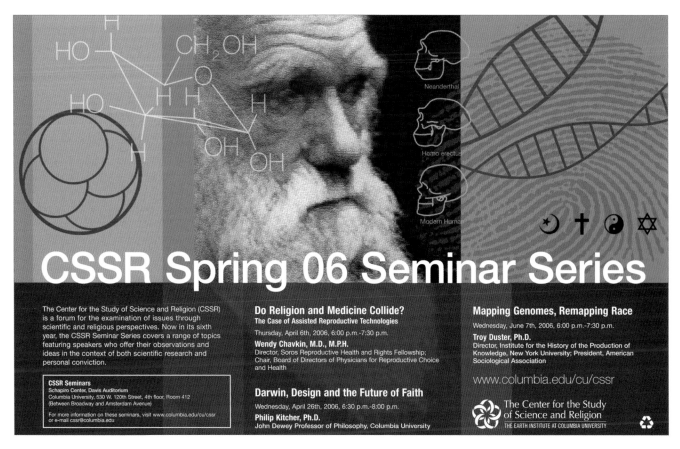

CSSR Spring 06 Seminar Series

The Center for the Study of Science and Religion (CSSR) is a forum for the examination of issues through scientific and religious perspectives. Now in its sixth year, the CSSR Seminar Series covers a range of topics featuring speakers who offer their observations and ideas in the context of both scientific research and personal conviction.

CSSR Seminars
Schapiro Center, Davis Auditorium
Columbia University, 530 W. 120th Street, 4th floor, Room 412
(Between Broadway and Amsterdam Avenue)

For more information on these seminars, visit www.columbia.edu/cu/cssr
or e-mail cssr@columbia.edu

Do Religion and Medicine Collide?
The Case of Assisted Reproductive Technologies
Thursday, April 6th, 2006, 6:00 p.m.-7:30 p.m.
Wendy Chavkin, M.D., M.P.H.
Director, Soros Reproductive Health and Rights Fellowship;
Chair, Board of Directors of Physicians for Reproductive Choice
and Health

Darwin, Design and the Future of Faith
Wednesday, April 26th, 2006, 6:30 p.m.-8:00 p.m.
Philip Kitcher, Ph.D.
John Dewey Professor of Philosophy, Columbia University

Mapping Genomes, Remapping Race
Wednesday, June 7th, 2006, 6:00 p.m.-7:30 p.m.
Troy Duster, Ph.D.
Director, Institute for the History of the Production of
Knowledge, New York University; President, American
Sociological Association

www.columbia.edu/cu/cssr

The Center for the Study
of Science and Religion
THE EARTH INSTITUTE AT COLUMBIA UNIVERSITY

照片上的元素及在照片上做半透明色塊壓底，為三欄式文字編
排加分不少。

這張海報是關於健康議題的演
講，文字只編排在最上層。

93. 以架構輔助不同媒體

區塊跟顏色可以幫助傳遞訊息。有時運用客戶名稱中的隱喻能夠有助於選定顏色和頁面的動線。可以在頁面上各處設置導覽列,將各類訊息放置在不同方格中或是相鄰的空間。在訊息稠密的網站上,整個頁面可能看起來就像一個大都會一樣:井井有條卻又忙碌喧囂,不過有時,正是一趟讓人頭暈目眩的路程才能帶你抵達目的地。

黑色標題的橫條和計程車黃的方格,是「計程車設計」(Design Taxi)網站的招牌特色。

名稱

Website

客戶

Design Taxi

設計公司

Design Taxi

設計指導

Alex Goh

這個新加坡的「計程車設計」網站,整個編排引導了使用者的視線在格線間來回移動。在資訊密集的網站上,充滿邊框、直線、box、導引、色彩、灰階深淺、連結和搜尋工具——不過搜尋不到星巴克。

由於網站提供大量訊息，因此利用了許多塊狀空間和深淺不同灰階來編排。有時候瀏覽點選有點困難，要找到連結網頁的標題須費點心思。

考量到會常常更新及便於更新資料，版面設計以功能取向，而非精緻美觀。

銷售商品並不一定代表全部能賣出去。透過電子報、網站上列的大量廣告傳單，甚至包括banner，許多公司所介紹的特點看起來都很棒，而且版面編排得很有組織又具說服力，清楚明確地傳達訊息。

名稱
Emailers

客戶
HotSpring

設計公司
BTDNYC

設計者
Beth Tondreau,
Suzanne Dell' Orto

這一套Jpeg圖檔是專為透過電子郵件發送訊息設計的，可讓每封電郵版面格式維持一致，但內容訊息和主圖不同。

Hot Flash
DISPATCHES FROM THE WORLD OF GREATER POSSIBILITIES

Starting a book club seems like a no-brainer for a hugely successful bookseller, right? Not so fast. **Barnes & Noble came to HotSpring** for help in creating a dynamic **new book club program** that would build communities of readers. Our approach focused on in-store gatherings, online interaction, and bookseller involvement that would excite readers, Barnes & Noble personnel, authors and publishers alike. The new clubs introduce the books that everyone will be talking about to the people who want to talk about them first— **adding an important human dimension to the Barnes & Noble brand.**

Barnes & Noble asked us:
"What would make a Barnes & Noble book club interesting to people beyond the book?"

If you are looking for a fresh, outside perspective to reveal new ways to think about your business, contact Claire @ 212.390.1677 www.hotspringnyc.com

Hot Flash
DISPATCHES FROM THE WORLD OF GREATER POSSIBILITIES

AOL had just made it services free to consumers, the most significant marketing change since the company's inception in 1989. With revenue generation now riding entirely on advertisers, AOL **asked HotSpring: what will set AOL apart** from its competitors? Through a combination of in-depth research with consumers, advertisers and AOL personnel, and an analysis of AOL's offerings, **we helped the AOL team make the most of their assets and position themselves for growth**—surprising the market with the breadth and depth of both their portfolio and their consumer users.

How does the company that was once the "big dog" avoid becoming the "old dog" in a market where names like Google and YouTube have changed the game?

If you need to rethink your market positioning
contact Claire @ 212.390.1677 www.hotspringnyc.com

HOTSPRING

Hot Flash
DISPATCHES FROM THE WORLD OF GREATER POSSIBILITIES

When **Time Inc** asked us to help them **position a new magazine for women** that would be **sold exclusively through Wal*Mart**, we knew that they were onto something. After we talked to the women it was intended for, we could articulate exactly what that "something" should be. We didn't count on a magazine for hard-working women across the country stirring the passions of **hard-boiled New York media critics.** But *All You* caught the eye of Larry Dobrow, who captured the essence of what the magazine brings to its readers in a single reading and **delivered a publisher's dream endorsement:**

" *. . . any product or brand or whatever that's targeting families oughta be in* All You. *Whether or not you buy into its unapologetic populism, it makes an awful lot of sense as an ad venue.* "

—Excerpt from *All You,* by Larry Dobrow. Thursday, May 11, 2006. Media Post's *Magazine Rack* www.mediapost.com

If you need to brush up your brand's proposition—
or articulate it in a single way that everyone can agree to,
contact Claire @ 212.390.1677
www.hotspringnyc.com

HOTSPRING

橫向階層的編排將訊息各個部分分為幾個區域。所有版型維持一致,公司商標則固定出現在郵件下方。此格線設計相當有彈性,能放入各種長度不同的內容,或在引述文句的區塊中放入不同的標點符號。

左頁:此文件是以電子郵件群組發送,版面設計是將標題作為刊頭,以單色橫條固定在頁面上。

95. 讓畫面動起來

超大平面設計須遵守大型排版的一些原則，如下：

- 在字型大小、粗細和顏色明暗上大膽發揮，讓彼此爭相表現，創造出版面動感。

- 考慮字母形體的立體感。
- 思考力學的部分，比較一下與在紙面上字型的差異。會移動的字型需要額外的間距，才能清楚好讀。

名稱
Bloomberg Dynamic
Digital Displays

客戶
Bloomberg LLP

設計公司
Pentagram, New York

藝術指導／設計、環境視覺
Paula Scher

藝術指導／設計、動態展示
Lisa Strausfeld

設計者
Jiae Kim, Andrew Freeman
Rion Byrd

專案建築師
STUDIOS Architecture

專案攝影
Peter Mauss/Esto

電子看板上超大膽的大型平面設計，訊息會在看板上移動，既傳送資訊，也打出品牌。

左右兩面：此超大平面設計結合了內容、數據和風格。

這些充滿動態感的訊息印製在四條橫板上，顏色各不相同。字型大小和字母顏色則依訊息內容而有所不同，除了傳達數據要點，也呈現出觀點。

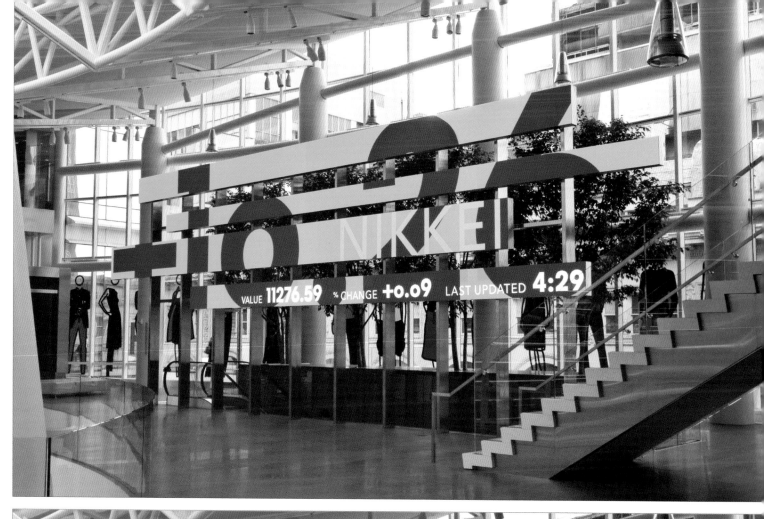

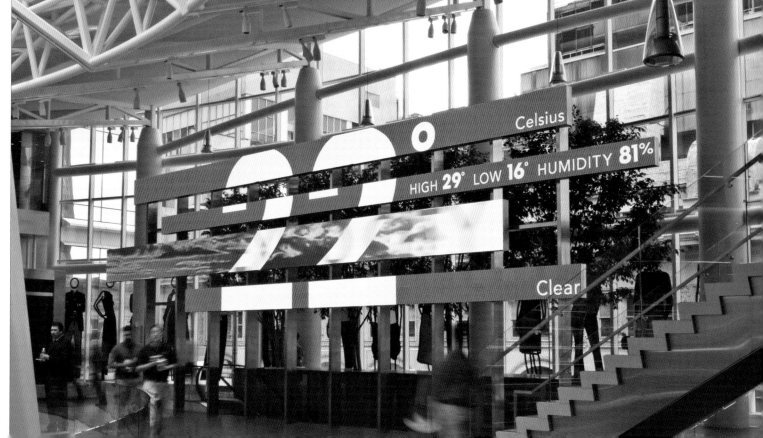

96. 分成單元

網站就和平面印刷的頁面一樣，同等大小的單元可以有多種方式區隔內容，包括讓網站更為生動的影音區。

流動性
在互動設計的新領域，值得一提的主題便是具流動性的格線和版面。一旦紙張頁面大小不再是要素，該怎麼辦？你會以主觀的空間感，將版面放在螢幕中央？還是會設計流動性版面，使其在不同大小的螢幕上自行重新調整？網頁專家可能會偏好後者，但要記住的是，設計這種版面在技術上較為困難。

名稱
Website

客戶
Earth Institute at
Columbia University

創意指導
Mark Inglis

設計公司
Sunghee Kim, John Stislow

以單元做區別，可呈現豐富又多元的訊息。

本頁和左頁：首頁的單元是設計在操作主選單下方，可結合多種空間配置運用。

・刊頭和連結設置的部分，可以橫跨整個頁面單元的寬度。
・單一單元可呈現個別主題。
・兩個單元合起來可做為補充欄。
・頁面周邊的單元可設計成長條形縱欄，做為最新消息和活動的公布欄。
・單元也可放入影片。

從首頁跳至其他頁面瀏覽，可以讓讀者更進一步深入閱讀。

後面分頁使用單元組織，並且稍微脫離原有版面配置，依資訊種類改為橫向階層編排。

97. 清楚呈現

許多傑出設計者聲稱自己設計時不用格線。
然而他們設計的版面都空間寬闊、極富質
感,而且頗有氣勢。多數設計者並未意識到自己
其實是遵行好設計的基本原則,讓內容更凸顯,
而且清楚呈現。

去背圖展現出遊戲中的人物如何被建構出來,以及動畫是如何
製作的。橫向線條放在人物下方,而人物形體不規則的線條,
為整個跨頁頁面提供動感。

名稱

The Art of Halo

客戶

Random House

設計公司

Liney Li

這本電玩書特別介紹《最後一
戰》的繪製藝術,裡面的英雄
人物看起來超級無敵。

▲ The evolution of Master Chief from wire frame, rendering, and finally clad in his battle armor.

The collaborative process at Bungie wasn't confined to the *Halo* team. There were several Bungie artists and programmers working on other titles during the various stages of *Halo*'s development. "I didn't do a lot on Halo—I was assigned to a team working on a different project," said character artist Juan Ramirez. "But most of us would weigh in on what we saw. I like monsters and animals and creatures—plus I'm a sculptor, so I did some sculpture designs of the early Elite.

"When I came on, I wasn't really a 'computer guy'—I was more into comics, film, that kind of thing. I try and apply that to my work here—to look at our games as more than just games. Better games equals better entertainment. A lot of that is sold through character design."

▲ One of the public's first looks at Halo came in the November, 1999 issue of Computer Gaming World. the evolution of Master Chief from wire frame, rendering, and finally clad in his battle armor.

THE MASTER CHIEF

Seven feet tall, and clad in fearsome MJOLNIR Mark V battle armor. the warrior known as the Master Chief is a product of the SPARTAN Project. Trained in the art of war since childhood, he may well hold the fate of the human race in his hands.

MARCUS LEHTO, ART DIRECTOR: *"At first, [Rob [artist Robt. McLees] and I were the only artists working on Halo. After that we hired Sheik [artist ShiKai Wang], who's just great from the conceptual standpoint. I'd do a preliminary version of something, then Sheik would work from that, and really enhance the concept.*

"The Master Chief design sketch that really took hold came after heavy collaboration with ShiKai. One of his sketches—this kind of manga-influenced piece, with ammo bandoliers across his chest, and a big bladed weapon on his back—really caught our imagination.

"Unfortunately, when we got that version into model form, he looked a little too slender, almost effeminate. So, I took the design and tried to make it look more like a modern tank. That's how we got to the Master Chief that appears in the game."

4 THE ART OF HALO

CHARACTER DESIGN 5

The Spartan was huge, easily seven feet tall. Encased in pearlescent green battle armor, the man looked like a figure from mythology—otherworldly and terrifying. Master Chief SPARTAN-117 stepped from the tube and surveyed the cryo bag. The mirrored visor on his helmet made him all the more fearsome. a faceless impassive soldier built for destruction and death.

The technician felt a pang of fear—and sorrow for the Covenant troops that would have to face this Spartan in combat.

—Excerpt from *Halo: The Flood* by William C. Dietz, the novelization of the game.

An integral part of creating a good story is the creation of believable and interesting characters. Bungie's 3-D modelers craft designs of the various characters that appear in-game, which must then be "textured"—telling the game engine how light and shadow react on the model. From there, the models must be rigged so they can be animated. "Overlap is vital, particularly among modelers and animators," says animator William O'Brien. "We depend on each other for the final product to work—and none of us can settle. We always have to up it a notch."

"Our job is to bring the characters to life in the game," said Nathan Walpole, animation lead for *Halo 2*. "It's what we're best at. We don't use motion capture—most of us are traditional 2-D animators, so we prefer to hand-key animation. Motion capture just looks so bad when it's done poorly. We have more control over hand-keyed animation, and can produce results faster than by editing mocap."

Crafting the animations that bring life to the game characters is a painstaking process. "Usually, we start with a thumbnail sketch to build a look or feel," explained Walpole. "Then you apply it to the 3-D model and work out the timing."

"Sometimes the timing's a bit off. It's hilarious," adds animator Mike Budd. "Everyone comes over and has a good laugh. Working together like we do keeps us fresh. There's such a variety of characters—human and alien. And you work on them in a matter of weeks. You're always working on something new and interesting.

▲ A pair of Grunts prepare to engage the enemy. Screen capture from Halo.

To design the characters' motions, the animators study virtually any source of movement for inspiration—though that can create some challenges for animator William O'Brien. "Just being surrounded by people with good senses of humor makes it easier to do your job. The drawback is I've always had my own office. To animate a character, I often act out motions and movements; this gives you a sense of what muscle and bone actually do. But now, I have an audience. 'Hey, look at the crazy stuff Bill's doing now!' So now, I tend to do that kind of work on video, in private."

◀ Opposite page: Captions needed for illustrations 1, 2, 3 , and 4.

2

CHARACTER DESIGN 3

本書版面兼具古典和未來感的風格。藍色色塊上的圖說，使用了不同顏色來與主文做區隔。做為區隔用的直線和指標（箭頭及「左」或「右」的文字）是以亮橘色呈現。

頁面邊界的暗色區形成補充欄，讓各個角色有所區隔。

98. 朝未來邁進

有時必須拋開設計的固有形式，如寬敞的邊緣、易讀的字體，以及用在正確地方的斜體。在某些狀況，「錯」的設計可能才是對的。若設計表現本來就為引發興趣與想像，跳脫規則的方法反而更為完美。

Design and the Elastic Mind

右圖：彈性。層次。引人入勝。

名稱

Design and the Elastic Mind

客戶

Museum of Modern Art

設計公司

Irma Boom, the Netherlands

封面字體

Daniël Maarleveld

在這本《設計與彈性思維》的展覽目錄中，設計者跳脫傳統版面的設計。結果就像此展覽的主題，有時多所啟發，有時令人感到衝擊。

Foreword

With Design and the Elastic Mind, The Museum of Modern Art once again ventures into the field of experimental design, where innovation, functionality, aesthetics, and a deep knowledge of the human condition combine to create outstanding artifacts. MoMA has always been an advocate of design as the foremost example of modern art's ability to permeate everyday life, and several exhibitions in the history of the Museum have attempted to define major shifts in culture and behavior as represented by the objects that facilitate and signify them. Shows like Italy: The New Domestic Landscape (1972), Designs for Independent Living (1988), Mutant Materials in Contemporary Design (1995), and Workspheres (2001), to name just a few, highlighted one of design's most fundamental roles: the translation of scientific and technological revolutions into approachable objects that change people's lives and, as a consequence, the world. Design is a bridge between the abstraction of research and the tangible requirements of real life.

The state of design is strong. In this era of fast-paced innovation, designers are becoming more and more integral to the evolution of society, and design has become a paragon for a constructive and effective synthesis of thought and action. Indeed, in the past few decades, people have coped with dramatic changes in several long-standing relationships—for instance, with time, space, information, and individuality. We must contend with abrupt changes in scale, distance, and pace, and our minds and bodies need to adapt to acquire the elasticity necessary to synthesize such abundance. Designers have contributed thoughtful concepts that can provide guidance and ease as science and technology proceed in their evolution. Design not only greatly benefits business, by adding value to its products, but it also influences policy and research without ever reneging its poietic, nonideological nature—and without renouncing beauty, efficiency, vision, and sensibility, the traits that MoMA curators have privileged in selecting examples for exhibition and for the Museum's collection.

Design and the Elastic Mind celebrates creators from all over the globe—their visions, dreams, and admonitions. It comprises more than two hundred design objects and concepts that marry the most advanced scientific research with the most attentive consideration of human limitations, habits, and aspirations. The objects range from

邊緣窄小、特異的字型，小到不行的頁碼及頁眉，都是要呼應主題，試圖引起閱讀興趣，讓人深思。

sometimes for hours, other times for minutes, using means of communication ranging from the most encrypted and syncopated to the most discursive and old-fashioned, such as talking face-to-face—or better, since even this could happen virtually, let's say nose-to-nose, at least until smells are translated into digital code and transferred to remote stations. We isolate ourselves in the middle of crowds within individual bubbles of technology, or sit alone at our computers to tune into communities of like-minded souls or to access information about esoteric topics.

Over the past twenty-five years, under the influence of such milestones as the introduction of the personal computer, the Internet, and wireless technology, we have experienced dramatic changes in several mainstays of our existence, especially our rapport with time, space, the physical nature of objects, and our own essence as individuals. In order to embrace these new degrees of freedom, whole categories of products and services have been born, from the first clocks with mechanical time-zone crowns to the most recent devices that use the Global Positioning System (GPS) to automatically update the time the moment you enter a new zone. Our options when it comes to the purchase of such products and services have multiplied, often with an emphasis on speed and automation (so much so that good old-fashioned cash and personalized transactions—the option of talking to a real person—now carry the cachet of luxury). Our mobility has increased along with our ability to communicate, and so has our capacity to influence the market with direct feedback, making us all into arbiters and opinion makers. Our idea of privacy and private property has evolved in unexpected ways, opening the door

top: James Powderly, Evan Theo Watson, and HELL. Graffiti Research Lab. L.A.S.E.R. Tag. Prototype. 2007. 60 mw green laser, digital projector, camera, and custom GNU software (L.A.S.E.R. Tag V1.0, using OpenFrameworks)

New forms of communication transcend scale and express a yearning to share opinions and information. This project simulates writing on a building. A camera tracks the beam painter of a laser pointer and software transmits the action to a very powerful projector.

16

17 bottom: James Powderly, Evan Roth, Theo Watson, DASK, FOXY LADY, and BENNETT48ENATE. Graffiti Research Lab. L.A.S.E.R. Tag graffiti projection system. Prototype. 2007. 60 mw green laser, digital projector, camera, custom GNU software (L.A.S.E.R. Tag V1.0, using OpenFrameworks), and mobile broadcast unit

for debates ranging from the value of copyright to the fear of ubiquitous surveillance.[2] Software glitches aside, we are free to journey through virtual-world platforms on the Internet. In fact, for the youngest users there is almost no difference between the world contained in the computer screen and real life, to the point that some digital metaphors, like video games, can travel backward into the physical world: At least one company, called area/code, stages "video" games on a large scale, in which real people in the roles of, say, Pac Man play out the games on city streets using mobile phones and other devices.

Design and the Elastic Mind considers these changes in behavior and need. It highlights current examples of successful design translations of disruptive scientific and technological innovations, and reflects on how the figure of the designer is changing from form giver to fundamental interpreter of an extraordinarily dynamic reality. Leading up to this volume and exhibition, in the fall of 2006 The Museum of Modern Art and the science publication Seed launched a monthly salon to bring together scientists, designers, and architects to present their work and ideas to each other. Among them were Benjamin Aranda and Chris Lasch, whose presentation immediately following such a giant of the history of science as Benoit Mandelbrot was nothing short of heroic, science photographer Felice Frankel, physicist Keith Schwab, and computational design innovator Ben Fry, to name just a few.[3] Indeed, many of the designers featured in this book are engaged in exchanges with scientists, including Michael Burton and Christopher Woebken, whose work is influenced by nanophysicist Richard A. L. Jones; Elio Caccavale, whose interlocutor is Armand Marie Leroi, a biologist from the Imperial

圖片放在跨頁裝訂處，這在一般版面編排是不被允許的。

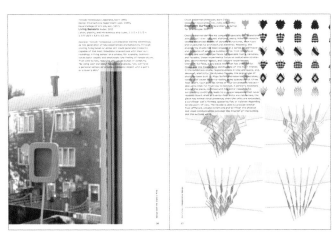

此頁在編排上刻意將圖壓在字上。

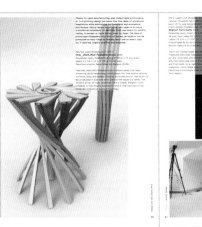

放有文字的透明區塊壓在圖上。

99. 跟著感覺走

一旦花了不少功夫學習格線設計，要全然拋開實在不太容易。多做功課。讀讀設計史，包括引發某些思潮的社會影響力。研究與構思要編排的內容，再設計欄位，要注意版面呈現，讓字體清晰易讀。慎選字型後，仍要不斷微調，直到整體完美無缺。

然後相信你的直覺。設計出一種版型，能讓內容加分，並且展現出你對主題獨到的個人見解與風格。

名稱

Typography Assignment,
UArts, Philadelphia, PA

指導老師

Jennifer Bernstein

設計者

Daniela Lien (Galliard),
Michael Lassiter
(Franklin Gothic)

Alexander Lawson的《字型解剖全書》廣受歡迎，學生利用書中介紹的字型來設計版面，從這些跨頁可看出他們學到了選用字型的精髓。

本頁及左頁：這幾頁版面顯示從初始概念到大功告成的過程，看得出來要設計精美的版型，得不時做調整。這些學生設計的版面主要是運用文字編排來呈現字型演變史的主題。

Franklin Gothic

by Alexander Lawson

When the late Stevens Watts was manager of the American Type Founders' foundry, he was fond of saying that 'while types come and go, Franklin Gothic goes on forever.' The type was a perennial best seller, and over the past seventy years it has been one of the best-known representatives of a style of type notable for its multiplicity of forms, the modern gothics. These faces are not, despite their name, gothics - at least in the traditional understanding of the term. And Franklin Gothic is doubly misnamed, having no historical relationship to Benjamin Franklin.

If anyone can be blamed for the gothic misnomer it is perhaps the corporate body of the Boston type and stereotype foundry, which back in 1837 issued a new series of types without serifs under the name gothic. Probably it was the bold weight of this type that prompted the designation. In any event, the Boston firm was the first foundry in America to introduce a serifless design then attaining great popularity in Europe, particularly England and Germany.

In the post-World War II era, when sans-serif types dominate the typography of the marketplace, it is difficult to recall that typefounders up to the beginning of the nineteenth century sought to please only book printers. It was the industrial revolution that brought to printers, as to manufacturers, countless changes and the introduction of extrabold types, called fat faces, patterned somewhat akin to the Didot and Bodini styles. These were welcomed for their display value by printers specializing in the production of broadsides, handbills, and posters.

The impact of the new commercial types evidently stimulated William Caslon IV - of the famous English typefounding family - in 1816 to offer experimentally a monotone type without serifs under the name two-line English Egyptian. This 28-point type, produced in capitals only, was the first sans serif to be purveyed as a printing type.

Caslon's design did not meet with immediate support, primarily because its introduction coincided with that of the well received square-serif faces currently being issued by competing typefoundries. But by 1825 the German firm of Schelter and Giesecke was also offering a series of condensed sans serifs, which included lowercase characters. Then, in 1832, three English foundries brought out additional sans-serif types. One of these firms, that of William Thorowgood, termed the style 'grotesque,' a classification that is still standard in Britain for the sans-serif types that originated in the nineteenth century.

By 1850 all of the world's typefounders were issuing sans serifs in an endless, and confusing, variety of weights and widths. This typographic overkill continued until metal types were largely superseded by film fonts in the past few decades.

When the American type founders issued Franklin Gothic in 1905, it didn't seem that the company needed another gothic.

For after ATF had been formed in 1892 - as an amalgamation of many American typefoundries - the new firm issued a specimen book that showed about fifty gothic types. Some of these types had such colorful names as Turius, Altona, Octic, and Telescope, but most of them were simply numbered. Many of the faces were difficult to distinguish, but all of the widths now common in gothic series were represented from extra-condensed to extra-extended.

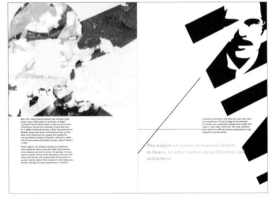

100. 丟掉規則

本書論及諸多使用格線設計的規則，同時也觸及其他排版基本要素，例如內容編排、空間和顏色。

　　就如本書開頭所說，設計首要原則就是要能搭配主題。釐清內容的階層關係，並注意文字編排，無論版面是傳統清晰風格，還是活潑地混搭不同字型與粗細皆然。在版面編排時技巧決定了一切。頁面要協調，且要有一致性。

　　從本書學習原則，然後再自己構思。

　　不過，規則並非一切。

　　瞭解設計原則雖然極為重要，但不時打破原則也同樣重要。沒有任何書或網站可以教你所有的東西。觀察。提問。向他人學習。保持幽默感。樂在其中。要有彈性但堅守理念。切記成功的設計取決於各元素巧妙的搭配。不要只為了編排設計出一個東西就隨便做做。準備就緒，就往格線世界出發。好好享受吧！

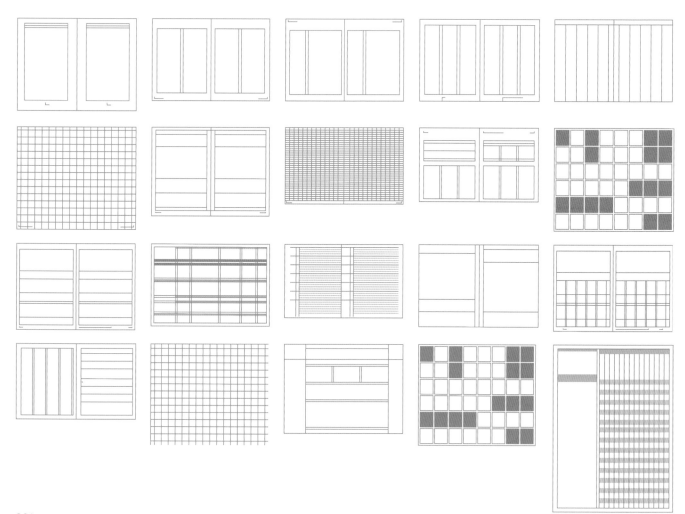

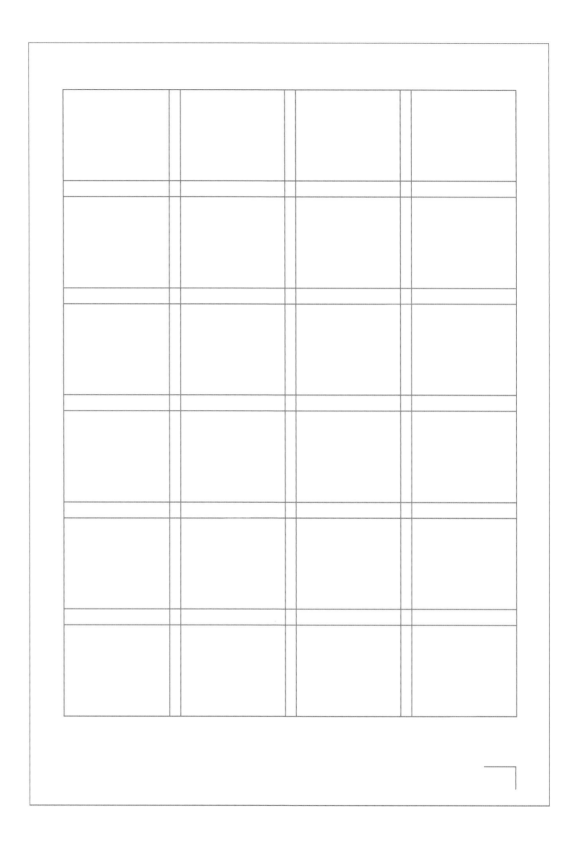

詞彙解釋

正文後附加資料（**Back Matter**）——附加內容，不屬於正文一部分，如索引、註釋、參考書目、詞彙解釋和索引。

CMYK——全彩印刷的四原色：青綠色、洋紅色、黃色和黑色（**K**）。

欄位（**Column**）——涵蓋文字或圖片的縱向空間。欄位內的文字是橫向編排。

置左（**Flush Left**）——文字在左緣對齊。右方邊緣長短不一，但不會差太多。

齊右（**Flush Right**）——文字在右緣對齊，左方邊緣長短窄不一。

字體（**Font**）——就電腦數位系統而言，字體是指一種字型所呈現的樣貌，而且是用來排版。字型和字體常被（錯誤地）混為一談，誤以為兩者可以相互替換。不妨把字體想成是完成的製品，字型則是設計，字體乃字型尺寸與樣式的結合。

正文前資料（**Front Matter**）——一本書中出現在正文之前的內容，如書名頁、版權頁和目錄。

JPEG——聯合圖像專家小組（Joint Photographic Experts Group）的縮寫。這種用於網路圖片的壓縮檔案格式，不適合傳統印刷用。

齊頭齊尾（**Justify**）——將橫排文字的左右兩邊對齊。

版型（**Layout**）——在頁面或螢幕畫面上安排各元素，例如文字或圖像。

發行欄（**Masthead**）——所有與出版物相關的人名表，會附上職稱。發行欄也會放上與出版物相關的訊息。

負空間（**Negative Space**）——物形和背景之間的空間，常用於美術、雕刻或音樂。

孤字（**Orphan**）——段落中的最後一字，獨自出現在頁面或欄位的最上方端。

無線膠裝（**Perfect Binding**）——一種無線膠黏的裝訂形式。印刷的裝訂邊先以膠黏，再糊上書封。然後再把膠裝好的書其餘三邊修齊。

Pica——字型計量單位。一pica等於12pt。以Postscript列表機來說，一pica等於1/6吋。

像素（**Pixel**）——電腦螢幕上顯現的最小單位。（代表圖片解析度。）

Point——文字排版的計量單位。一pica為12 pt，72 pt大約等於一吋。

RGB——紅色、綠色、藍色為電腦螢幕顯示的顏色。在掃描圖片時，Photoshop畫面的圖像即以紅綠藍呈現。在一般傳統印刷時，圖片必須要轉成CMYK的TIFF檔案格式。

欄外標題/頁首標題（**Running Head**）——位於頁面最上方，顯示內容類別和位置。欄外標題可以包括頁碼。欄外足標也是同樣元素，位在頁面下方。

連續走文（**Running Text**）——連續完整的稿子，一般不會再插入標題、表格、插圖等。

騎馬釘裝訂（**Saddle Stitched**）——以類似釘書針的釘子於頁面對折處裝訂。

飽和（**Saturated**）——色彩不灰暗、顏色鮮豔。一旦飽和度增加，灰階部分就會隨之減低。

去背（**Silhouette**）——圖片背景被消除，只留下人物或實體。

章頭留白（**Sink**）——從頁面最上方（或頁面邊緣處）到章名之間的距離。

壓印（**Surprint**）——將某色壓印在另一色上方。

文案（**Tagline**）——摘自文章的slogan或幾句話。

TIFF——標籤影像檔案格式（Tagged Image File Format）的縮寫。這個格式可儲存和傳送點陣、灰階和彩色圖像。TIFF檔案格式是最適合用來印刷的檔案格式。

字型（**Typeface**）——具有特定特徵的文字設計。各種字型可以有共同特色。一種字型可包含各種設計面向，如斜體、粗體、小大寫及粗細不同。字型是指設計。參見字體。

文字編排（**Typography**）——指排版風格、編排和版面呈現。這也可說是以字型來設計的藝術。

留白（**White Space**）——頁面或螢幕空白區域，上面沒有任何文字或插圖。

孤行（**Widow**）——一短句在段落結尾處單獨成行。一般認為孤字和孤行是可替換的同義詞。

延伸閱讀

書籍

Antonelli, Paola. *Design and the Elastic Mind.* Museum of Modern Art, 2008.

Birdsall, Derek. *Notes on Book Design.* Yale University Press, 2004.

Bringhurst, Robert. *The Elements of Typographic Style.* Hartley & Marks Publishers, 1992, 1996, 2002.

Heller, Steven, and Fili, Louise. *Stylepedia. A Guide to Graphic Design Mannerisms, Quirks, and Conceits.* Chronicle Books, 2007.

Kidd, Chip, *Work: 1986–2006; Book One.* Rizzoli International Publications, Inc., 2005.

Lawson, Alexander. *Anatomy of a Typeface.* David R. Godine Publisher, Inc., 1990.

Leborg, Christian. *Visual Grammar.* Princeton Architectural Press, 2004.

Lee, Marshall. *Bookmaking: Editing, Design, Production.* Third Edition. W. W. Norton & Co., 2004.

Lidwell, William; Holden, Kristina; Butler, Jill. *Universal Principles of Design.* Rockport Publishers, 2003.

Lupton, Ellen. *Thinking with Type.* Princeton Architectural Press, 2004.

Rand, Paul. *Design Form and Chaos.* Yale University Press, 1993.

Samara, Timothy. *Making and Breaking the Grid.* Rockport Publishers, 2002.

Spiekermann, Erik, and E. M. Ginger. *Stop Stealing Sheep & Find Out How Type Works.* Peachpit Press, 2003.

Stevenson, George A., Revised by William A. Pakan. *Graphic Arts Encyclopedia.* Design Press, 1992.

Updike, Daniel Berkeley. *Printing Types; Their History Forms, and Use.* Volumes I and II. Harvard University Press, 1966.

網路上文章

Haley, Allan. "They're not fonts!"
http://www.aiga.org/content.cfm/theyre-not-fonts

Vinh, Khoi. "Grids are Good (Right)?" Blog Entry on subtraction.com

圖片出處

原則的編號以粗體標示

Principles **7**, 16; **8**, 17; **20**, 40–41; **83**, 166–167
AdamsMorioka, Inc.
Sean Adams, Chris Taillon, Noreen Morioka, Monica Shlaug

Principle **34**, 68–69
AIGA Design for Democracy
164 Fifth Avenue
New York, NY 10010

Principle **75**, 150–151
Artisan
Vivian Ghazarian

Principles **32**, 64–65; **54**, 108–109; **73**, 146–147; **90**, 180–181
Marian Bantjes
Marian Bantjes, Ross Mills, Richard Turley

Principles **4**, 13; **5**, 14; **12**, 24–25; **16**, 32–33; **94**, 188–189
BTDNYC

Principles **17**, 34–35; **28**, 56–57; **40**, 80–81; **65**, 130–131
Carapellucci Design

Principles **17**, 34–35; **65**, 130–131
The Cathedral Church of Saint John the Divine

Principle **60**, 120–121
Collins
Brian Collins, John Moon, Michael Pangilnan

Principles **18**, 36–37; **46**, 92–93; **76**, 152–153
Croissant
Seiko Baba

Principle **64**, 128–129
Design Institute, University of Minnesota
Janet Abrams, Sylvia Harris

Principle **84**, 168–169
Design within Reach/Morla Design, Inc.
Jennifer Morla, Michael Sainato, Tina Yuan, Gwendolyn Horton

Principle **93**, 186–187
Design Taxi

Principle **91**, 182–183
Suzanne Dell'Orto

Principle **70**, 140–141
Andrea Dezsö

Principles **22**, 44–45; **25**, 50-51; **35**, 70-71; **43**, 86–87
Barbara deWilde

Principles **42**, 84–85; **48**, 96–97; **62**, 124–125; **92**, 184–185; **96**, 192–193
The Earth Institute of Columbia University
Mark Inglis, Sunghee Kim

Principle **77**, 154–155
The Heads of State
Jason Kervenich, Dustin Summers, Christina Wilton

Principle **19**, 38–39
Heavy Meta
Barbara Glauber, Hilary Greenbaum

Principle **85**, 170–171
Cindy Heller

Principle **21**, 42–43
Katie Homans

Principle **82**, 164–165
INDUSTRIES stationery
Drew Souza

Principle **29**, 58-59; **31**, 62-63; **39**, 78-79; **53**, 106-107
Kurashi no techno/Everyday Notebook
Shuzo Hayashi, Masaaki Kuroyanagi

Principle **99,** 199
Michael Lassiter

Principle **99**, 198
Daniela Lien

Principles **26**, 52–53; **59**, 118–119; **79**, 158–159
Bobby C. Martin Jr.

Principle **97**, 194–195
Liney Li

Principles **9**, 18; **71**, 142–143; **88**, 176–177
Mark Melnick Graphic Design

Principles **5**, 14; **25**, 50–51
Martha Stewart Omnimedia

Principle **60**, 120-121
The Martin Agency
Mike Hughes, Sean Riley, Raymond McKinney, Ty Harper

Principles **44**, 88–89; **58**, 116–117
Memo Productions
Douglas Riccardi

Principles **27**, 54–55
Metroplis magazine
Criswell Lappin

Principles **11**, 22–23; **13**, 26–27
Fritz Metsch Design

Principle **98**, 196–197
The Museum of Modern Art
Irma Boom

Principle **56,** 112–113
Navy Blue
Ross Shaw, Marc Jenks

Principle **47**, 94–95
New York City Center
Andrew Jerabek, David Saks

Principle **30**, 60-61
The New York Times
Design Director: Khoi Vinh

Principle **28**, 56–57
New York University School of Medicine

Principle **86**, 172–173
Nikkei Business Publications, Inc.

快速操作指南

1

評估內容

❏主題是什麼？
❏是否有大量連續走文？
❏有許多元素嗎？比方說段落標題？副標題？書眉？圖表？
　表格？還是圖片？
❏編輯會決定並標示內容的重要順序？還是你得自己評估認
　定？
❏需要用到插圖還是照片？
❏最後是正式印刷，還是放到網路？

2

事先計畫，
了解製作詳細狀況

❏會以什麼方式印製？
❏是單色、雙色，還是四色？
●●● 如果是以傳統方式印刷，在編排時就必須使用或搭
　　　配解析度300的tiff檔。
●●● 解析度72的jpeg檔不適合傳統印刷，只適用網路瀏
　　　覽。
❏是否有很多元素？如段落標題？副標題？書眉？還是圖
　表？表格？圖片？
❏是以傳統印刷，還是會放到網路？
❏頁面的最後完成尺寸？
❏有規定頁數嗎？是否有彈性增減的空間？
❏客戶或印刷廠是否對於邊緣有最小限制？

3

選擇版型、邊緣及字型

❏充分利用所有的頁面／版面，設計出最好版面。
●●● 若是專業技術性內容或頁面本身較大，可使用雙欄
　　　或多欄式格線。
❏決定邊緣留多少。這對入門者來說是最難拿捏的一環。給
　自己多點摸索時間。記住，即使要放進版面的內容非常大
　量，保留一些空間還是對設計有所裨益。
❏就第一個步驟評估的內容來決定要用何種字型。對於要編
　排的內容，能選用多種字體，還是只能用一種，再用不同
　粗細變化？
●●● 大部分電腦都有內建字體，但要花點時間多熟悉一
　　　下各種字體。有時也可大膽試試樸實保守的字型，
　　　未必總要用新潮的字體。
❏思考一下字型的大小和行距。若有具體想法可以先擬個草
　稿，然後把文字放進頁面看看合不合適。

4

了解字型和排版原則

□ 對排版來說，句點後只空一格。（編按：此指英文排版）
●●● 版面設計與文書處理不盡相同，你要設計的是合適版型。原先比照打字機空兩格的方式已經過時了。（編按：此指英文排版）
□ 在一段中，若要拆分文字換行，避免過多連字號或奇怪空行，只要以自動換行處理即可。（編按：此指英文排版）
□ 使用字型本身的引號，而不是數學標記（這些直線常用來標記英寸和英尺）。
□ 使用拼字檢查。
□ 確定選用的粗體和斜體是字型本身的斜體。如果你的排版軟體有自動加粗或使用斜體功能，不要輕易選用。那不是正確字型。

注意不佳的斷行空白，比方說名字拆開、連續兩個連字號，或是行末破折號緊接在連字號後。
●●● 當然，如果你在本書找到文句分段不對處，我很樂意聽取建議，於再版印刷時改正所有錯誤。
□ 空格大不同。

破折號 作為文法或文章敘述停頓標記。
短破折號 作為時間性篇章或連接數字。
連字號 連接字句，在行末分隔字詞。

正確引用
避免「錯誤引用」

"Dumb Quotes"
錯誤引用

"Smart Quotes"
正確引用

"Dumb Quotes"
錯誤引用

"Smart Quotes"
正確引用

特殊字元與重音符號

特殊字元

–	Option – hyphen	短破折號
—	Option – Shift – hyphen	長破折號
…	Option – ;	刪節號（這個字元在行末不能像三個句號一樣分開）
•	Option – 8	項目符號（星形標記特別好記）
■	n *(ZapfDingbats)*	填滿黑格
□	n *(ZapfDingbats, outlined)*	空白黑格
©	Option – g	
™	Option – 2	
®	Option – r	
°	Option – Shift – 8	度數符號（例如102°F）
¢	Option – $	
"	Shift – Control – quotes	英寸標記（同「正確引用」）

重音符號

´	Option – e	（例如Résumé）
`	Option – ~	
¨	Option – u	
˜	Option – n	
ˆ	Option – i	

5

瞭解好的編頁準則

編頁
□ 編頁時，避免孤字孤行（見詞彙解釋）。
□ 參考就好，但不沿用前面頁面。
□ 注意，當你上傳檔案給印刷廠時，必須連同你的文件和圖片，附上字型一起封裝，不論是用QuarkXPress或InDesign都一樣。

致謝

Curating a book like this is an adventure and an experience. I thank Steven Heller for suggesting me for the task. I also wish to thank Emily Potts for her direction and patience.

The many professionals featured in the book took time to assemble materials, answer questions, and graciously grant the use of their projects. I thank and admire all of them and have learned from their talent and work.

I am grateful to Donna David for the opportunity to teach, as well as some glossary terminology used in this book. Throughout this book, I've noted that graphic design is a collaboration. Janice Carapellucci proves my words. Thanks to Janice's clarity and organization and the energy that sprang from working together, this book is a stronger guide; it was a delight to work with her. I'm also grateful to Punyapol "Noom" Kittayarak, Suzanne Dell'Orto, Kei Yan Wat, Tomo Tanaka, Yona Hayakawa, Judith Michael, Anna Tunick, and Michèle Tondreau—all of whom were generous with their contacts or time—or both.

My favorite collaborator, Pat O'Neill, was characteristically witty, wry, wonderful, and patient when the demands of a small business and this book meant that his spouse was constantly embroiled. To say Pat is generous and nurturing is an understatement.